WILDLIFE
PHOTOGRAPHER

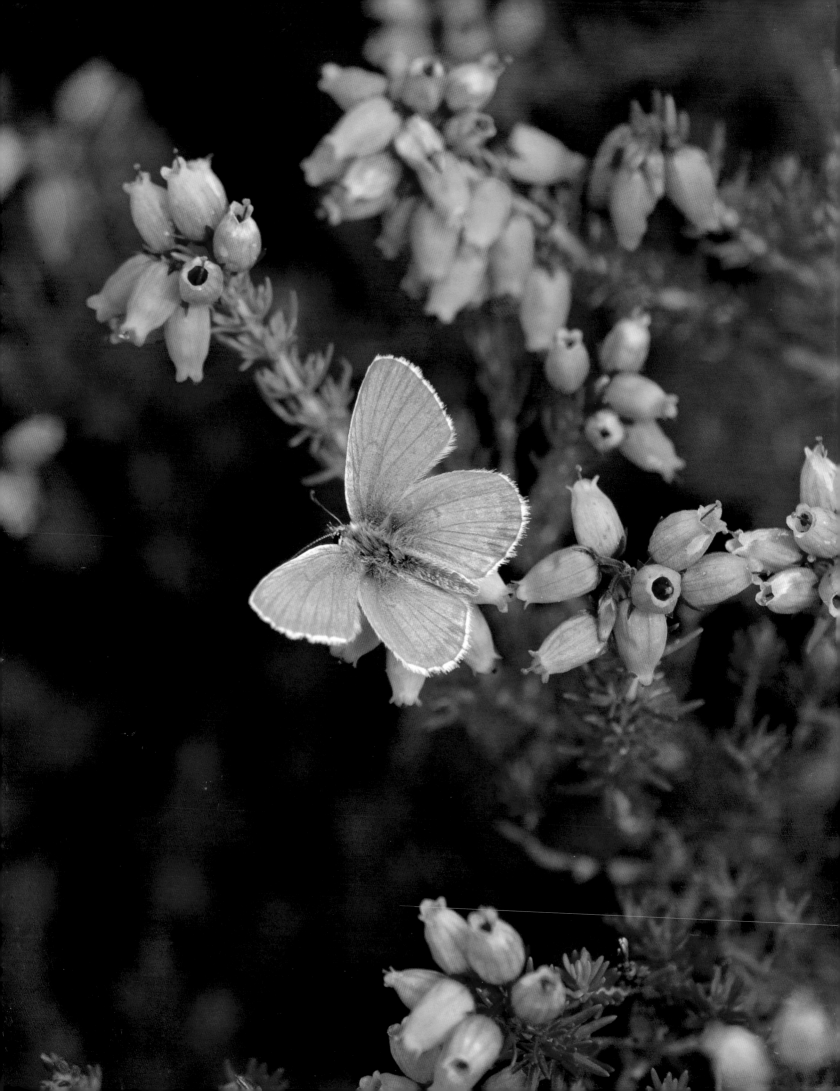

WILDLIFE PHOTOGRAPHER

a course in creative photography

CHRIS GOMERSALL

F

FRANCES LINCOLN LIMITED
PUBLISHERS

For Pat, Hannah and Alice

Frances Lincoln Limited
4 Torriano Mews
Torriano Avenue
London NW5 2RZ
www.franceslincoln.com

A catalogue record for this book is available from the British Library

ISBN 978-0-7112-3119-1

Printed and bound in China

9 8 7 6 5 4 3 2 1

◀ *Silver-studded blue
butterfly nectaring on
bell heather (overleaf).*

ETHICAL STATEMENT
The photographs in this book have not been digitally altered in
any way that is intended to mislead the viewer or misrepresent
the subject. In those rare instances where alterations have been
made, these are explained in the accompanying text. Similarly, all
living subjects depicted are genuinely wild and free, except in a
small number of cases where there was felt to be justification for
inclusion, and then the circumstances are fully explained in the
captions. The welfare and integrity of living subjects and their
surrounding habitats have been prioritized at all times.

CONTENTS

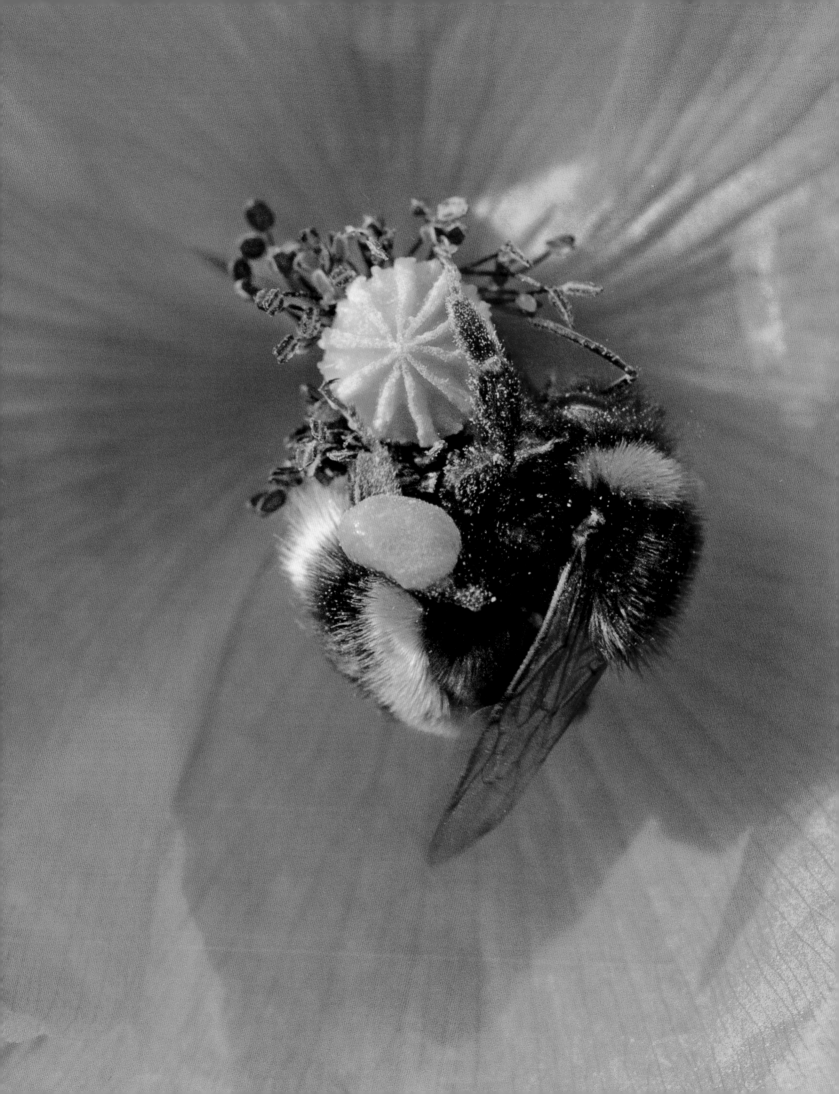

INTRODUCTION

*The great book, always open and which we should make an effort to
read, is that of Nature.*
Antoni Gaudí

For most of the history of wildlife photography, and that's well over a century now, there was only one game in town – the challenge of capturing a large enough image of a recognisable wild animal that was correctly exposed and in sharp focus. The technical and practical limitations were simply so great, most people gave it up as a bad job. It was a specialist discipline that only a determined few were able to master. Today, though, we have much improved optics, powerful digital sensors and automated camera functions that open up this territory to many more people, and at the same time extend the realm of the achievable. Wildlife photography has come of age. Increasingly, photographers are seeking to look beyond the basic craft, while audiences too are becoming more sophisticated. They are no longer satisfied with dry accounts of where you've been and what you've seen, but they want to know how you saw it and what you felt. And what's your message? In that sense, we're only just catching up with most other fields of photography in learning how to express ourselves. This makes it an exciting time in the continuing emancipation of wildlife photography, and a compelling reason to be involved.

Traditionally, the critics have not been well disposed towards the genre of wildlife photography, frequently dismissing it as sentimentalist or nostalgia driven. The art establishment seems to be only interested in the metropolitan, and on the rare occasions it has turned its attention to the photography of animals it has been restricted to the zoo animals and domestic pets as featured in the works of the great Garry Winogrand and Elliot Erwit, for example, ignoring the wider natural environment. Gradually, however, those prejudices and preconceptions are being challenged and broken down, championed by institutions such as the Wildlife Photographer of the Year competition that now attracts colossal interest from hopeful entrants and eager audiences alike. Undoubtedly this has been one of the principal agents for change and has led to photographers stretching themselves and testing the limits of technology as well as their own creative visions and the tolerances of their audiences. But we still have some way to go if we want to be taken seriously in the salons of London, Paris and New York.

In any case this mass participation should be welcomed, and gives us cause for optimism. It's a forceful statement testifying to the wide appeal of wildlife photography, that most accessible, democratic and pervasive of art forms. Of course this popularity is not without problems, creating pressures on the environment that need to be managed, but overall it must be seen as a positive and benevolent influence. People who strive to photograph wildlife inevitably learn a great deal about natural history in the process, and the collective fruits of their labours can only lead to a wider public understanding. The environment needs more ambassadors with cameras, provided they are well informed and act responsibly. To that end, I address such concerns in the chapters 'Saving the Earth' and 'Truth, Ethics and Integrity'.

So what's the difference between wildlife and nature photography? Well I don't make a distinction here, and to be honest I'm not very interested in the semantics. For the purposes of this book I am happy to include both animal and plant kingdoms together with the landscapes of the natural world, reasoning that we shouldn't disregard the wider ecosystem and the habitats that support life. In any case, the rather artificial boundaries between landscape, nature and wildlife photography are becoming increasingly blurred, as too the divisions between the conventional practices of photography, digital art and graphic design, all of which we need to embrace and learn to use effectively. Arguing over the terminology does not advance our cause. Having said that, I do concede that a great many of my illustrations feature birds, since this is my particular specialism, but only where these are the best photographs I can find to reinforce a particular point.

◄ *A buff-tailed bumble bee with full pollen baskets.*

This is most definitely not a technical manual, and I do assume some prior knowledge of the basic principles of photography. That's because there are now better ways to disseminate that kind of information: through web forums and blogs, video tutorials, and many other new media. Such vehicles are much better placed to respond to our rapidly changing technology. My intention here is to address the issues and ideas pertaining to nature and wildlife photography, the creative processes, the subjects themselves and the passion we feel for them – the philosophy of wildlife photography, if you like – and then to explore what we can do to improve our vision and methods of interpretation. I don't talk about what type of camera bag you need, which brand of lens or tripod head to use, and certainly not which software for raw file conversion – even though these seem to be the subjects that most wildlife photographers agonize about. Believe me, these are all red herrings. My justification for saying this is based on the evidence of leading many photography workshops and teaching tutorials over a couple of decades. I don't see too many examples of badly exposed or out-of-focus photographs any more – it's actually quite difficult to take a duff shot with today's equipment. What I do encounter though, quite frequently, is a failure of vision and a lack of creative ideas, and this is where I think there's a gap in the current literature this book seeks to address. I claim no uinque authority – if others are ready to contribute to the debate, so much the better.

Whether these more creative aspects of wildlife photography can be taught is debatable. I offer no template, no magic bullet, nor even a ten-point plan. Beware snake oil salesmen offering instant remedies. What I can do, I hope, is to offer guidance, spark ideas, make you think, and encourage you to ask the right questions. And perhaps through sharing some aspects of my own evolution as a photographer I can make it a slightly shorter and easier journey for others – though none of us should be under any illusion that this must ultimately and necessarily be our own private journey of self-discovery. That's also one of the greatest rewards.

So please don't set out to imitate what I have done, or to recreate the work of other published photographers. That's really not a sincere form of flattery, it's a cop out. If this book is to achieve anything, it should lead you to challenge and question all you read here, and to seek out fresh modes of expression through the great medium of photography. Aspire to be the original artist, not merely the tribute act. We are all creators, and we have the means. Be inspired.

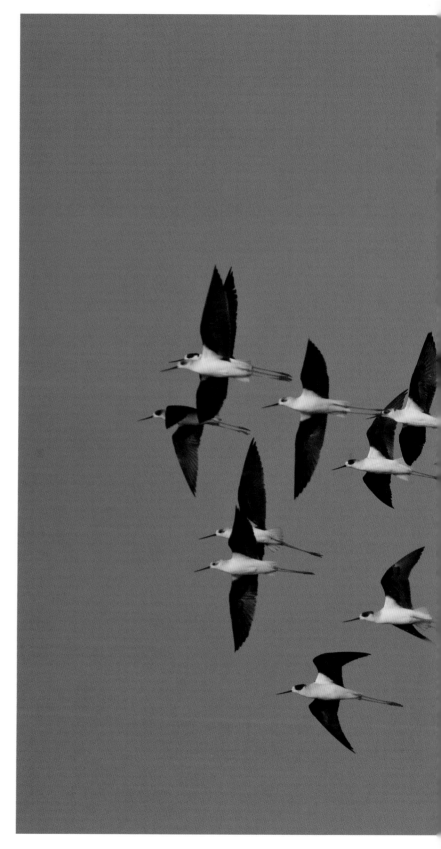

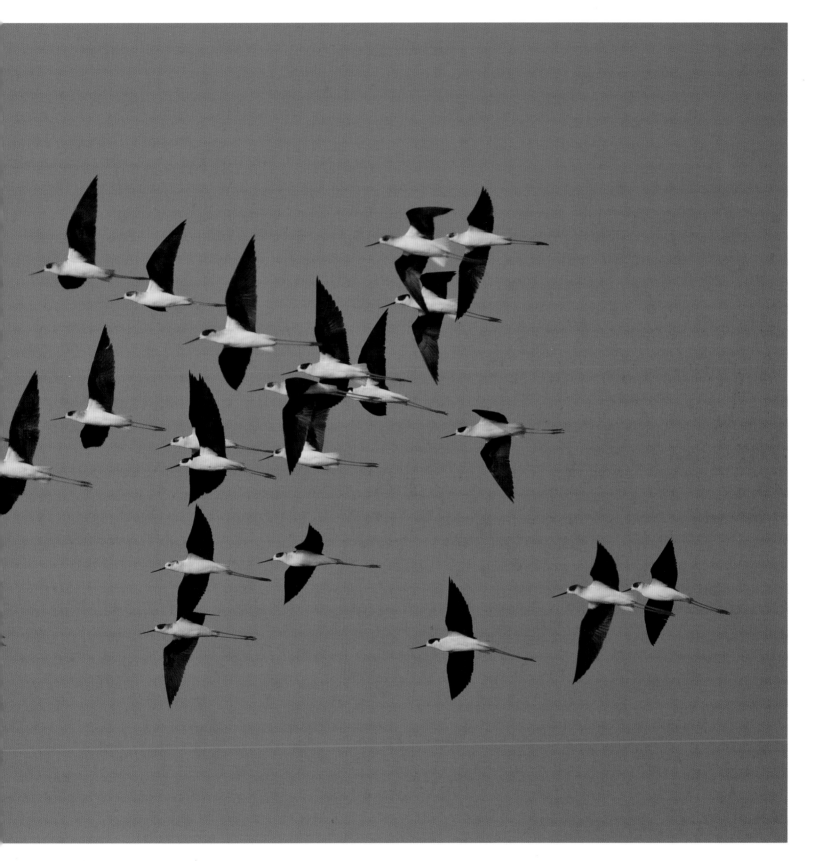

▲ *A flock of black-winged stilts flying in formation, in Portugal.*

▶ *European brown bear in the Finnish taiga.*

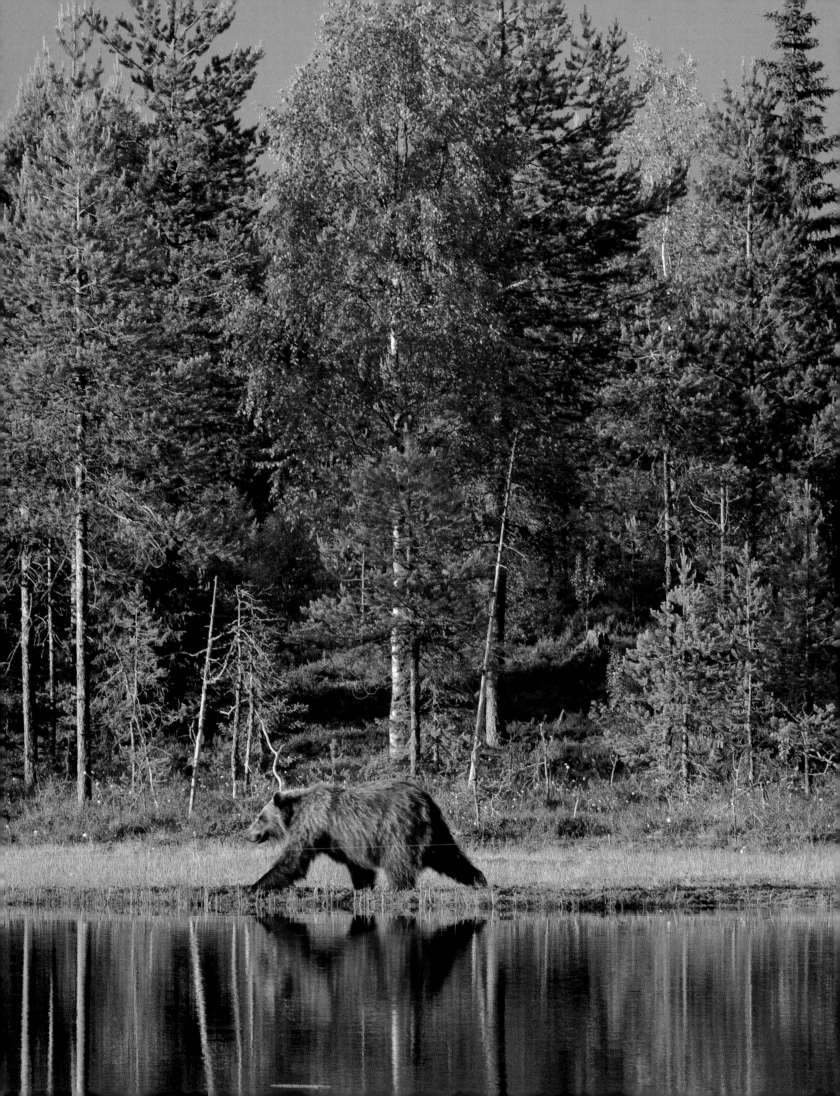

First Forays

And hark! How blithe the throstle sings!
He, too, is no mean preacher:
Come forth into the light of things,
Let Nature be your teacher.
William Wordsworth

THE CASE FOR GOOD PLANNING

Here's a scenario that will no doubt be familiar to every aspiring wildlife photographer. Imagine you are taking a walk in the countryside with your camera gear. You don't really have a subject in mind, but it's a pleasant day so you thought it was worth exploring the picture making possibilities. After a while you happen to see a deer standing near the edge of the woods, and naturally enough you think this would make a good subject for a photograph. Bearing in mind that all your equipment is stowed in your backpack, you only have a moment to assess the situation and get on with the job. These are just some of the things that should be going through your mind:

- How should I approach the subject, and what are the chances it will flee?
- Where is the wind coming from and is the subject downwind or upwind of me?
- Are there other people around who might disturb the deer?
- Are there other animals around which might distract or interact with it?
- What happened last time I tried this?
- Which lens should I use?
- Do I like the foreground and background, and can I change them by moving around?
- What is my ideal viewpoint and camera position, and can I reach it?
- Where is the sun in relation to me and the subject?
- How can I best take advantage of the light?
- Are any filters required?
- Do I need to use supplementary light such as fill flash?
- Should I use a tripod, or handhold?
- What's my best metering method?
- What are the optimum shutter speed, lens aperture and ISO sensitivity settings?

- How much depth of field desired?
- Will I have the time or opportunity to adjust the camera settings as I go along?
- How should I frame the image?
- Upright or horizontal format?
- Level or tilted?
- What should I include and exclude from my picture?
- Where should I place the subject in the frame?
- What should I elect as my focus point?
- Autofocus or manual?
- Which AF pattern or mode to use?
- Should I wait for eye contact, a head turn, a catchlight?
- Will the sound of my shutter disturb the animal?
- Single frame or continuous burst?
- Can deer see red?
- Is this the rutting season?
- Did I read somewhere that stags charge people when threatened?
- Should I have left the dog at home?
- Er . . . why is he running away?

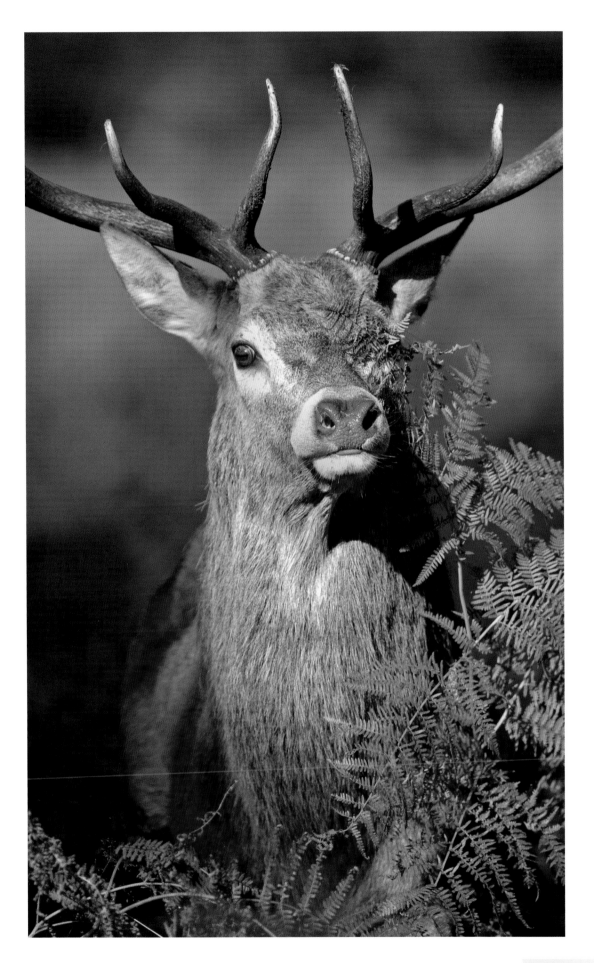

◄ Not entirely a
chance encounter,
this red deer stag was
found in a predictable
regular haunt during its
autumn rut.

Clearly there's an awful lot that needs to be taken into account when you begin to analyse the processes – a veritable maelstrom of technical, ecological, practical and aesthetic considerations. Believe it or not, most experienced wildlife photographers will take all this in their stride without even realizing that's what they are doing, but it's bewildering and rather intimidating if you're not used to it, and some points will inevitably get overlooked or go unanswered.

Continuing your journey, now with telephoto lens fitted to your camera mounted on to a tripod, you reach the crest of a hill and a fantastic landscape opens up before you. Suddenly there is a brand new set of questions to pose and fresh decisions to be made, and inevitable changes to your equipment and approach. A whole new project, in effect. An hour later but only a few metres on, and you come across a butterfly nectaring on a wildflower. Whoah, here we go again!

There are some obvious conclusions to be drawn here, if you're not to be overwhelmed with choices every time you encounter a possible subject and set about composing a picture:

- Concentrate on one project at a time
- Research your chosen subject
- Pre-visualize the desired result
- Choose your time and location
- Anticipate the likely behaviour
- Become proficient in the use of your equipment

Implementing this approach, most of the questions raised in the original hypothetical example should have already been addressed before you arrive on location. And the more answers you have, the more you can turn your attention to the creative side of the process and the more responsive you can be to changing circumstances. Surprisingly, while we all know this is the best recipe for success, many still persist with the unplanned and haphazard approach. It is, however, a compelling reason why photographers tend to specialize. Even if you can carry all of the various lenses and accessories required to photograph the wild wonders of the earth in their glorious diversity, you can only use one set of kit at a time. More to the point, it's almost impossible to maintain continual awareness of subjects near and far, large and small, high and low, moving and still, animal, vegetable and mineral. Decide what aspects of nature most interest you, which subjects you are well placed to photograph, whether by virtue of your location, your contacts, your education, the equipment you own, or

whatever. Then calmly set about making a plan of action ahead of your next field outing, so the next time you go out, you should already have a good idea of what to expect when you get there. At the very least, you need to be conversant with your basic camera controls and settings, and in possession of some basic knowledge of the species that you are going to photograph.

DEVELOPING FIELDCRAFT SKILLS

I believe it's no accident that most successful nature photographers began with an interest in nature, and the photography came into their lives later. Acquiring the necessary field skills doesn't seem any major undertaking if it's done out of a natural passion, begun in childhood and continued through your adult life. It must be a much tougher proposition for somebody starting later in life – whereas basic camera skills can be picked up much more easily. That's not to say you'll have necessarily developed the visual perception to become a truly talented photographer, but we'll look at ways of addressing this later in the book. If you're the sort of person who notes every bird seen on your way to the shops, or delves under stones and decaying logs for invertebrates while walking the dog, then you probably have the necessary fieldcraft and observational skills already. You hear a brief burst of birdsong, and you can not only identify the species but you also know which tree it will be in. That level of awareness can't be gleaned from books, only from first-hand experience repeated over a long period of time. If you're in this happy place, the biggest hill has already been conquered. If not, there's plenty that can be done to help you to start your ascent.

That word 'fieldcraft' seems to be the key, and I would define this as the ability to accurately anticipate and observe an event in nature and, equally importantly, be in a position to record that event with a camera.

There's plenty to understand about the natural world, and much which remains unknown. Think habitat requirements, breeding cycles, diurnal and seasonal rhythms, migrations, social behaviour, food chains, predator-prey relationships, interdependencies, adaptations, environmental threats . . . the list goes on. The more you know about this stuff, the better you'll be able to direct your photography. At a very basic level, then, you need to be informed about what geological conditions and soil types suit a particular species of wildflower, and which food plant is favoured by such-and-such an insect larva. And it's no good looking for flocks of geese on the marshes in the summer months when they are only here from October to March. Basic stuff, as

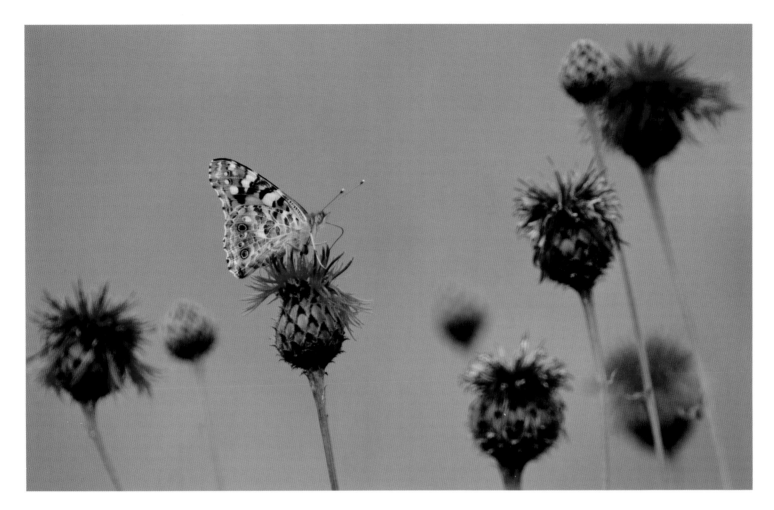

I say, but easily taken for granted if you've grown up with that interest or had the benefit of a scientific education and maybe an inspirational teacher. Certainly, much of it is there in the reference books and field guides, and this is an obvious starting point. None of us can remember everything, so the library and the Internet are always obvious sources of support, but they don't come close to substituting for first-hand experience out in the field.

Field trips led by experienced naturalists are so often the key to unlocking the mysteries of the natural world, and this is particularly true for young people, for whom a small amount of guidance at a critical juncture in their developing interest can lead to a lifetime's enrichment. In my own youth, reliable bird field guides were not that easily obtainable and adult rôle models were few. But we were fortunate in having a family friend who was a keen amateur naturalist and mentor and I used to look forward to his annual visits from Sweden. I still remember some of the tips on bird identification he shared with me so many years ago: for example, you can always spot a common sandpiper, even without binoculars, because when it flies it never raises its wings above the horizontal. Once you have seen that in real life

and believed the evidence of your own eyes, it sticks. And after you've picked up a few more such nuggets, you develop the confidence to rely on your own observational skills, and start to amass a mental database of relevant facts for your own future reference.

As an adult, these skills might take rather more nurturing, but again the key is to get out in the great outdoors in the company of an expert. This can take the form of club membership, adult education classes, guided walks, specialist holidays and workshops, or outings with a group of friends. In the early days, why not forget about your camera altogether and just concentrate on – and enjoy – getting to know the wildlife and developing your fieldcraft? You could further consolidate these new found skills by volunteering at a nature reserve or country park, or on a research project, where you'll find the enthusiasm of others acts as a huge morale boost and inspiration.

SUPPORT GROUPS

A similar approach can be followed with your photography, as your wildlife knowledge and awareness grows. The recent rise in popularity of digital photography has led to a rapid growth in camera club membership, and these are good places to meet up with like minds and foster mutually beneficial working relationships. There are usually a few members in each club who have a special interest in wildlife photography. Find the people who really want to get out there and get on with it, and associate with them, rather than those who just want to fantasize and drool over new equipment. Most countries also have national wildlife or nature photography associations, which very often organize guided field outings. Perhaps they also host annual conferences or festivals that provide ideal opportunities to network and research new ideas, techniques and equipment. The online community is also a great way to give and receive feedback through web forums, portfolio groups and photo sharing websites. But these should always be seen as secondary to gaining experience in a field situation – the lessons learned here are the ones you'll remember.

Wildlife photography workshops can be of value, particularly with plants and invertebrates where group size doesn't impact so much on your chances of finding suitable subjects. With birds and mammals, however, it's rather more difficult to go mob-handed. Furthermore, not many workshop tutors want to risk the wrath of dissatisfied clients who mostly expect oven-ready photo opportunities, so they tend to concentrate on the captive and semi-domesticated, or on well-tried and tested set-ups. So be clear in your expectations before embarking on this route, and be discerning in your choice of tutor. Workshops can be really beneficial in other aspects of developing your photography, but I would argue that they aren't usually the best way of encouraging self-reliance and independent field skills.

LOOK LOCAL

As your knowledge and confidence grow, you ought to think about adopting a local patch. Most professionals agree that they do their best work in areas that are close to home, or at least in places they return to on a regular basis. It's quite possible to run one or more of these alongside each other, but the important thing is that they should be readily accessible and visited frequently. Through repeat visits you will gradually gain an understanding of what lives there, what's common and what isn't, where to look at a particular time of year, prevailing conditions, typical behaviours, flowering times, the local effects of

wind and tide, and so on. It's this kind of familiarity with a place and its inhabitants that leads eventually to truly effective anticipation. Of course you need to put in the man hours, but ideas for photographs that once seemed fanciful and remote now begin to come within your grasp. At least some of the time, you will manage to predict successfully an event or sequence of events. Many still get away, but a few work out just as you hoped and planned. You believe less in the luck that only others seemed to enjoy, and trust more in your own instincts.

INFLUENCING ANIMAL BEHAVIOUR

We also have the option to influence events in nature through our own intervention – and this is where we find lots of discussion and disagreement among photographers and conservationists over what's acceptable practice. Activities such as provisioning food and water sound innocuous enough, but they may have profound consequences. What if, for example, you are baiting wild animals to an area where they may become vulnerable to predators, or it's just before the hunting season opens? Or what if you are causing wild birds or animals to become reliant on an artificial food source that might suddenly be withdrawn, or have a negative impact on their subsequent ability to hunt or forage for natural food? All such actions need to be well considered. But assuming you've done your homework and taken all the necessary precautions, introducing a regular source of abundant food and water is the most common and reliable method of managing wildlife in to a photographable situation. Clearly different sorts of food need to be used to target different species or subjects, and you should expect to experiment. Variations on the feeding station theme include providing a shallow pool for drinking and bathing, convenient perches, bedding or nesting material, vital minerals, a safe roosting place – think of some more! Typically, photographers like to partially conceal the bait (under leaves or in a hollow branch, for example) or crop them out of frame in their final pictures, depending on how 'attractive' or natural it is in appearance. Once we find ourselves controlling the situation, there is also the opportunity (temptation?) to arrange other elements in the picture, perhaps introducing approach perches or walkways, adding foreground or background, inserting a few well chosen flower spikes or seed heads – in effect, creating a set, much as you would in a studio. Artifice rather than art, perhaps. But here we are straying in to the territory of composition, which is the subject of another chapter. In the end, all of these are simply devices for trying to improve your chances of predicting an outcome and reducing your time commitment; more manipulation than genuine anticipation, I suppose.

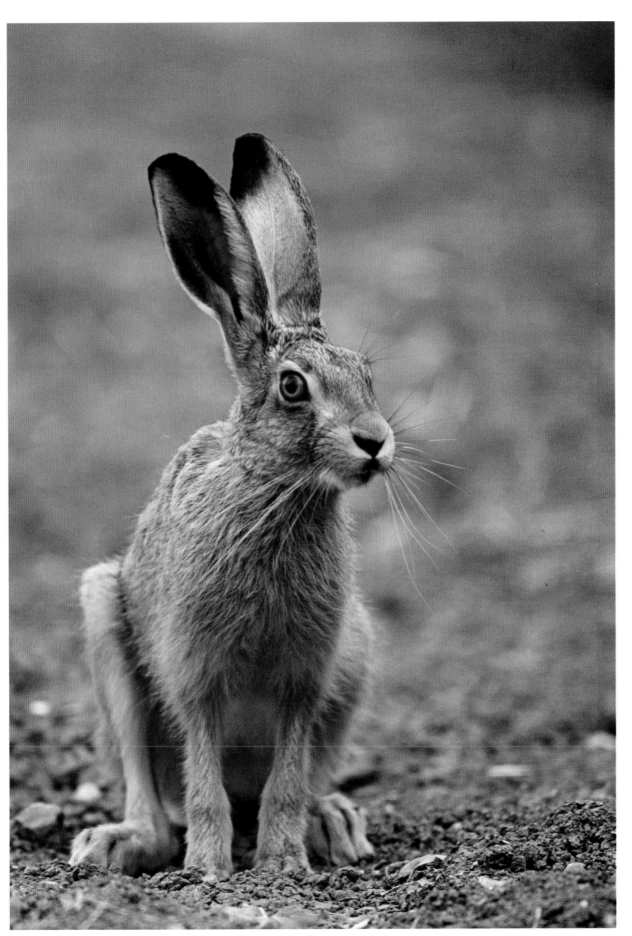

◀ I spotted this brown hare lying prone in its form, close to a farm track near my home, and then watched from the car. It remained motionless for another 45 minutes, then gradually relaxed, groomed and stretched, and loped straight towards the camera and stared, before casually proceeding on its way.

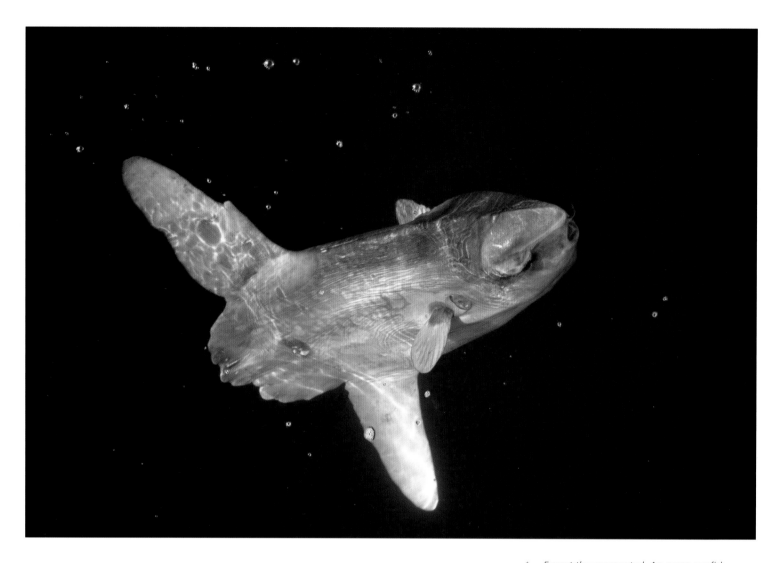

GETTING CLOSE WITH THE CAMERA

The time-honoured method of getting close to wildlife for
photography is by means of the portable hide, or blind. In the
pioneering days of the early twentieth century, it used to be thought
that the hide needed to resemble a natural feature in the countryside
to be effective – such as a tree, haystack or cow. The black and
white photographs of the Kearton twins on their early escapades
with stuffed animals tend to raise a chuckle these days, but they
were generally successful, if over-elaborate. We now know that for
most subjects it is sufficient to be concealed from view behind a wall
of plywood or opaque fabric. In many cases it could be fluorescent
orange and make no difference at all to the subject, but we like to
be seen to be doing it right – or rather, not seen at all by curious
passers-by – so it's usual to adopt a camouflage pattern, and perhaps
even some extra netting, branches or foliage for good measure. And
to be fair, there are some subjects where this cautionary approach is
absolutely necessary so it's wise to adopt best practice from the start.

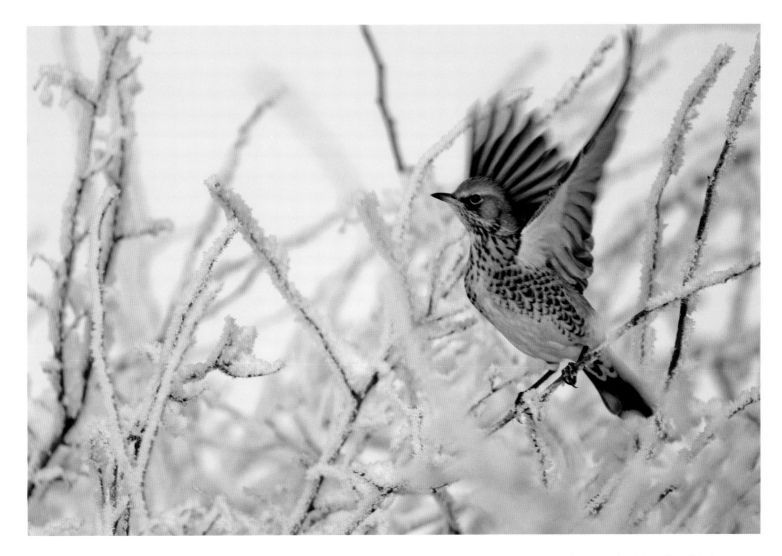

That would include gradual introduction of the hide up to its final working position, and the use of an accomplice to walk you in and out (most animals don't count, so won't notice one of you has stayed behind). Hides are most useful for photographing birds, and some mammals, but I'm hard pushed to think of any other animals where they might be effective. Equally you can't plant one in the middle of nowhere and hope to be successful, so deploy carefully – perhaps alongside a feeding station or watering place as described above.

Traditionally, portable hides would have been pitched close to birds' nests and involved lots of trimming back of 'inconvenient' vegetation, but fortunately we are more concerned about the welfare of our subject these days. In any case there's less need to encroach with the availability of longer and faster lenses, and more responsive digital sensors. These effectively allow us more freedom of choice about the types of behaviour and the places in which we photograph. Be aware that for certain specially protected species you need a licence from the government to photograph them at certain times of the year,

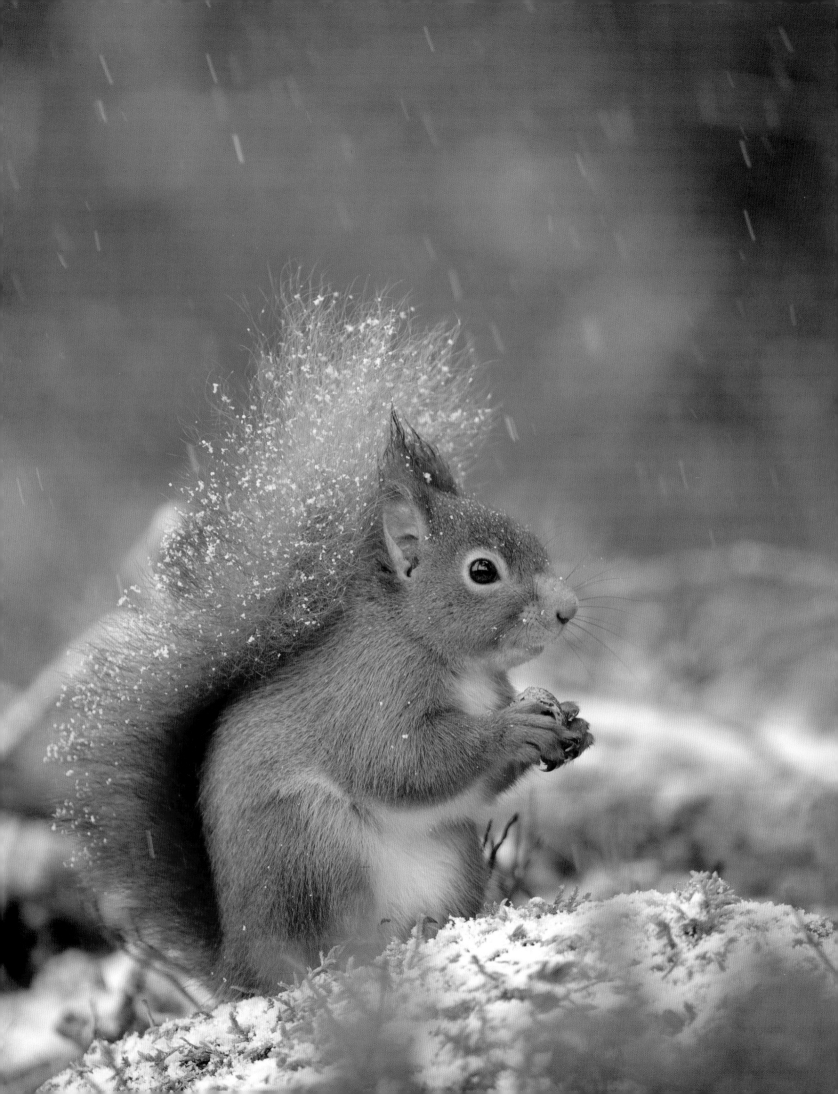

at or near a nest, with dependent young and so on. Furthermore, in some countries and certainly in many national parks, the use of portable hides is totally prohibited, so you will need to check the law and how it pertains to your photography.

Hides come in all shapes and sizes. Naturally there is a good selection of commercially available hides in all manner of hi-tec materials, but there is no reason why you couldn't press into service a tent you already own or one of those fishing or beach shelters you can pick up cheap from motorway service stations, with only minor modification required. Then there are the floating hides for aquatic subjects, if you're feeling adventurous, and strange contraptions which pop up out of chairs or cascade like a curtain from a wide-brimmed hat, if you're not too fashion-conscious! There's no shortage of innovation in this arena. For many, the use of a vehicle as a mobile hide is the most practical way of manoeuvring within range of a wild creature without disturbing it, but of course your working radius is now very much more restricted by the nature of the terrain. Most nature reserves and country parks have permanent hides for the convenience of visitors, and these are usually at well-considered locations for close-ish views of wildlife. That doesn't mean they are necessarily suitable or ideal for photography, or that photographers will always be welcomed if they hog the best spot for hours on end. And, increasingly, purpose-built photography hides are being offered for rent at wildlife hot spots all over the world for those who are cash rich but time poor. The best of these will not only have established a regular regime with a tasty repertoire of dependable wildlife subjects,

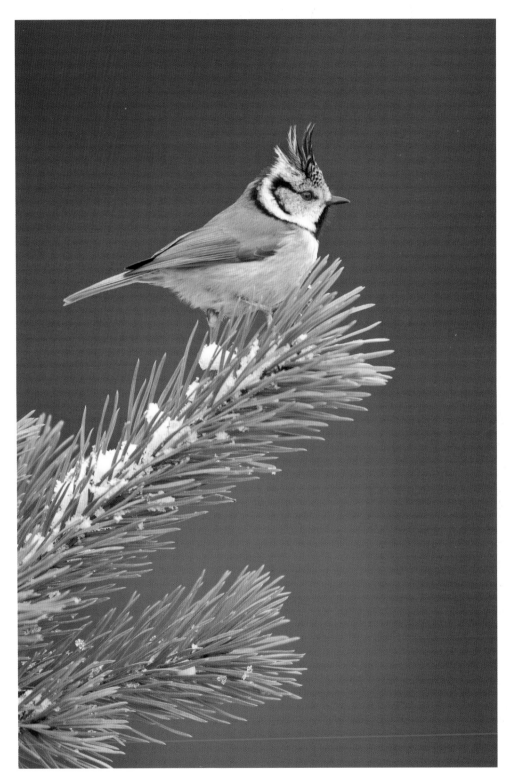

◀ A classic example of the feeding station and hide technique. This red squirrel is accustomed to a regular food supply in the same area of the forest, but the stash of hazelnuts is easily hidden from view for the photograph.

▲ In this photograph, the feeding station is positioned just out of frame. The crested tit is using an approach perch of Scots pine placed for the purpose, which was chosen to be consistent with the bird's usual preferred habitat.

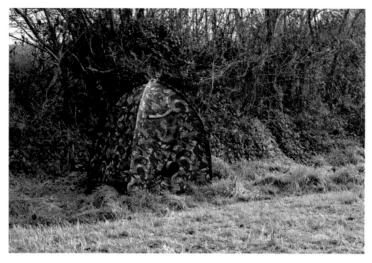

▲ A typical, commercially available, portable dome hide. Here the telephoto lens is set up in a low position for photographing ground-feeding birds.

▶ Life depends on water. Ensuring a steady, clean supply in an otherwise dry area is sure to attract wildlife, so staking out a water hole in an Indian national park is a typically reliable way to find tigers. Or you can try a birdbath in your garden and see what turns up.

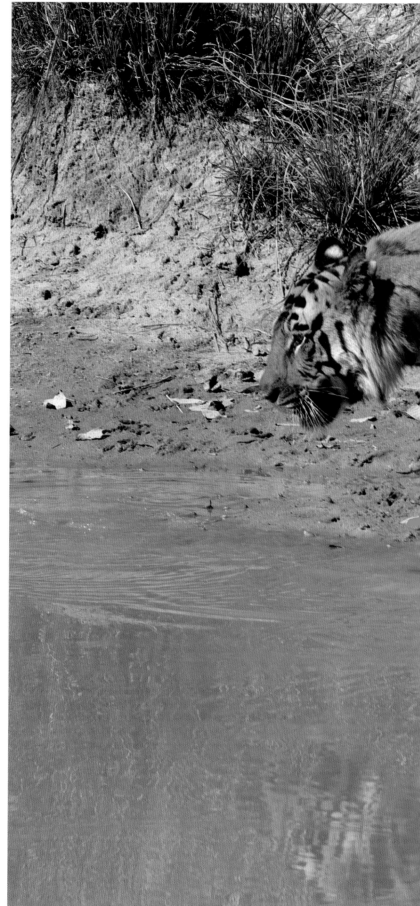

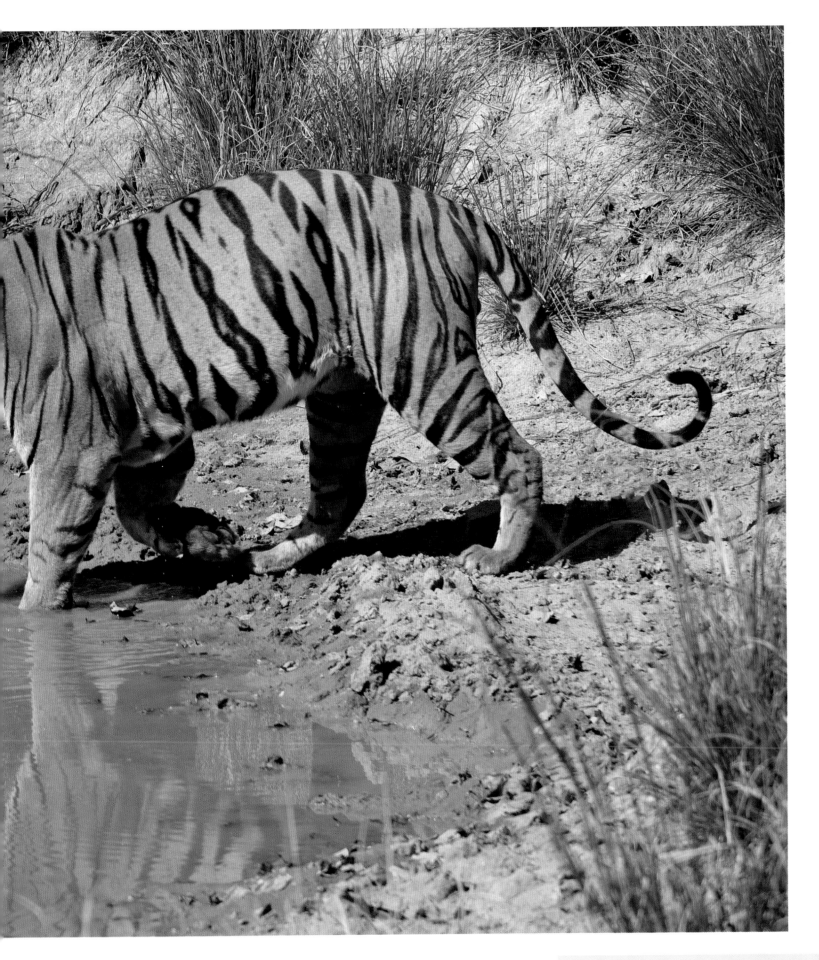

but they will have already thought out and accounted for such things as sympathetic backgrounds, sun position and wind direction, as well as your personal comfort. Here, in effect, you are capitalizing on somebody else's fieldcraft and preparation, or buying a commodity, so you can imagine this is a hot topic for debate between the purists and the pragmatists in the wildlife photographic community.

Now you don't necessarily need to be standing right next to the camera to operate it, as long as the camera itself is in the right place. You can use remote triggering devices such as extended cables, infra-red or radio beacons. This is definitely a technique worth exploring where you have identified tolerant subjects, say in your own garden, and opens up new perspectives with the opportunity to use much shorter focal length lenses, for an ant's eye view of the world. Normally you would still want to be concealed in a hide and watching events unfold, in command of operations and deciding on the opportune moment. But there are new levels of technological sophistication and automation, with such things as remote-controlled tripod heads and wireless live-view monitoring now coming in to the public domain, allowing for ever more distance between you and your subject. A logical extension of all this is the camera trap, or beam-triggered device, whereby an animal's own movement can be used to fire your camera shutter while you might be miles away and totally unaware of what's happening at that precise moment. While such tools tend to be welcomed for biological monitoring and have even been used to confirm the survival of species once thought to be extinct, they are frequently frowned upon when in the hands of photographers rather than scientists – presumably because it's thought to be an abdication of that critical judgment of precisely when to make the exposure. However, it still demands great foresight and preparation to locate these cameras in the right place, in a way that they will be tolerated by the subject and not cause disturbance, as well as considering such things as composition and lighting. In short, you still need the field skills.

SHORTCUTS AND BOUGHT-IN SERVICES

There are, of course, lots of other shortcuts for achieving the intimate access you need for photography, but they come with caveats. Captive collections of wildlife, game ranches and bird of prey centres all enjoy a booming trade and generally love to cater for photography groups. Indeed, many are established for that single purpose, and at the extreme end some offer trained animal models that you can rent by

the hour and take out on location. It's big business. Most of us have taken advantage of the convenience of a zoo, aquarium or falconry collection at some time or other, and it's easy to be seduced by the notion of the free lunch. Who can fail to be thrilled by the experience of eyeball-to-eyeball contact with a golden eagle? And after you've filled several memory cards during your close encounter, you feel duly satiated – or should that be 'bloated'? It's the instant gratification we all crave, but after you've done this a few times you want to be thinking about starting the diet and getting fit. Fit to take some real 'nutritious' wildlife photographs. So while there's an argument to support the value of captive subjects in a teaching situation, or for obtaining pictures that would otherwise place undue pressure on a wild population, it's a pity so many photographers seem to rely on these establishments for most or even all of their image making. This will be discussed further in the chapter 'Ethics, Truth and Integrity'.

Closely allied to this approach would be the photography of sick and injured animals, including those recently rehabilitated into the wild, or the exploitation of wildlife in temporary captivity – for instance, those creatures trapped for ringing or tagging purposes or as part of a scientific research programme. It might be fine to feature these *in situ* as part of a documentary study, but it's another matter altogether to try to pass them off as wild and free. In any case, in the context of this discussion, it teaches you nothing about how to find and work with animals in the wild.

Sooner or later, you will probably find the guided tour, photo safari or expeditionary cruise an irresistible attraction. We are all susceptible to the allure of exotic destinations we've seen on television, where the animals are large and so much tamer than our own. On the whole these tours generally meet our expectations and deliver the opportunities, but you should be mindful of the way the brochures and television programmes edit down to the highlights, the restrictions imposed on you when working from a vehicle, and the inevitable compromises involved in any group holiday. It's still the only practical way to go for most of us, and our choice seems to improve every year in the wake of each new David Attenborough series. I have no doubt that these holidays satisfy the demand of most photographers' ambitions, with a ready supply of photogenic subject matter, although they are something of a self-fulfilling prophecy. We see a friend's holiday photos or a prizewinner in a competition, and we want a slice of the same for ourselves – and so the pool of desirable subjects is defined.

TRACKING AND STALKING WILDLIFE

At the other extreme, the stalking of wild animals poses the photographer possibly the ultimate challenge and the greatest reward. There is undeniably some primeval satisfaction about hunting your quarry, pitting your wits against a wild animal. But apart from that, it also offers the greatest potential for creating pictures that aren't so easily repeated or copied. There's a lot of mystique surrounding the technique of stalking, and it's been built up as something of a black art. Certainly I wouldn't want to diminish the difficulty, and it isn't as simple as donning the right coat. But much of it comes down to common sense and, as ever, putting in the time.

It's not a straightforward matter to generalize about techniques that will suit any stalking situation. So here are just a few things I know about the fieldcraft of stalking the Eurasian otter, as it applies to the coast-living populations of Scotland's northern and western isles.

- Otters are most active in the early morning and late evening, and around low tide. However, they can be found at all times of day and all states of the tide. So use the statistics as a guide, but don't be a slave to them.

- Otters have poor eyesight at distance, but very keen senses of smell and hearing. Switch off mobile phones, bleeping watches, pagers and any other electronic devices you're carrying, and make sure your camera functions are set to silent mode. If you have a silenced shutter facility, use it. It's probably not necessary to avoid showering for a week, but (and forgive me for stating the obvious) don't wear eau de cologne, aftershave, or other strong scents, and don't suck on aromatic sweets or smoke cigarettes. Stay downwind if possible.

- You should dress in dark, earth-coloured fabrics, which don't rustle – but it doesn't have to be military style camouflage. Swishy, waterproof over-trousers are definitely out. Wear a close-fitting hat and have dark gloves and face-covering material available for the final stages of the approach. The bank-robber's balaclava is not a good look – I find that an army surplus scrim scarf serves the purpose very well, and can be easily carried in a coat pocket. A mosquito head net would work too.

- One person is much more likely to be successful than two, and as the group size increases the probability of success reduces dramatically. Work alone by preference, or in pairs at a push.

- You need to be mobile, silent and fleet of foot, so carrying a tripod would only compromise these requirements – leave it behind. Maybe use a bean bag, but you can also use rocks or the ground as camera support, or rely on image-stabilized lenses.

- Try to keep your silhouette off the horizon as you walk a length of coastline, staying in the shadow of the bank where possible. Scan well ahead of you with binoculars, pausing frequently to look for otters on the shore but particularly out to sea. And don't forget that they can also appear from inland, especially if there's a stream or freshwater outfall they can use as a convenient highway.

- If you are more than one person, talk as little as possible, and then only in whispers.

- Tracks and signs such as sprainting points may indicate recent otter activity, but they seldom point you to an otter there and then. They do tell you it's worth being extra vigilant, and that it's a good area to return to.

- Harbour seals, especially the pups, can look superficially like otters out at sea. Seals have larger, rounder heads, and their smooth wet coat shines and glints in the sun. Otters have a three-lobed appearance in calm water (head/body/tail), and often show a flick of the tail as they dive.

- Otters like to take short cuts and tend to travel along coasts in straight lines, from point to point, headland to headland. If they have caught a large fish that is too big for them to handle in the water, they will almost always make for the nearest point on the shore to deal with it there.

- Once you have located an otter, lie down on the ground immediately and watch what happens next. You may have to watch for a long while (possibly hours) before an opportunity arises to make a safe approach, especially during a sustained bout of feeding activity. Frequently they will slip away undetected and you'll have to start over.

- Approach from downwind, if necessary by making a detour inland, out of sight, and coming around from the opposite side.

- Move in closer by treading very carefully, watching your every step, and avoid displacing stones, crunching shingle, popping seaweed or falling over in a heap – this can be very difficult indeed and it doesn't help if the rocks are slippery with wet algae.

- Rapidly assess your best approach route, and try to use natural features such as large boulders for cover. In the final stages, maybe the last 100 metres, you should be prostrate on the ground and crawling commando style if out in the open.

- If the otter is swimming but heading for shore in a determined

▲ If you want to photograph otters, you need to be able to read the signs.

◄ Tracks of a wild otter on a Shetland beach, leading into the sea. An animal has passed this way since the last high tide, but is it still in the area?

▶ The fruits of a successful stalking operation. After a short nap and a thorough rub down on the sun-dried rocks, this otter is ready to resume fishing. The photographer is ready for a long nap.

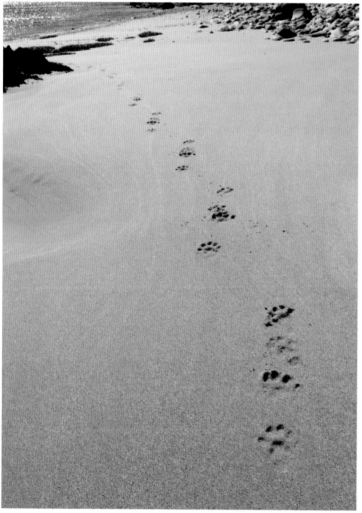

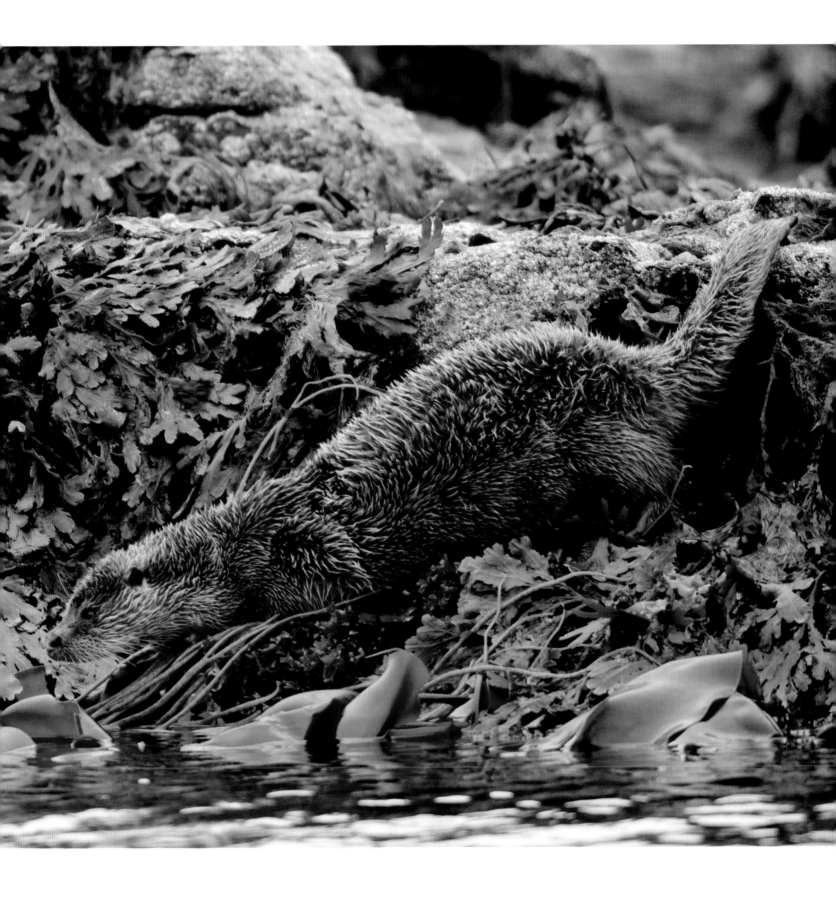

▼ *Working with captive birds of prey like this handsome golden eagle can produce some superficially impressive results in a very short space of time. Here, the paraphernalia of falconry is easily hidden by the snow. But what do you learn, and who does it fool?*

fashion, say with a large fish, you may have chance to cover some ground quickly each time the otter dives – but I wouldn't risk more than about fifteen seconds. Keep watching for it to surface and be ready to freeze or drop to the ground. With luck and experience, you can anticipate a landing place and get to a close vantage point before the otter arrives ashore.

- Only try to move closer if the otter appears to be settled in what's it doing and not paying attention to you. If it is preoccupied with eating a large fish or sleeping on the shore, then you have a fair chance of getting in close. If it's looking alert and sniffing the air, don't move a muscle or make a sound – you may have already blown it.

- An otter near its holt or a mother with young cubs is likely to be even more cautious than usual and not at all easy to photograph. In the UK, you need a special licence to be permitted to photograph otters at their holt or with dependent young, so check out the legal requirements, and if you do stumble into a sensitive situation, be alert to the circumstances and prepared to move on.

- Don't cut off an otter's escape route to the sea, and if you're working in groups of two or more stay close to each other and don't try to approach the animal from different angles.

- Even if you do everything correctly, your presence can be given away at the last minute by an alarm-calling oystercatcher or arctic tern: bad luck!

- If you surprise an otter at close range, (say you inadvertently disturb a sleeping otter on the shore), it's best to rest that area for a few days to give the animal a chance to settle down and forget the experience before you try again.

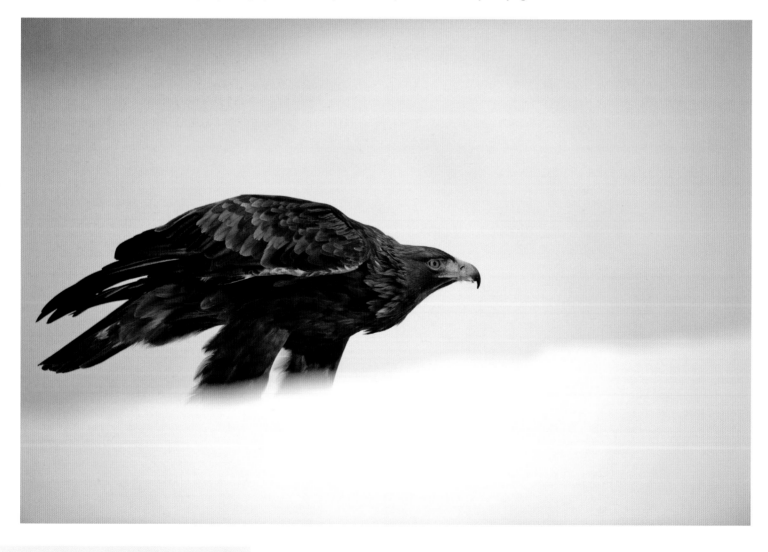

This is not intended to be an exhaustive list, just an indication of the sort of things you need to know. Probably a book could be written on this subject alone. You'll still need to gain an appreciation of the kind of places otters like to frequent, in order to make good predictions, and gather up-to-date local knowledge about active holts in any given area. For many people this will be a bridge too far, as they simply don't have the time to commit to such a grand, time-consuming project. In such circumstances you might be well advised to seek out the services of a local guide. Some of these techniques and practices will be applicable to other species, but in the main you'll need to research each potential subject for yourself, in at least as much detail as this.

HABITUATION

Fortunately, not every subject is so difficult and demanding as the otter. Photographers like to talk about having stalked a subject when in reality they were able to come within camera range without breaking sweat, and often this is as a result of habituation. Habituation is a behavioural change over time, where an animal no longer responds to a stimulus such as the presence of a person because it has learned there is no threat. The zoologist Jane Goodall relied on this simple form of learning to allow her to conduct her field studies on chimpanzees, and wildlife film-maker Hugh Miles used it to be able to approach and film pumas in Patagonia. If you go out with the same family or group of animals every day for several months, gradually they will habituate to your presence and let you get closer until eventually they ignore you altogether and carry on behaving as normal. You might think that this isn't much use to those of us with only four weeks holiday a year and a lawn to mow, but of course it's essentially the same thing with the tame squirrels that come to the picnic tables in the local nature reserve, or the deer in a well-visited country park – just that it's been achieved through repeat exposure to many different people. Look for other examples that can be worked to your advantage.

BEST PRACTICE

There are many routes and choices available to us in the pursuit of wildlife photographs. The most rewarding of them tend to involve imagination and diligence, through the development of fieldcraft. But if the proof of the pudding is in the eating, then what do we look for in a photograph as evidence of good fieldcraft? Qualities such as respect for, and empathy with, the living subject spring to mind. To that end, I suggest that the subject should appear to be at ease, behaving naturally, in the right habitat, and unaware of the camera. Make this your goal.

Please don't assume that the only worthwhile photography involves travel to foreign lands and imagine you have to adopt the television presenter lifestyle to become a 'proper' wildlife photographer. On the whole, there is far too much attention being paid to a small pool of blue chip species like tigers, penguins and bears – sometimes dubbed the 'charismatic megafauna'. We seem to be enthralled by predators, and animals with big eyes that resemble infant humans, at the expense of everything else. So many subject areas are almost totally neglected by photographers and have hardly been pioneered even now. For example, freshwater fishes and amphibians are nearly always photographed in aquariums rather than in their natural habitat, and most small mammals are routinely removed to controlled conditions for photography. Can it be that hard to depict them in the wild? Who's prepared to get wet? And what's wrong with slime moulds, or nematode worms? Come on, get out there and celebrate biodiversity!

▶ *Desert adapted African elephants in Damaraland, Namibia – photographed from a safari vehicle on a guided tour (overleaf).*

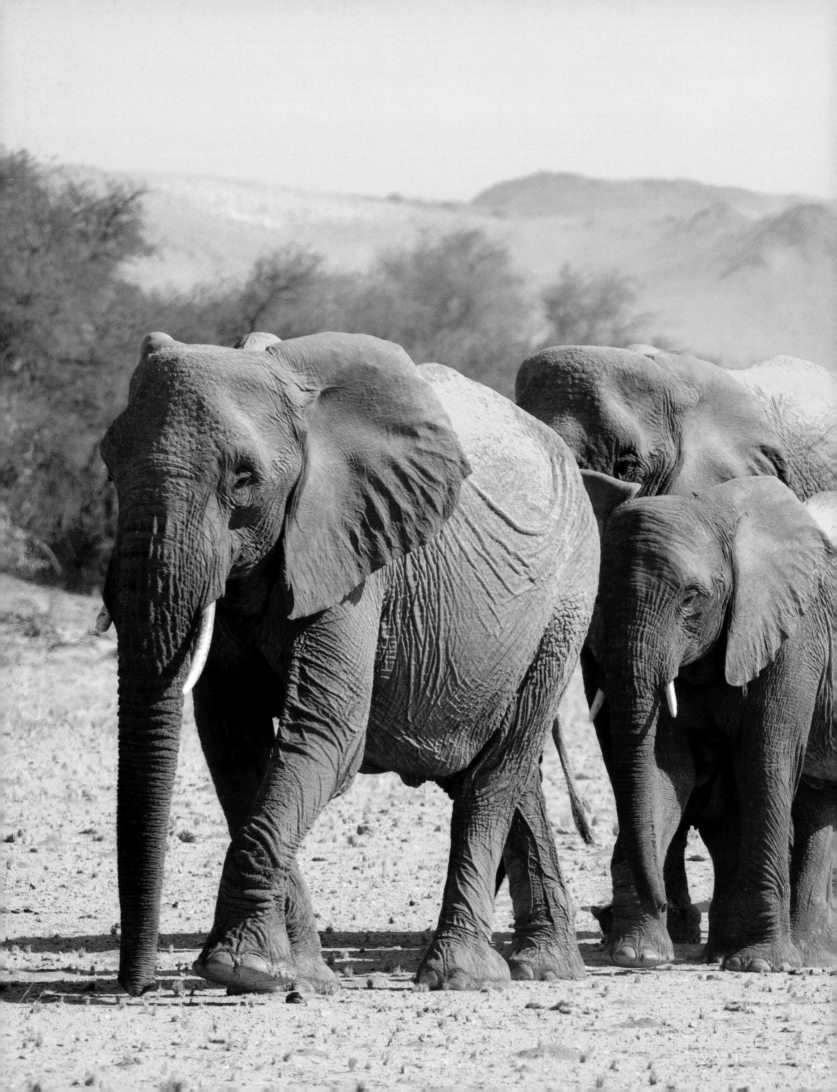

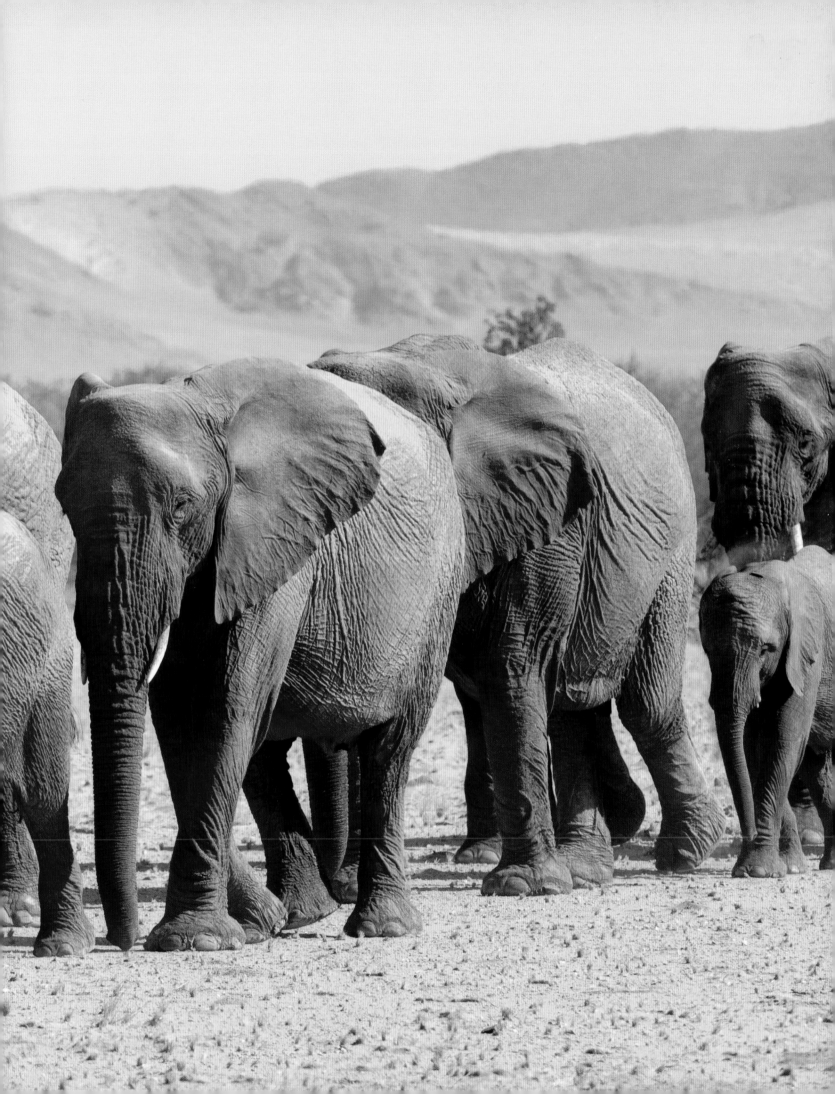

Order from Chaos

All Nature is but Art, unknown to thee;
All Chance, Direction, which thou canst not see.
Alexander Pope

Successful wildlife photography depends upon, among other things, careful and well-considered composition. As with all types of photography, you need to be able to render a three dimensional scene effectively in two dimensions. Precisely how to do this is open to interpretation and personal preference, but it's not entirely a subjective process; some aspects are both measurable and predictable in their effect on our visual perception. People have been trying to define principles and rules of composition for well over 2000 years – mathematicians, painters, architects, musicians, philosophers and psychologists have all had something to contribute to our understanding of composition. Rather than attempt to review everything that's been said on the subject, I want to pick and choose those ideas and observations that seem most relevant to wildlife photographers. This chapter deals with the geometry or design of photographs, that is, the spatial distribution of objects within the boundaries of the rectangular frame.

Photography is a reductive rather than an additive process. Unlike drawing and painting, we don't create our work on a blank canvas – we begin with everything before us, and have to make some sense of it by what we choose to include in our picture, and how we organize those elements within it. In many ways, as photographers we have less freedom of expression than painters in the way we compose, because most often we are unable to rearrange things to match up to our imaginations – and this is especially true in the field of wildlife photography – but we do have technological devices at our disposal to extend our creative abilities in other ways.

THE SELECTION PROCESS

Our first practical choice is whether to orientate the camera in the horizontal or vertical axis, bearing in mind that our eyes and brains are more accustomed to scanning in a side-to-side rather than an up-and-down direction. This – and the ergonomics of cameras – probably accounts for why most people are more comfortable using the camera in its horizontal (or landscape) orientation and viewing pictures this way. Now that's all very well, but the printed page is normally the other way up. Really, we need to know the end use of the photograph before we can decide which way to hold the camera. Vertical format is good for printed books, magazines, and newspapers, as well as portrait prints, but horizontal format suits monitor viewing and most AV presentation. On balance, however, we should probably use the camera on its end more frequently. And if you have the chance, which admittedly isn't always so in wildlife photography, take the shot both ways.

Next we need to think about what to include and exclude in our picture, and the way this decision can radically alter its meaning – or, more frequently, subtly shift its emphasis. This can be achieved through change of viewpoint, choice of lens focal length, framing in camera, the way light is used, focus point and lens aperture selection, cropping the picture after the event, and other means. So what is your subject, and how does it relate to the things around it? For example, do you want to show the whole creature, or just a detail? The landscape as far

John Ruskin, in his letters to artists of 1857, summarized the purpose of composition thus: 'It is the essence of composition that everything should be in a determined place, perform an intended part, and act, in that part, advantageously for everything that is connected with it.' This idea of intended unity is a recurring theme throughout literature – that the parts of a picture should combine to form an organic 'whole'. Similarly, Diderot likened it to the way the parts of an animal connect with each other to create a single functioning body. That seems an apt metaphor for the wildlife photographer.

However, note that Ruskin also said: 'The essence of composition lies precisely in the fact of its being unteachable, in its being the operation of an individual mind of range and power exalted above others.' So there you have it – if it's already proscribed in a book, it isn't original!

as you can see, or some topographical feature in the middle distance? The flower and its reproductive organs, with or without the insect that pollinates it? So it is necessary to decide on what you feel is important and interesting and begin to plan your photograph around it.

You will often hear the expression 'less is more' and this principle of economy finds resonance in other areas of the arts. We can readily appreciate how a few well-chosen words or a single broad brush-stroke can be so much more powerful than the verbose or fussy; hence the power of poetry. The same is often true in photography but the maxim does have its limits. While you want every element to be contributing somehow to the success of the picture in its entirety, so that nothing is wasted, you also need to feel assured that nothing has been left out. Move in closer, progressively and systematically rejecting all those elements that contribute nothing meaningful to the final photograph. Ditch the superfluous. Then move back, or zoom out, and re-assess. Is there a better picture with a wider view and smaller subject size?

Compare the two versions overleaf of the photograph of a preening common crane. Here I was working from a fixed hide with my largest focal length telephoto, and this crane was really quite close to me. The first version is the largest image I could make with the optics available to me at the time. You can see that it shows neither the whole bird, nor enlarges sufficiently the area of principal interest. The visible outline of the crane – the body, wings and legs – only serve as a distraction, drawing the eye away from the main action. The second version is cropped in post-production and approximates to my initial visualization of the final image – the picture I really wanted to take. Although it's a substantial enlargement

with much information discarded, you can see that it loses nothing of the core interest. We can now concentrate on the deftness of the crane's bill and the bird's delicate plumes, while the ruby red eye is allowed to shine. It's an intimate study of the preening behaviour of the crane, highlighting some of its rather beautiful and subtle features.

VIEWPOINT

A common failing among novice photographers is not fully exploring the viewpoint options – where to position the camera. All too frequently they will settle for the easiest approach, as the scene first presents itself, and probably taking the picture from a standing position. Overcoming this reluctance is another vital step towards actively creating powerful photographs rather than mere snapshots. This is especially true when using telephoto lenses, since their narrow field of view means that a very minor shift in camera position can make a massive difference to how your subject appears relative to its foreground and background. Moving a metre or two either side, or up and down, can so often transform a picture.

Where plants and animals are concerned, so many of them are naturally ground-dwelling, and getting down to their level is a relatively simple (well, for the younger reader) and an effective treatment, bestowing a sense of intimacy with the subject. But there will be other approaches, and it's always worth weighing up the alternatives. What about climbing that tree, wading into the lake, standing on a vehicle, or looking up at those tall flowers from underneath? Unexpected or unconventional viewpoints bring impact to our pictures, so look for variety.

FIGURE AND GROUND

It's important to remember that what some may dismiss as 'empty space' can be a vital component of a photographic composition. We might make the analogy with a significant pause in a theatrical performance, or a well-timed silence in a phrase of music. This is the concept of 'figure and ground', sometimes known as 'positive space' and 'negative space' in photography – where the ground comprises the bits of the picture that aren't the subject. This negative space is just as important as the subject itself and needs to be given due consideration; something which is frequently overlooked, particularly by the beginner. Mozart famously remarked that he was increasingly preoccupied with the 'spaces between the notes', and that's an idea we could sensibly borrow from a revered master of composition.

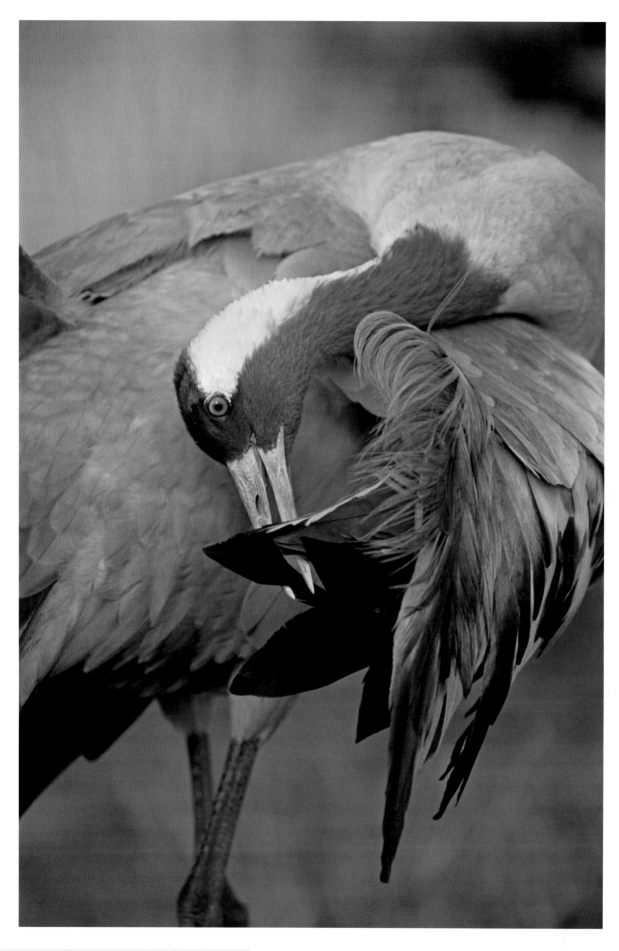

◀ A portrait of a perfectly relaxed, preening common crane. Note how your attention keeps drifting to the background and the bird's legs that are quite irrelevant to the main point of the picture.

▶ Retaining all the significant information, but now contained in a simplified but much stronger composition. Our gaze follows the rough circle formed by the wing plumes, neck, head and bill, but comes to rest very comfortably at the bird's eye.

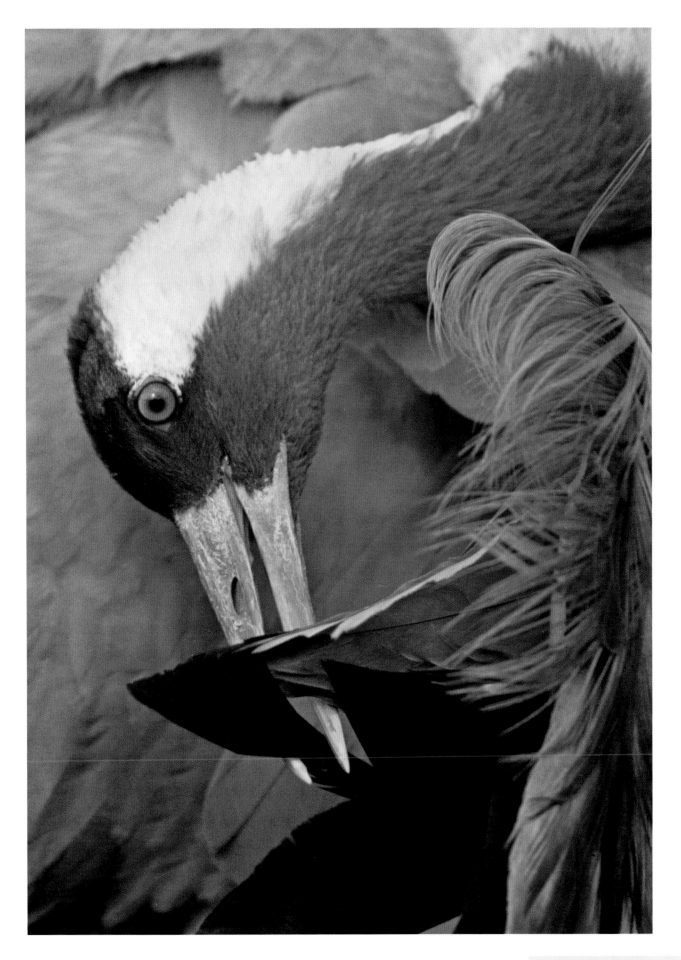

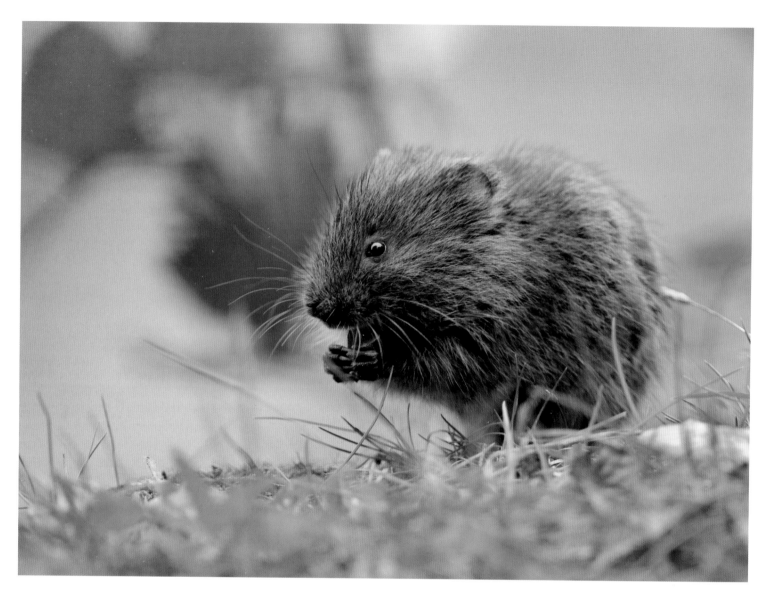

▲ An intimate,
ground-level view of
a water vole, seen
through a telephoto
lens.

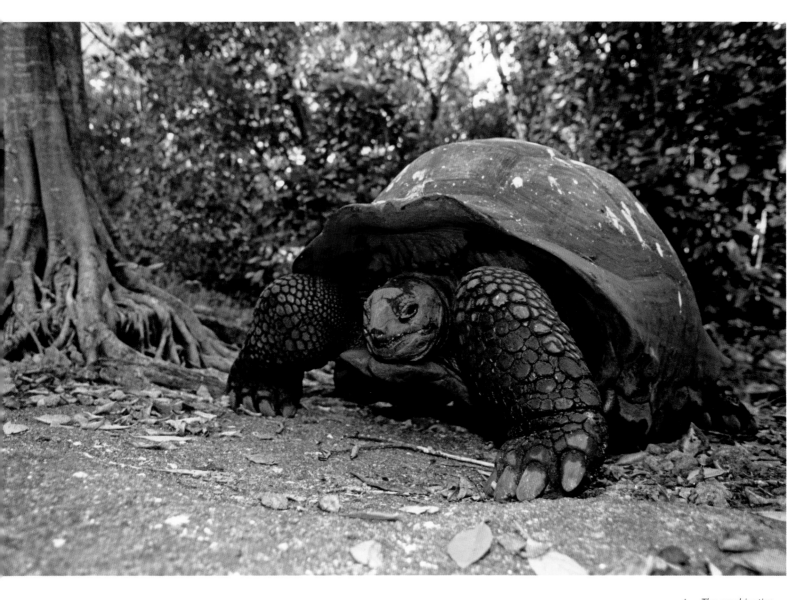

▲ The combination
of low viewpoint, wide-
angle lens and small
aperture invite us in
to the world of this
giant tortoise in the
Seychelles.

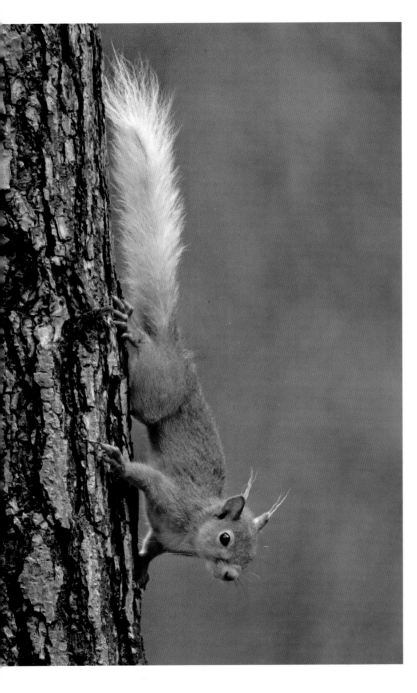

A stereotypical wildlife close-up, with the subject shown large in frame against a soft, non-intrusive background – a natural function of using a telephoto lens at a wide aperture. Here the coat of the red squirrel contrasts very effectively with the muted, out-of-focus pine forest.

Let's take the example of the classic wildlife portrait: a red squirrel photographed using a telephoto lens and featuring a strong, proportionally large subject, sharply focused, offset against a hazy, blurred background by use of a wide aperture and narrow depth of field (see above). You can see that the background here doesn't compete with the subject, and the colour contrast also helps to separate the two, but you still get a good impression of the forest habitat. The ground complements the figure. This is standard repertoire – straightforward, effective, and can be applied to many situations – and easily repeatable, as long as the background is far enough from the subject. It's our stock-in-trade response to most wildlife subjects.

To employ a musical metaphor, we might think of it as a simple melody played over a long sustained chord. However, that bland colour wash background treatment can easily resemble a studio set, and can soon become boring if relied on too heavily. Think how many slide shows you have witnessed with one animal close-up relentlessly following another. However fantastic these may be individually, sometimes we have to break up the monotony using other strategies. Furthermore, huge close-ups of wildlife subjects with little space around can easily make them look crushed or imprisoned – especially birds, which can't spread their wings. So be sensitive to the nature of the subject. The cleverest picture is rarely the one that shows the subject as large as you can make it.

Where we are dealing with a smaller relative subject size, by definition the ground becomes more prominent in the photograph, and the extended depth of field means it will be better defined. How we work this negative space in to the composition is now more critical, requiring more thoughtful use of shape, tone, colour and texture. In the photograph of the storm-petrel (opposite), note how the silky sea surface contributes significantly to the success of the overall composition, with its gentle waves and undulations. It suits the nature of the subject, a small, vulnerable seabird in a wide expanse of ocean – benign in its present state, but turbulent and hostile conditions are never far away. Musically, perhaps, these subtle patterns in the background correspond to a slightly more animated accompaniment.

Some nature photographers have experimented with the use of field studios for temporarily removing subjects from their habitat, depicting them against plain (usually white, and artificially lit) backgrounds, reminiscent of the botanical illustrations of the nineteenth century. This has the virtue of making us concentrate on the organism itself rather than the 'clutter' around it, and perhaps forces us to see things in a new way, and consider their places in nature. It is a technique which also lends itself to the clean page layout, and is therefore convenient for many a graphic designer. It's certainly one way to deal with that negative space, and could be thought of as the equivalent of the instrumental solo. But sometimes you want the rest of the band to play along.

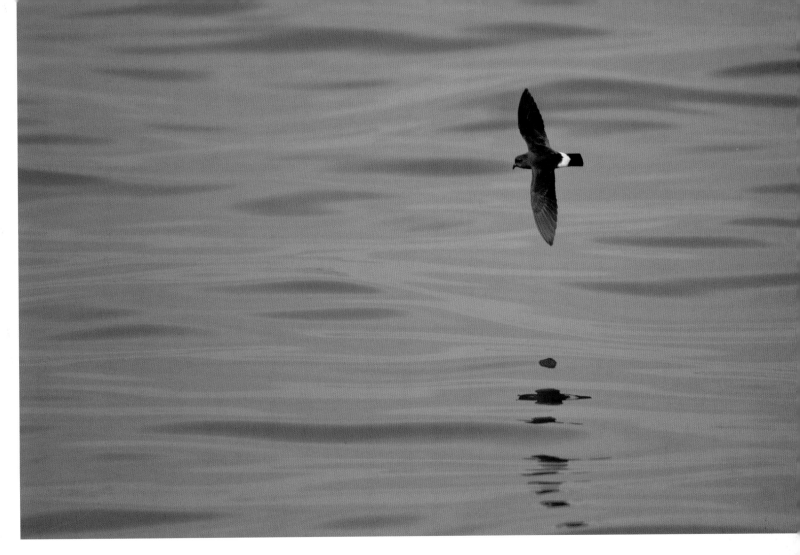

SUBJECT PLACEMENT

What about the issue of subject placement? It is all too easy to settle for a subject placed centrally in the frame, as this is the default auto-focus position in most cameras. It also follows quite naturally from the way we like to 'target' and centre our subjects psychologically. But it rarely works when you see the result reproduced in a two-dimensional photograph, and perfect symmetry soon becomes boring and predictable. Think of it as a piece of music in 4/4 where the accent relentlessly falls on the first beat of the bar, and you soon long for more interesting phrasing and dynamics. An asymmetric placement is more likely to stimulate interest, and here we customarily rely on the rule of thirds as a general guide. Using these off-centred points could be likened to varying the time signature or adding a touch of syncopation to our hypothetical piece of music. It's best to treat this rule fairly loosely, and there will be occasions when you can deviate from it quite dramatically – though if you place a subject very close to the edge of the frame or right in the corner, there needs to be strong justification for it.

In practice, you must learn the easiest ways to focus, lock and re-compose with your camera and lens combination to add interest and variety to your composition. In many situations, you might find it easier to focus manually. Or you can always crop the picture after

▲ *This flight shot of a European storm-petrel at sea demonstrates the effective use of negative space or ground, subject placement observing the rule of thirds, and the principle of lead room in the direction of motion. Explanations in the text.*

THE RULE OF THIRDS

The popularly applied 'rule of thirds' in art and photography is really a simplified version of the golden section, which has stronger foundations in geometry and dates back to about 400 BC. The painter John Thomas Smith adapted this and published his rule of thirds in 1797. Basically, this states that dividing a frame into three equal parts both horizontally and vertically gives us four lines and four intersection points which are useful aids to composition, creating power points or hot spots. These lines and intersections should guide us when considering where to place horizons and points of interest in a painting or photograph for maximum effect. Of course nobody measures this out in the viewfinder, and it would be totally impractical to attempt it with wildlife subjects, but there is pretty universal agreement that an off-centred subject is almost always more effective than the bull's eye treatment.

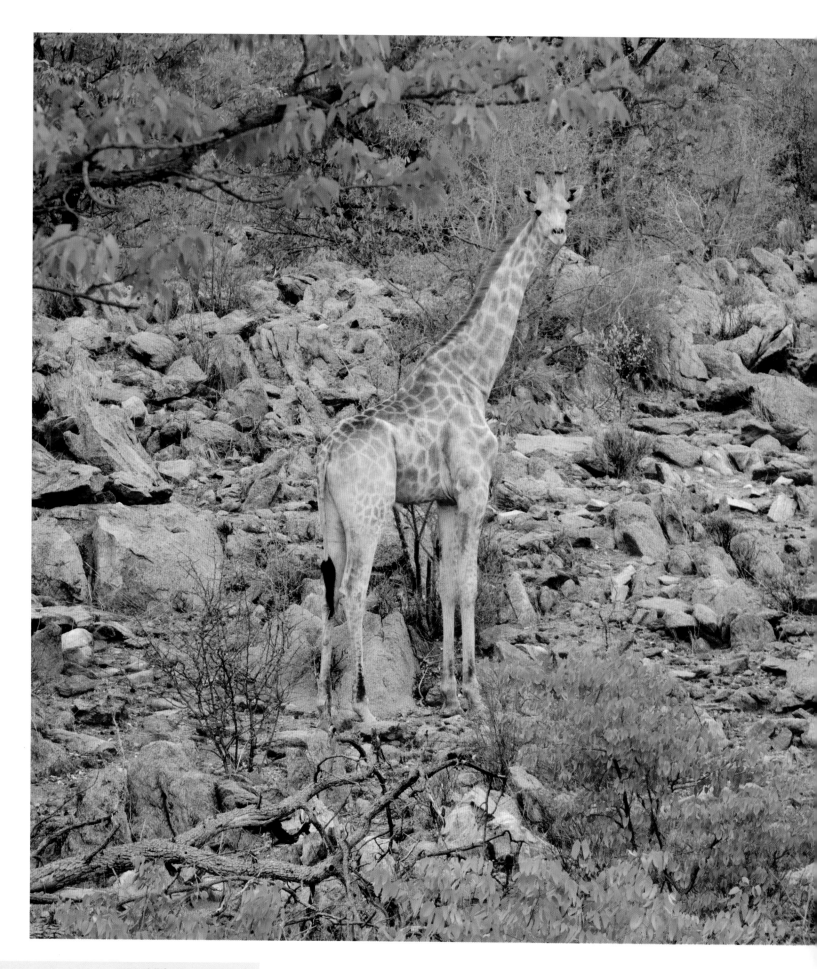

◀ *The way these mopane trees overlap the stony hillside gives us vital perspective cues, so we know the giraffe is large but further away. The contrasting green foliage also creates a soft, natural frame for our principal subject.*

▶ *There is tension in this photograph, because the tips of the red kite's wing and tail are touching the boundaries of the picture. This seems to anchor the bird to the edge of the frame and restrain it from free flight, which leads to our discomfort. At the same time, it very much draws attention to the bird's dynamic shape and outline, and even more so to the block of blue sky delineated in the top left corner. The inclusion of the tree line gives a helpful base to the picture, and adds context, so there is some limited resolution to the conflict.*

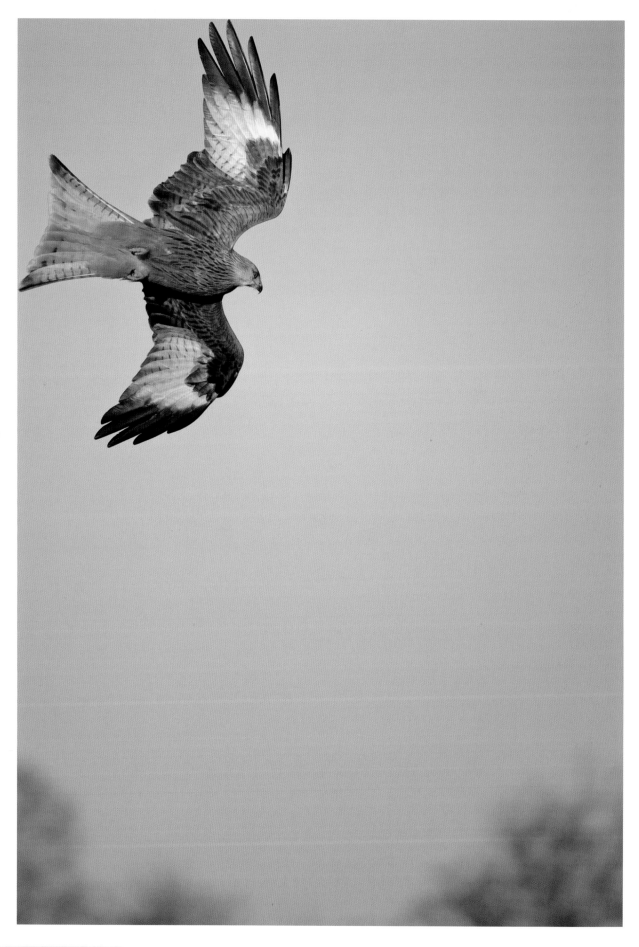

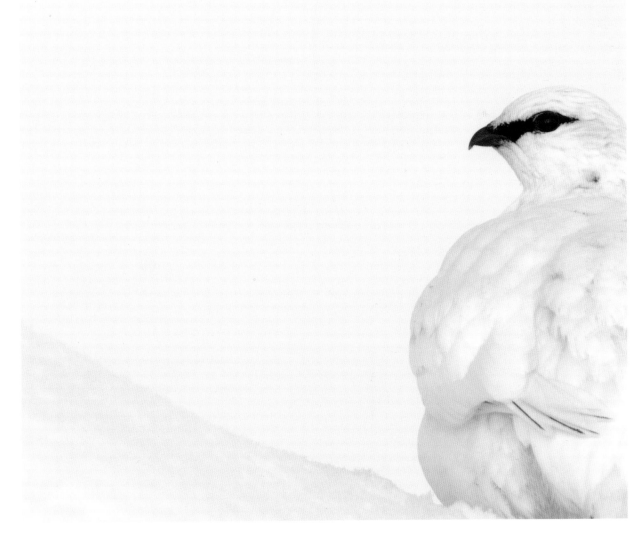

▶ An eccentric subject placement and crop that highlights the cryptic camouflage of the winter-plumaged rock ptarmigan – but does it really matter that much of the bird is chopped off? The picture speaks of winter. It also has the convenience of lots of copy space in which to overlay type, were I to be pitching for a full page spread in a magazine. At the time of first publication this kind of composition in a wildlife photograph might be regarded as contemporary, and probably will not please the traditionalists.

LINE OF SIGHT AND DIRECTION OF MOVEMENT

Line of sight and direction of movement are important considerations when photographing animals. It is the convention that you should leave more room in front of the subject than behind it, with the empty space referred to as 'lead room'. This is a principle frequently applied in art galleries, where you may have noticed that the portraits are generally hung so the eyes look inwards towards the middle of the room. It is also used by graphic designers, so that on the printed page an animate subject more often than not looks or moves towards the gutter of a double page spread.

You often hear photographers discussing whether a moving subject would be better shown travelling from left to right rather than right to left. The former is most often preferred, and I assume this is because it is the normal direction our eyes scan when reading. Do Hebrew and Arabic speakers express the same preference, I wonder?

the event if you don't discard too much (which would impact on the final resolution). For the storm-petrel with its notoriously erratic flight pattern, I nominated an upper right AF point and activated the camera's focus-tracking system – but it's certainly not easy with moving subjects from a rocking boat, and I've still made minor adjustments to the framing in post-production.

COMPLEX SCENES AND MULTIPLE SUBJECTS

The more notes we have on the page, the more important it is we have a sense of purpose and direction to the score. So as we include additional elements in our photograph, say multiple subjects, or the incorporation of more foreground and background, the more we must think about how all these elements relate to each other. If we can discern no logic or connection between these elements, we just see a jumble that makes us feel uncomfortable, and we register dissonance. But the considered inclusion of foreground devices, say a branch or a spray of vegetation, a trail of footprints or a meandering stream, can lend depth and perspective to our images and help to create visual pathways. In the colour photo of the southern giraffe (pages 40–1), for instance, the foliage of the mopane trees helps to give depth to the picture by creating a frame within a frame.

Lines and simple shapes will inevitably feature in our photographs, whether literal or implied. Straight lines are perhaps more abundant in the built environment than in the natural world, but of course the horizon is the most commonly encountered horizontal straight line, while tree trunks and flower stems are typical verticals. More often than not we will want to ensure that these are shown parallel to the edges

of the frame so they appear true, but a deliberate and exaggerated tilt can sometimes inject a new and interesting dynamic. Diagonal lines are particularly useful in that they introduce energy to a photograph, so angling a subject in the frame is very often desirable. And straight lines which recede towards a vanishing point appear as diagonals in two dimensions, giving an impression of depth. Once again, differing viewpoints are the key to applying these principles, so it can't be emphasized enough how important it is to work around your subject.

Where we have two or more subjects in the same photo, we will need to think about whether it's necessary to emphasize one over another, to make sure its voice is heard. The flower arranging school of composition likes to insist on odd numbers in a photograph, and groups of three wherever possible (for the lovely implied triangles). And while it's true that such arrangements are very comforting and satisfactory, you won't always be able to contrive a scene this way and nor should it be seen as universally desirable. Very often you'll encounter animals in twos. In nature there are good biological reasons why two individuals should come together – to court, to display, to mate, to fight over food or sexual favours, predator chasing prey, and so on. It makes no sense to ignore these facts, so you need to accommodate them somehow. Much

▶ *Selective focus and a narrow depth of field were used here to help this male capercaillie stand out from the foreground and background, while still alluding to its forest habitat. The large area of out of focus foreground lends depth to the picture without dominating the subject.*

FRACTAL GEOMETRY

Much established thinking on photographic composition stems from principles of Euclidean geometry – the idea that simple shapes such as triangles and circles can be exploited to make agreeable pictures. But nature is complex, and while there are many examples of naturally occurring pretty patterns, it more frequently appears to us as irregular and haphazard. In the opening paragraph of *The Fractal Geometry of Nature*, the great mathematician Benoit Mandelbrot observed: 'Clouds are not spheres, mountains are not cones, coastlines are not circles, and bark is not smooth, nor does lightning travel in a straight line.' He went on to prove how such seemingly complex patterns could be described by mathematical formulae. One of the most fascinating aspects of the study of fractals is the similarity between many natural systems, such as the way the branches of a tree resemble a river and its tributaries, or blood vessels and their capillaries. Whether this has any relevance for us when composing photographs of the natural world is questionable, but perhaps we shouldn't be too fixated on old-school geometry.

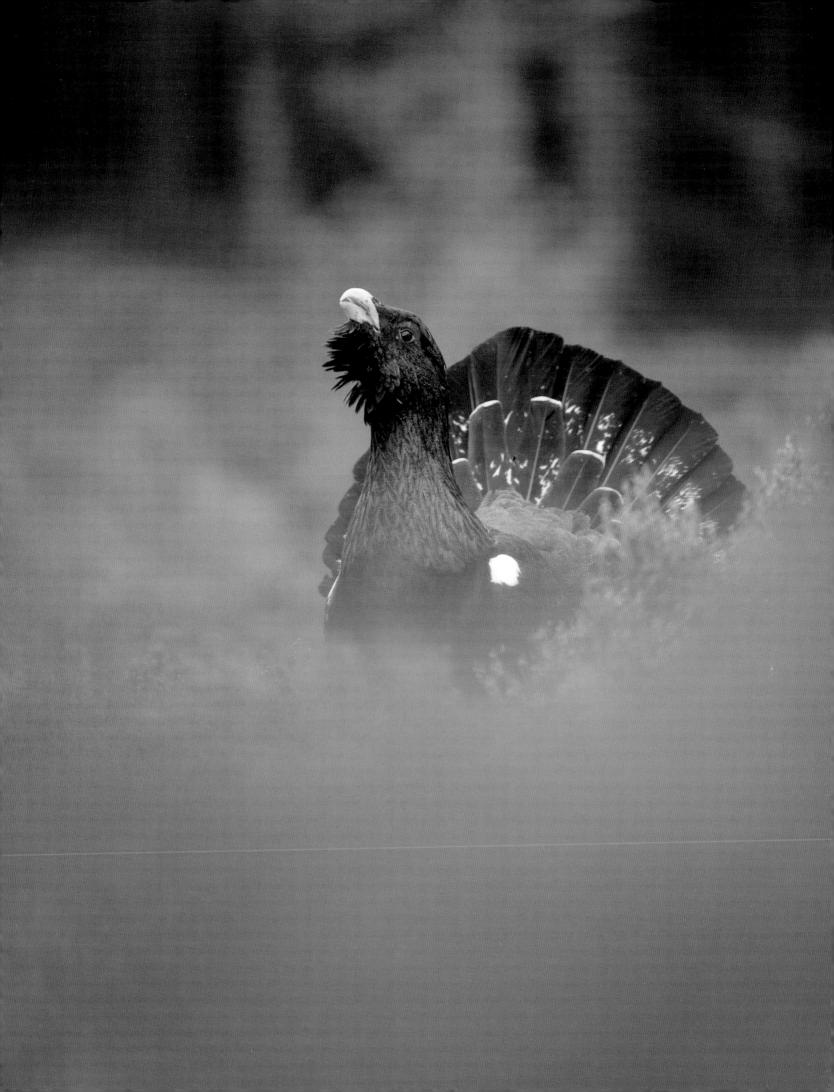

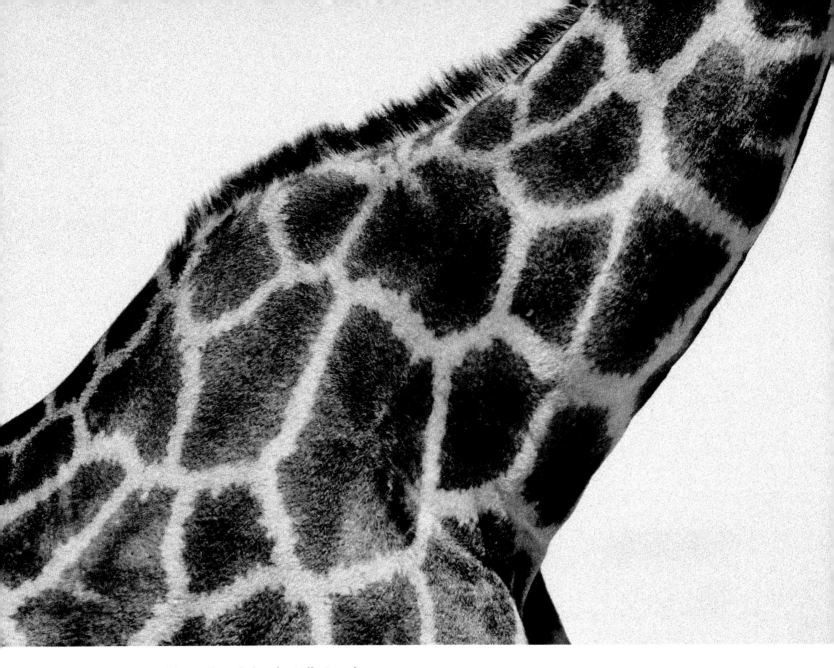

▲ This severely truncated form is obviously that of a giraffe. Even after
divesting it of its head and all its limbs, converting to greyscale and distressing
with Adobe Photoshop's 'Add Noise' filter, it is still instantly recognisable. This
is not a photograph about the ecology or behaviour of the giraffe, or about its
colouration, but rather a study of the reticulated patterns on its hide, and you
can't really be left in any doubt about that.

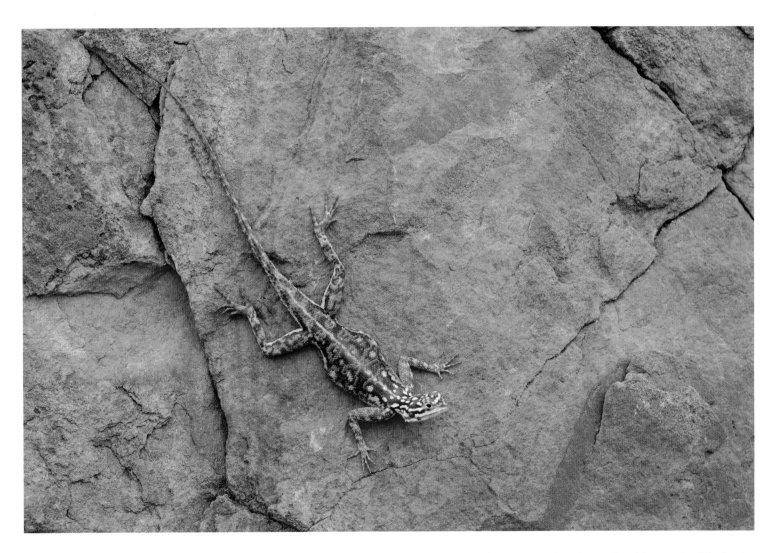

▲ *A Namibian rock agama on red sandstone. The oblique angle of the lizard and the fissures in the rock lend energy and dynamism to an otherwise static scene. If you can't see that straight away, think how much weaker it would be if the agama was orientated parallel with the frame edge. Since there's no horizon in shot, we can rotate the camera any way we see fit.*

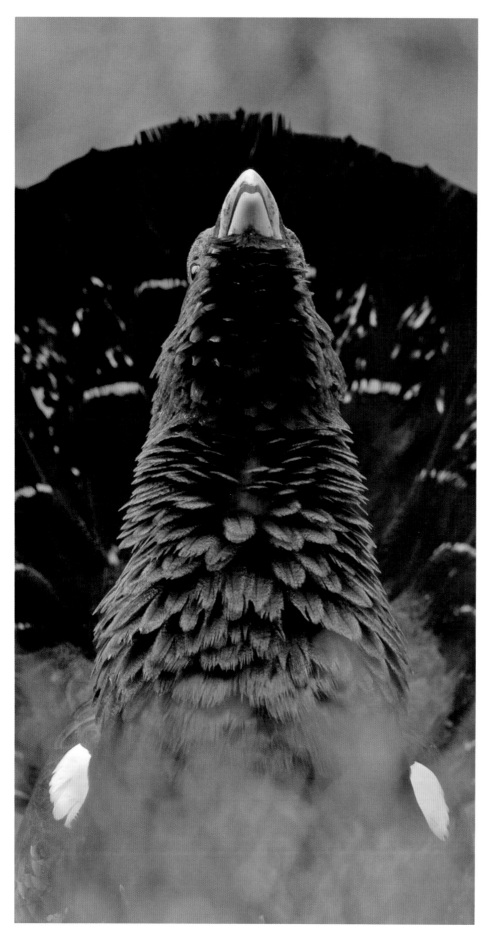

of the time, if we're dealing with two related subjects interacting with each other, they will be close enough to fall within the same plane of focus and we can treat them as equals performing a duet. If one is the dominant or more active participant, we might want to give it prominence, and this becomes all the more important as group size increases. Among the ways we can achieve this are by careful positioning of the figure we choose to be the centre of attention, by the way we light it, or by differential focus – so perhaps the principal character is sharply focused while the subsidiaries are in a different plane and outwith the depth of field. This tends to be most effective when the extras are very obviously out of focus, rather than not quite sharp, which could easily be mistaken for sloppy technique.

The larger the group, you'd think, the more difficult the challenge. However, where we have repetition of form, say with a field full of flowers, the trees in a forest, or a migrant herd or flock, we can use that pattern or rhythm to advantage. One form echoes that of another, and we can vary the rhythm by altering the spacing between the 'beats', by changing our viewpoint, or by what we accentuate – through choice of focal length, lens aperture, and so on. Where these repeated forms are very similar, and the rhythm is regular, figure and ground become interchangeable – in effect, the subject of the picture becomes the pattern itself. And there are many occasions when crowds tend to behave as a single organism, moving in formation, turning at the same moment, and so on, to help us out. See the three examples of the king penguin rookery (pages 52–3) which illustrate different ways of interpreting a crowd scene.

◀ *A rare example, where central subject position and near perfect symmetry work well in a photograph. Indeed, it's irritating that the capercaillie's left eye is slightly obscured, thereby ruining the symmetry.*

LOOKING OUTWARDS, LOOKING INWARDS

Where the subject is reduced in size, and the background
or surrounding landscape assumes much greater
significance in the photograph, once again the ground
itself can easily become confused with the figure and
we might not immediately recognize the subject of the
photograph. This ambiguity can be exploited to our
advantage, since that momentary delay in cognition serves
to intrigue the viewer. I'm thinking here in particular of
those environmental portraits or 'life in the landscape'
compositions where the habitat features large and the
wildlife subject is physically quite small in proportion to
the frame. To execute this successfully requires careful
attention to composition with thoughtful use of light, tone
and colour.

Revisiting our red squirrel, the wide view of it in the
pine forest (see page 56) succeeds because of the pattern
in the tree trunks and the fact that there isn't too much
distracting detail in the forest. The squirrel itself stands
out by virtue of its vibrant colour and its position in the
frame. You will note that there is a considerable difference
between this as a pre-meditated action and the simple
failure to get close enough to make a decent portrait!

These kind of photographs need to be reproduced
relatively large to appreciate their full effect, so they don't
suit every form of output.

At the other extreme, a similar visual delay can be
induced by deliberately disguising important visual cues
such as scale and form – as with the 'inner landscape'
or 'inscape', looking within and excluding the easily
recognisable outline. We are then forced to reflect on
the more abstract and graphical qualities of the image
rather than seek security in the familiar. In photographing
landscapes, a first step might be eliminating the horizon
that naturally draws attention to the sky. With living
organisms, it's a case of abstraction through loss of edges
– for example, looking at the detailed and intricate pattern
of a butterfly wing, the way the colours on a flower petal
bleed into each other, or the textures in the hide of an
elephant. The inclusion of a significant recognisable feature
such as an eye makes it easier for the viewer, whereas the
absence of such leans towards minimalism and demands
more in the way of interpretation.

As well as all of these conceptual considerations, at
the point of exposure we also have to carry out the minor
housekeeping chores such as checking that the horizon
is level, vertical lines are true, there are no pitfalls arising
from common contour (trees growing out of heads
etc.), no awkward foreground intrusions or distracting
highlights; the list goes on. There is a discipline attached
to this that involves diligently scanning to the very edges
of the picture through the viewfinder, while still being
conscious of the subject. This demands an extraordinary
level of awareness. But if we're photographing an animal,
it can very easily move – so all the foregoing 'rules' of
composition may have limited value.

In the end it's very much an organic process, emotional
rather than measured. I won't say intuitive because it's a
skill that can be learned and developed. Not easy, no – but
then neither is composing and conducting a symphony,
or creating any artistic masterpiece. This isn't painting by
numbers.

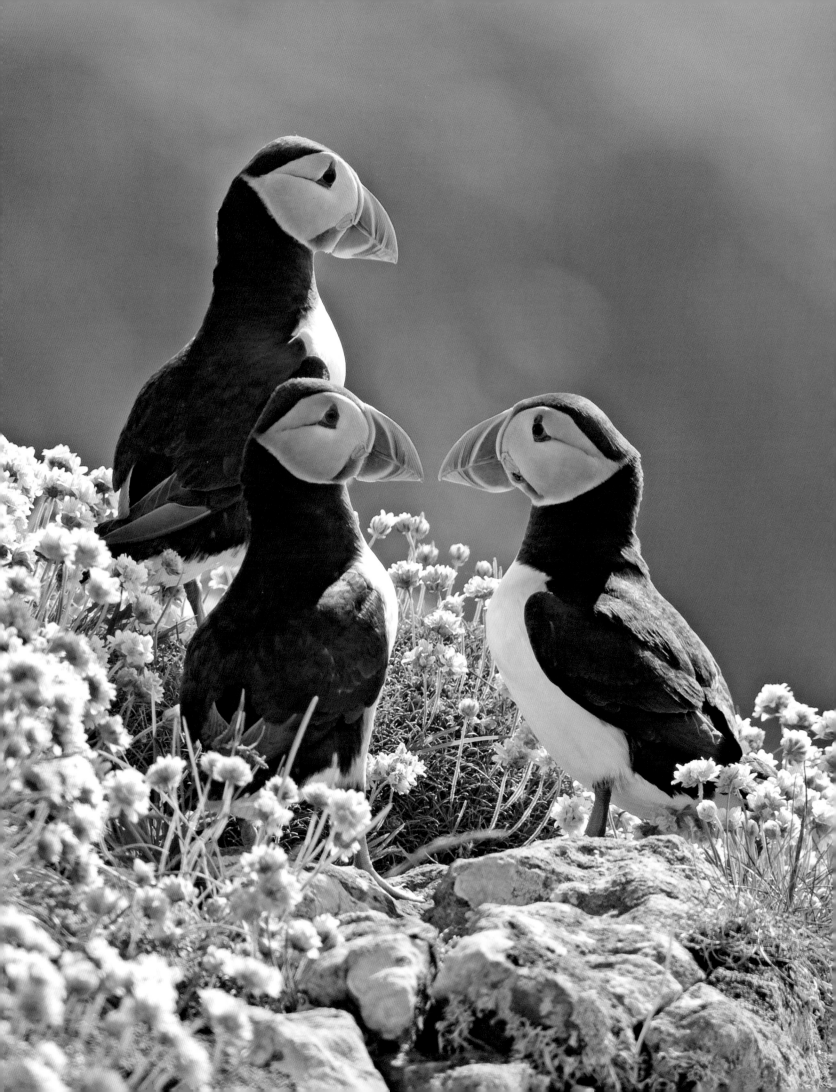

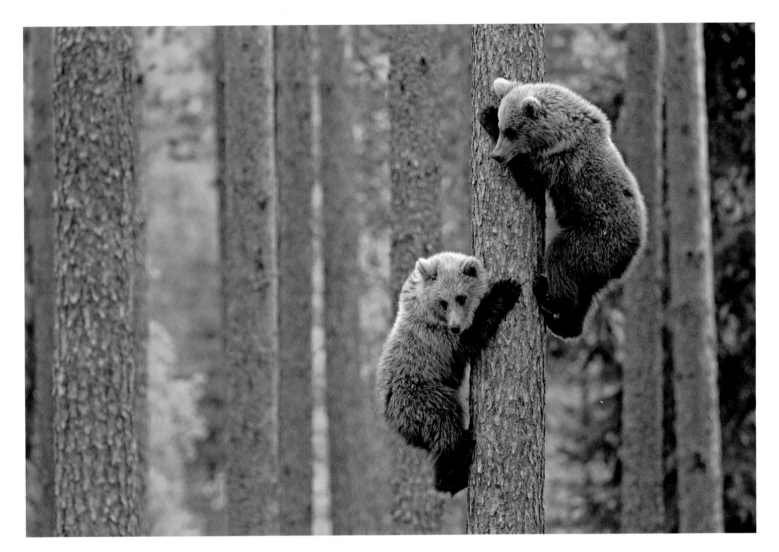

◄ *Attractive groups of three are not always that easy to find in nature, but these Atlantic puffins obliged.*

▲ *Where you have two subjects in the same photograph, how they relate to each other is critical. Here these sibling European brown bear cubs are diagonally opposed, so the implied oblique cuts across the vertical lines of the tree trunks to break up the symmetry. The cubs' postures mirror each other, reinforcing the bond between them, but their line of sight directs us out of the bottom of the frame to something mysterious and unseen – in fact, a large and threatening male bear they are trying to escape, but too far away to be successfully incorporated in to the composition.*

The choice of landscape format here helps to show the density of trees and gives the picture a better equilibrium than would a portrait format. It is important that the verticals are true and parallel to the edge of frame.

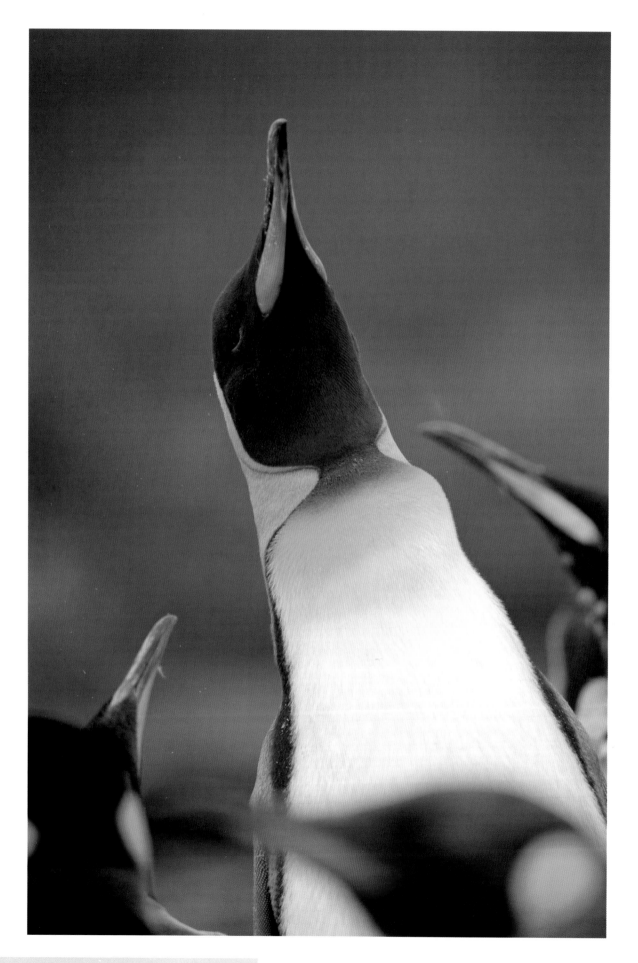

◄ It was impossible to completely isolate one entire king penguin from this busy rookery in South Georgia, but it might have been misleading to do that anyway. Use of selective focus and the tilt of the head effectively lift this bird out of the mass. The heads of the surrounding penguins are far enough out of focus not to compete for attention, while their bills helpfully point to the leading character.

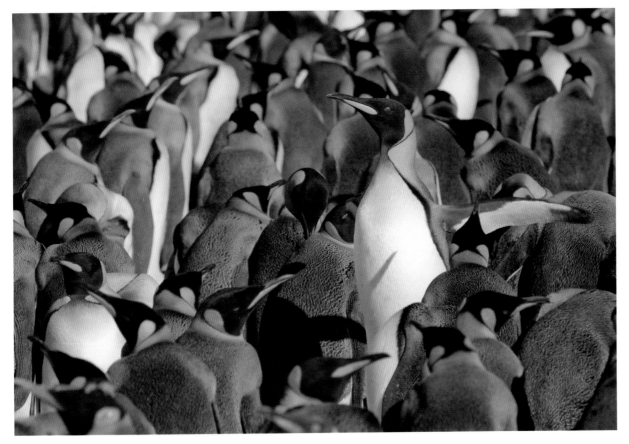

◄ In what so easily might have appeared as an amorphous mass of indistinguishable king penguins, one bird stands out as the focal point. It occupies a compositional 'hot spot' or 'power point', it is well-lit with a catchlight in the eye, it is in focus where the others aren't, and it's also behaving differently from all the rest. You are aware of the mass of birds in the rookery, but you're not distracted by them.

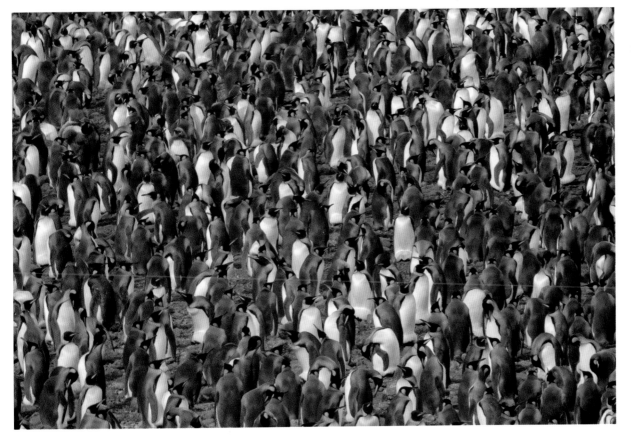

◄ An alternative treatment of the same large flock gives equal emphasis to each bird in the rookery, where they are all approximately the same size, in sharp focus and similarly lit. Pattern and uniformity completely take over and the search for a main subject proves fruitless; the subject is the pattern itself. It's reminiscent of a 'Where's Wally' puzzle, except there's no Wally.

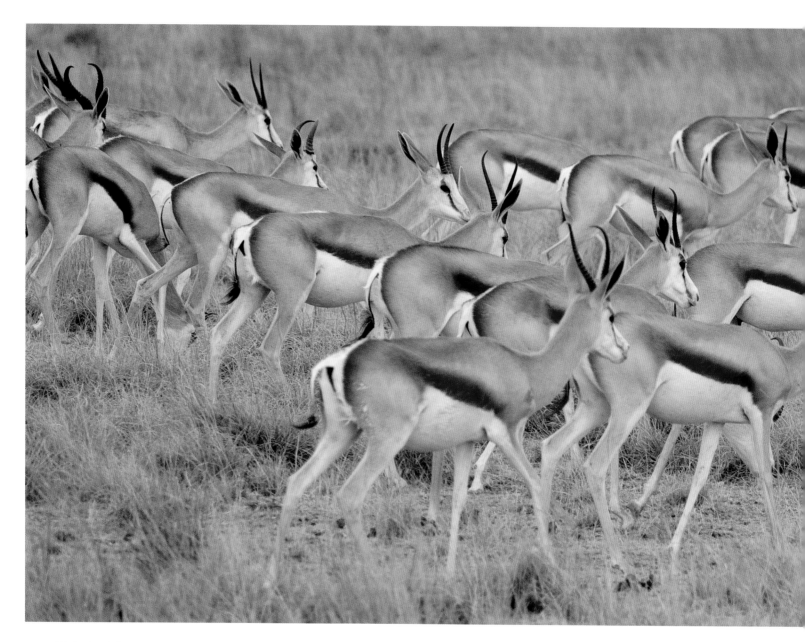

▲ *With this herd of springbok, the repeated forms
of striped flanks, white faces, and pointed antlers
effectively render the crowd as a single subject.
Cropping to the panoramic format excludes distracting
landscape features in the background without losing
any of the key characteristics of the savannah. The
eternal conundrum is where to crop the edges, as
some animals will inevitably be cut in half.*

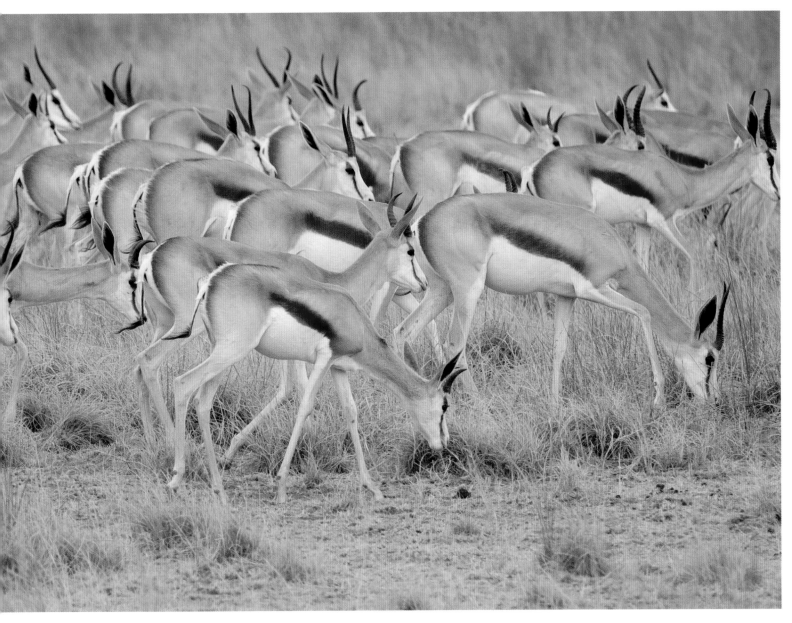

▶ It would have been easy enough to make a full frame shot of this fen raft spider, but the strength of the picture lies in the pattern of lily pads and the way they echo each other, their metallic texture, and the juxtaposition with the spider.

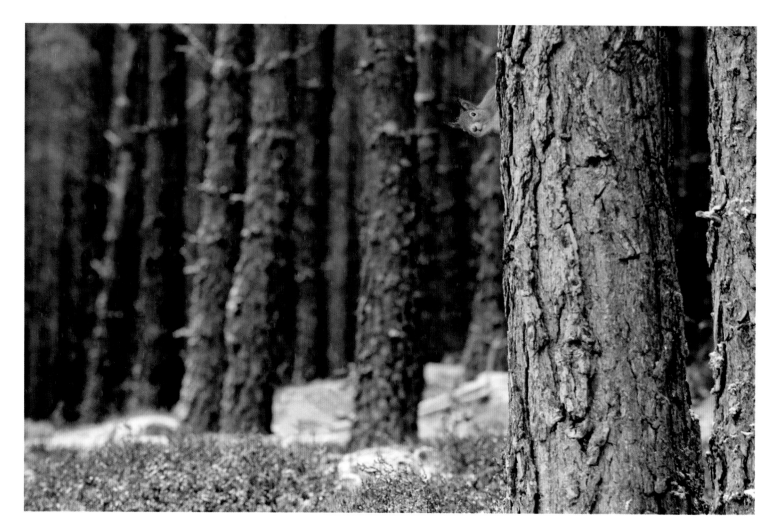

▲ *A counterpoint to the full-frame portrait of the same animal (page 38). The red squirrel can be tiny in the frame when sensitively composed, showing lots of its typical habitat while losing none of the animal's character.*

▼ *A 'life in the landscape' composition of a polar bear in the arctic pack ice. At this scale, the polar bear takes on an air of vulnerability.*

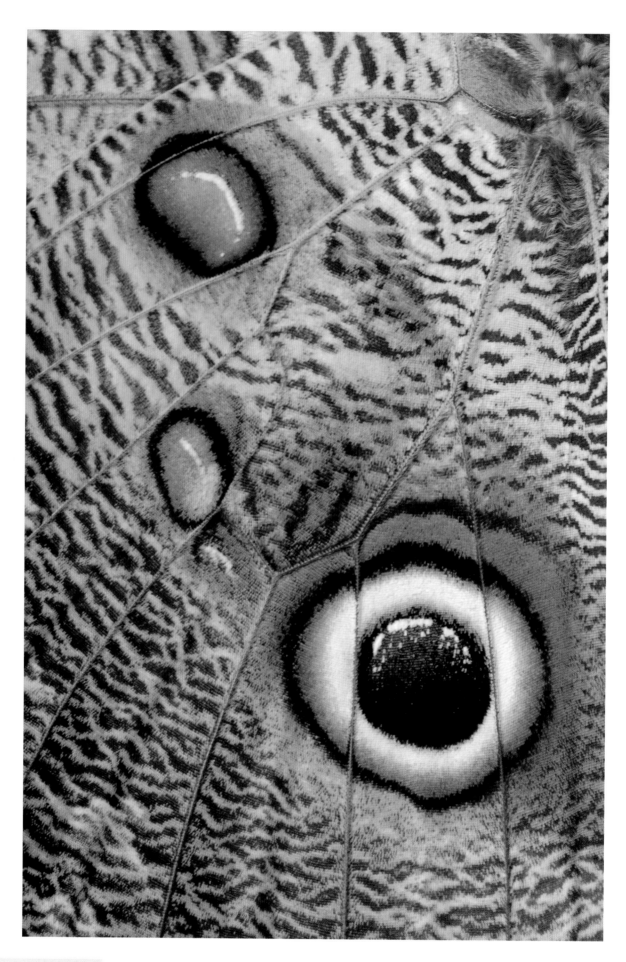

▶ *Detail of the wing of an owl butterfly, showing its eye spot (living specimen, but photographed in a captive collection).*

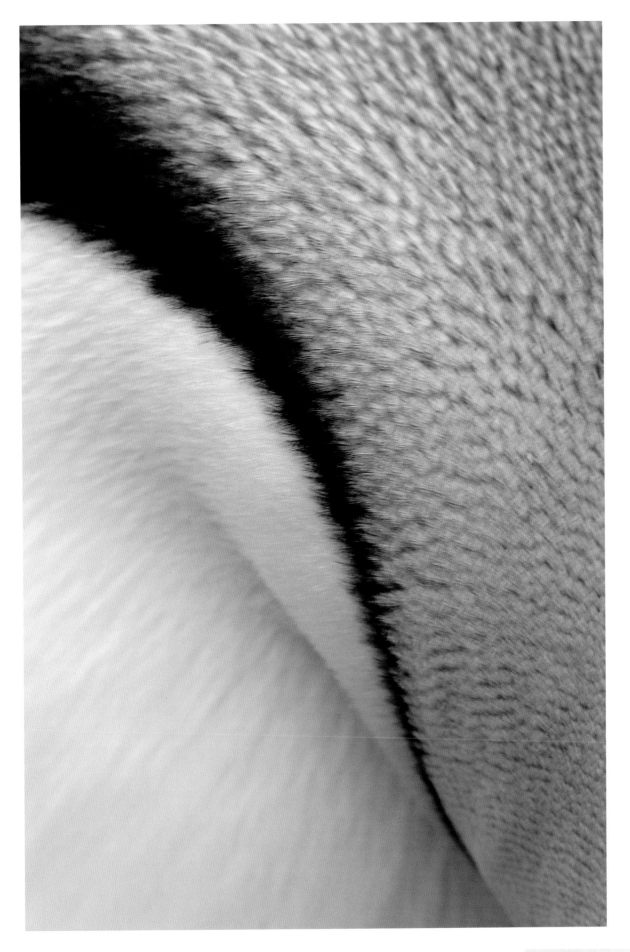

◀ No familiar outline, no eyes or limbs, no sense of scale – it's puzzling for a moment, and then we cotton on to what it is – but we're still not exactly sure which parts of the king penguin we're looking at. It's almost immaterial when we have that elegant S-curve, the delicate bands of colour and the soft plumage detail combining in a graphic abstract composition. Does it help to be told that the head is just out of shot at the lower right corner?

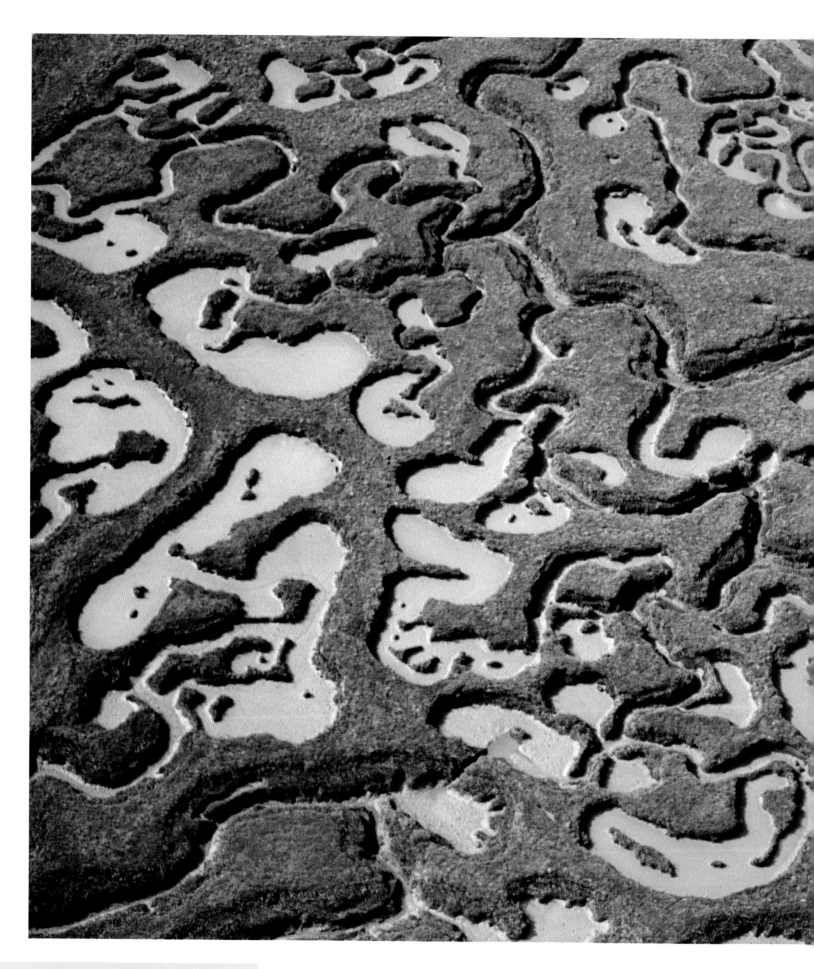

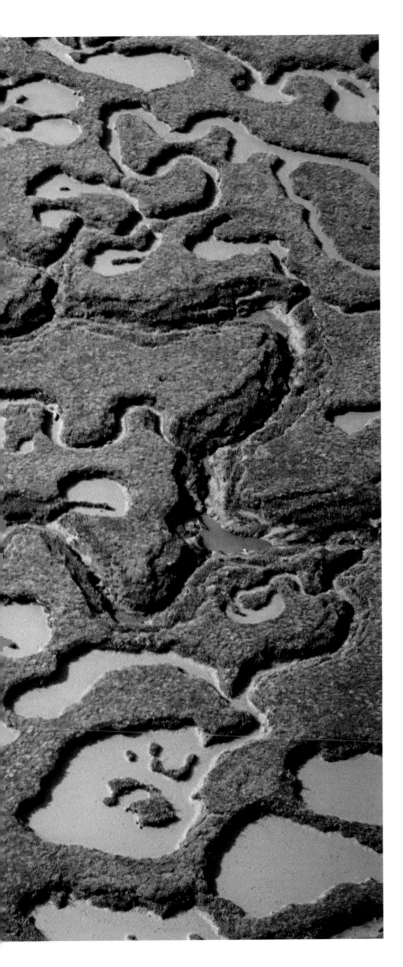

◄ *Is this a plant tissue section under a microscope, or an aerial view of a saltmarsh? The ambiguity arouses our interest.*

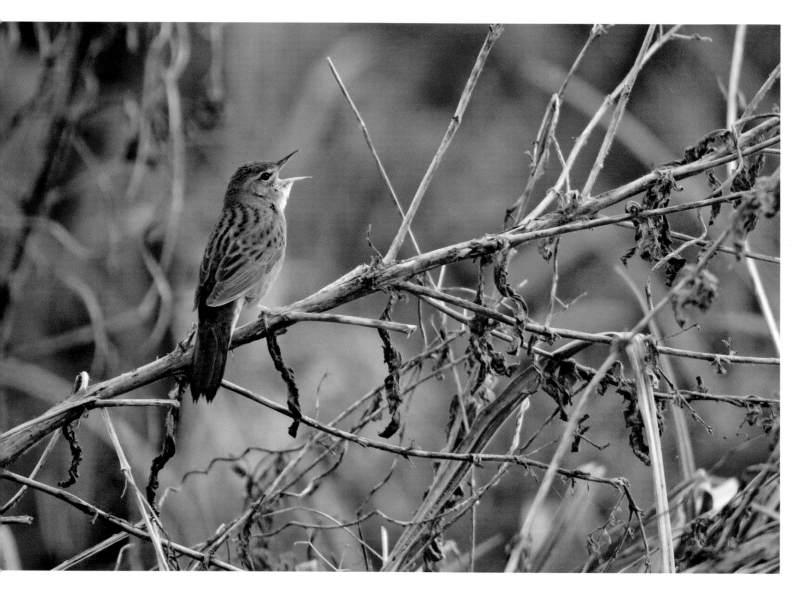

▲ The grasshopper warbler is most at home
in areas of dense scrubby vegetation, so this
photograph clearly shows it in its preferred habitat.
The composition features a busy and untamed
ground that verges on the chaotic, but is perhaps
justifiable as being quite appropriate to the ecology
of the subject.

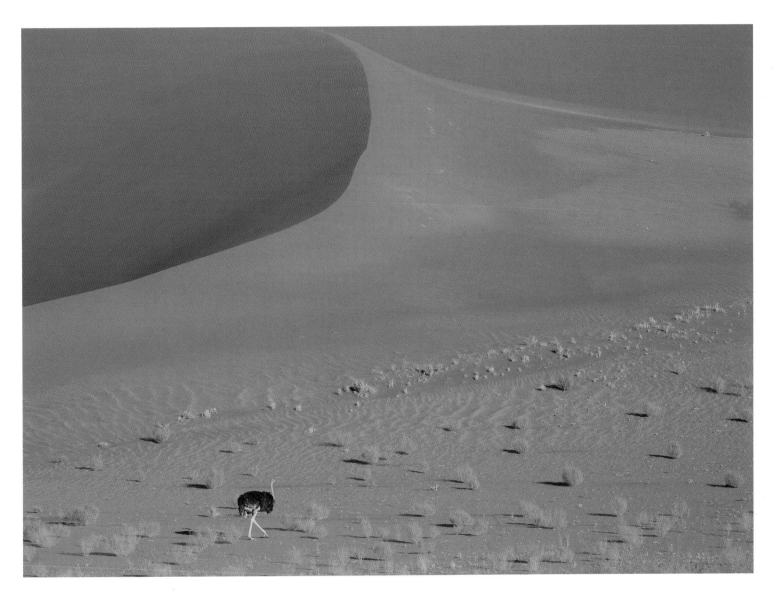

▲ *Successful composition very often depends upon creating a feeling of spatial harmony, so that all the elements of the photograph seem to be in their 'proper' place. It's not always possible, or wise, to adhere to strict rules. This picture of a common ostrich in the Namib desert has some unusual proportions and a slightly unexpected subject placement, but overall it retains that critical sense of balance.*

Seeing the Light

How glorious a greeting the sun gives the mountains!
John Muir

Photographic composition is not just about the relationship between line and shape, but also between tone and colour, which in turn depends on light. Here I am referring to light in the visible spectrum, and the aspects that concern us most as photographers are its intensity, direction, colour temperature and any modification applied (reflected, diffused light, etc.). We shall look at each of these in turn.

TONAL RANGE AND EXPOSURE

The distribution of shadows, highlights and mid-tones in a photograph constitute its tonal or dynamic range, and are graphically displayed in the now ubiquitous histogram. High tonal values or highlights can be likened to high pitch notes on the musical scale, while shadow tones equate to low pitch or bass notes. More often than not you'll be dealing with a fair mix of shadows, highlights and mid-tones in the same scene – notes from right across the register, as it were. How you expose for these tones will have a bearing on how they are emphasized in the final image, and thus where attention is directed. So you shouldn't necessarily just choose the average, 'correct' exposure. While you would normally want to retain as much information as possible in the shadows, on some occasions it might be cleverer to allow certain dark areas to be lost to black if that creates a more interesting mood or pattern. Portraying a wildlife subject as a silhouette would be an obvious example of using exposure creatively in this regard. The point is that you shouldn't be too hung up on the concept of the 'correct' exposure, but rather on the creative opportunities available to you to emphasize certain elements in the photograph. It's best if you can exercise that creativity in camera through intelligent use of metering and exposure, but fortunately in digital photography, and particularly if you are working in the 'raw' format, there is ample opportunity to make significant adjustments after the picture has been taken.

Just as you don't have to use all the notes on the piano keyboard in every piece, so you don't need to have a full range of tones from black to white in every photograph you make. You can control this at the point of exposure through your camera's metering system, and also afterwards in post-production to some extent. A 'high key' picture comprises mainly light tones, and a 'low key' picture mainly dark tones. A good example of a high key wildlife photograph would be a white swan or an arctic fox in the snow (or the rock ptarmigan on page 43). Conversely, a black bear or a raven in a cave would be examples of low key images. Neither should be trusted entirely to your camera's automated exposure system, which would attempt to render both scenes predominantly as mid tones – or grey, in other words – so you would need to over-ride by metering manually, or using the exposure compensation option.

`EXPOSING TO THE RIGHT´

You may have read about or been advised to 'expose to the right' in digital photography, in order to retain as much information as possible in the shadows. Because of the way digital camera sensors sample luminosity, there are more levels of tonal gradation recorded in the light tones than in the dark tones. Therefore, if we bias our exposure towards the highlights we will end up recording more levels of tonal information in the shadow areas. Clearly this shouldn't be done at the expense of clipping highlights (information lost off the top end of the tonal scale) when faced with scenes of high contrast, but as a general rule it makes sense to err in this direction. It has the effect of pushing the peak in the histogram towards the right, hence 'expose to the right'. It is also commonly summarized in the expression, 'expose for the highlights, process for the shadows', which is the opposite of what was considered best practice when working with negative film.

We're usually more alert to the danger of clipping the extremes, manifest as 'blown' highlights or 'blocked in' shadows, where all detail is lost off the ends of the histogram. I suppose a blown highlight could be thought of as a very high-pitched note that lies somewhere off the top end of the piano keyboard – it's there in the score, but you just

▶ This estuary landscape was 'under-exposed' according to the average meter reading, in order to prevent the bright reflections overpowering the detail and texture in the wet mud. It has also had the effect of making the stormy sky appear even broodier, and the deep shadows accentuate the curves of the sinuous tidal creek.

can't play it on your instrument. It's not so bad if there are only small and insignificant areas sacrificed in this way, say 'specular' highlights such as reflections off water, but you don't want to be discarding great swaths of information from this top end of the tonal scale. If you think of how too many repetitive notes on the triangle can be offensive to the ears, then an excess of blown highlights would be similarly undesirable in a picture.

There is a limit to the contrast range that can be captured by digital camera sensors in a single frame, and the typical range is between seven and ten 'stops' or exposure values (EVs), or a maximum contrast ratio of maybe 1:1,000. On bright sunny days, we frequently encounter scenes that exceed this contrast ratio, so we have to decide how to deal with the clipped extremes. It's rarely acceptable to burn out the highlights, so most often we'll have to allow the shadows to block in, and this might very well prove to be the most effective solution. However, there is a technique known as HDR photography, referring to 'high dynamic range', whereby a series of bracketed exposures of the same scene can be combined in HDR enabled software, to amalgamate the preferred selective tonal values into one final image. HDR therefore appeals to the technically minded photographers, and has undoubted value for rescuing extremes of tonal range in landscapes and static scenes – but the results can lack impact and character, and the fashion for this technique may be on the wane.

▼ *Early morning in the giant sand dunes of the Namib desert – a composition depending entirely on the patterns created by light and shade.*

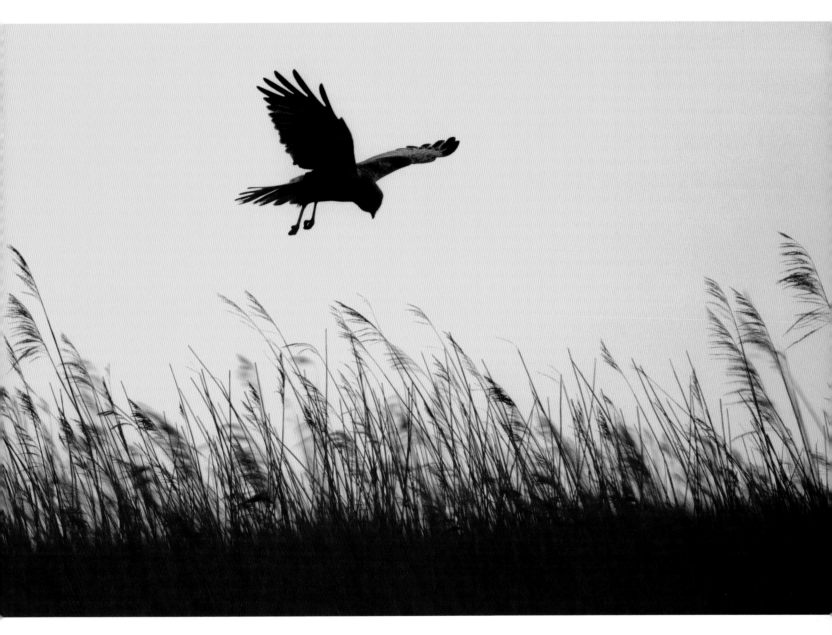

▲ *A strong and low back light meant that it would have been difficult to avoid silhouetting this marsh harrier in flight above a reedbed, but its distinctive flight profile and especially the dangling legs make it a strong image, typical of the wetland habitat.*

▲ A 'high key' rendition of a swirling mass of the confusingly named red knot (which are grey and white in their winter plumage), assembled at their high-tide roost. The proliferation of light tones might be thought of as the equivalent of using mainly the high-pitched notes on a piano keyboard. See also the case study on pages 184–5.

The histogram for the knot image shows a single high peak well up in the highlights sector – not a centred mid-grey, as would be expected from an automatic light reading.

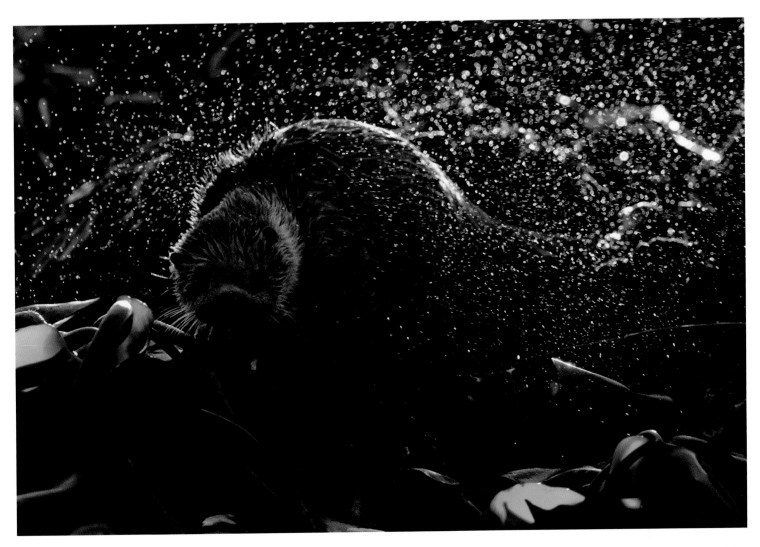

▲ An otter comes ashore and shakes itself dry, and the backlit water droplets shimmer against the shadowy background.

A characteristic 'low key' image, with the main tonal distribution firmly towards the left of the histogram. Note the minor peaks at extreme left and right, where some of the deepest shadows and brightest highlights have been clipped.

LIGHT SOURCE AND DIRECTION

The direction of light is a fundamental consideration in all photography, and in nature this generally means the relative position of the sun. For most of the history of wildlife photography we have been urged to work with the sun over our shoulder, pointing our own shadow toward the subject. This frontal lighting is certainly a pretty safe approach, ensuring even illumination and the least amount of distracting shadow. It is also likely to deliver a 'catchlight', that bright reflection or twinkle in the eye of our subject, lending it an air of vitality and alertness. As with the standard 'big close-up' portrait, this frontal lighting regime is simply the most utilitarian solution. It shows clear detail and is therefore applicable to most common types of photographic output, tending to be favoured by the editors of photographic field guides for example. But it doesn't afford shape, or impart much in the way of character, and gives rather a flat interpretation – the subject can all too easily resemble a cardboard cut-out.

Now if the main light source were offset to one side, even by just a few degrees, we retain most of those benefits (usually including the catchlight) but we begin to introduce some 'modelling'. The subject now appears more rounded and three-dimensional, and we also begin to reveal surface texture. As the light source moves progressively further to one side, the extent of the shadows increases, masking more and more detail, and any chance of a catchlight in the eye is more likely to be lost. Sidelight is rarely the preferred choice for wildlife subjects, in its extreme form yielding half-light, half-shade – so-called 'split' light. However, sidelight is very useful in showing

relief and texture in landscape and close-up photography – for example, the roughness of bark on a tree trunk, or indentations of animal footprints in sand or snow. It is probably an under-utilized technique among wildlife photographers.

Where the main light emanates from behind the subject, this is broadly referred to as backlight. It follows that most of your subject will now be in shadow and so might not sound very promising at first, but there are several ways to deal with this effectively.

▶ *Although this kingfisher is shown in profile, the light direction is slightly off full frontal so there is a degree of modelling created by the shadows which helps to prevent it looking too much like a cardboard cut-out. The late afternoon light of the northern winter has a low colour temperature and warm appearance, while the catchlight in the bird's eye injects some life in to the subject.*

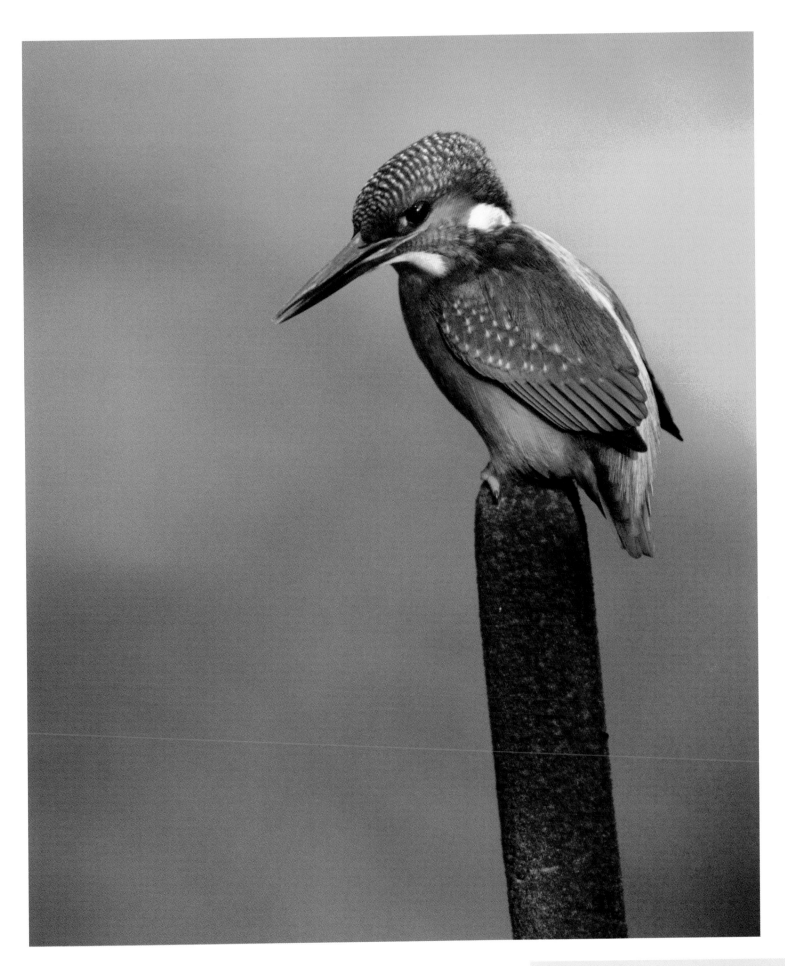

Once again there's a judgment to be made and you need to decide how to set the exposure. This will depend whether you wish to record detail in the shadows, or to let them go and record them as maximum black. Where the backlight is particularly low-angled and strong, it can produce a bright halo or glow around the subject and is sometimes termed rim light. You'll need to be using a lens hood here to prevent areas of 'flare' in your pictures, and in extreme cases may also need to make use of other blocking devices such as judiciously placed tree trunks between the sun and the front element of your lens. Or borrow a friend to cast their shadow across your lens. Rim light is most obvious with soft-edged subjects – such as the feathers of birds, plant seed heads, or mammalian fur – and has a tendency to soften and romanticize the subject. It's a technique frequently used by wedding photographers when shooting a portrait of a bride with long hair. Here it is usually tempered by the addition of a small amount of fill light, delivered by flash (we'll come back to this) so there is still plenty of detail in the foreground. Without the fill light, a rim lit subject appears more dramatic, and perhaps even menacing, especially if photographed against a dark background. Not so much favoured by the wedding photographer, then, but good with bears and wolves. So you can see there are many nuances attached to light direction, as well as tonal rendition, and they too will have a significant bearing on the mood of the photograph.

▼ Side lighting reveals relief and contour in a rock face of columnar basalt.

▶ Wrinkles are to be celebrated, and side lighting ensures all are clearly visible on the hide of this African elephant.

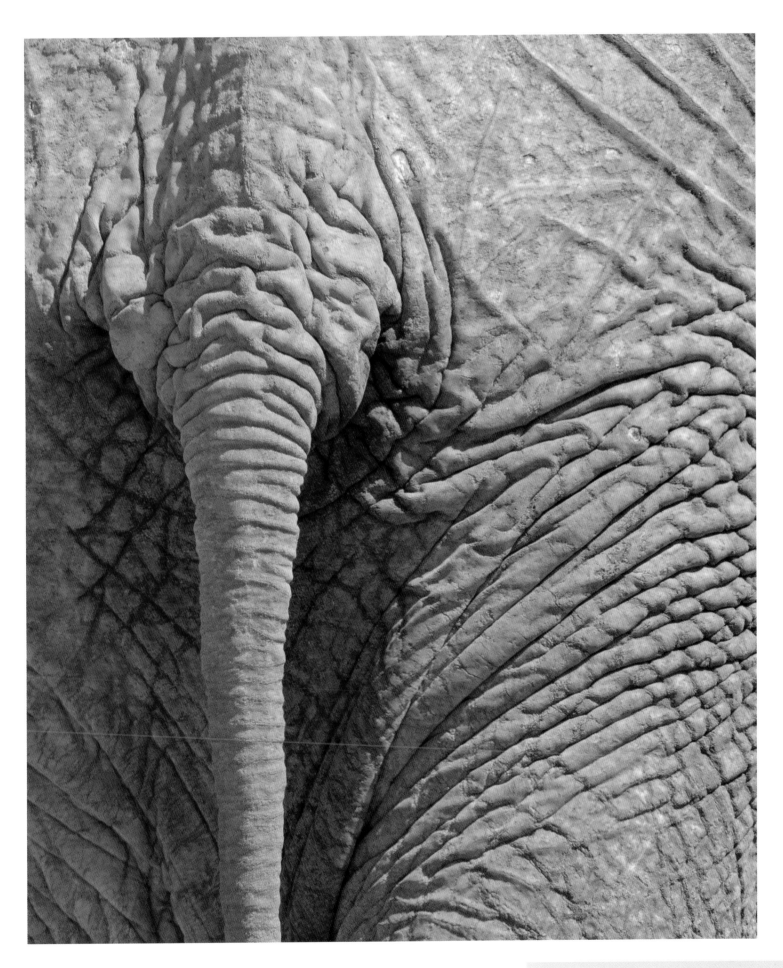

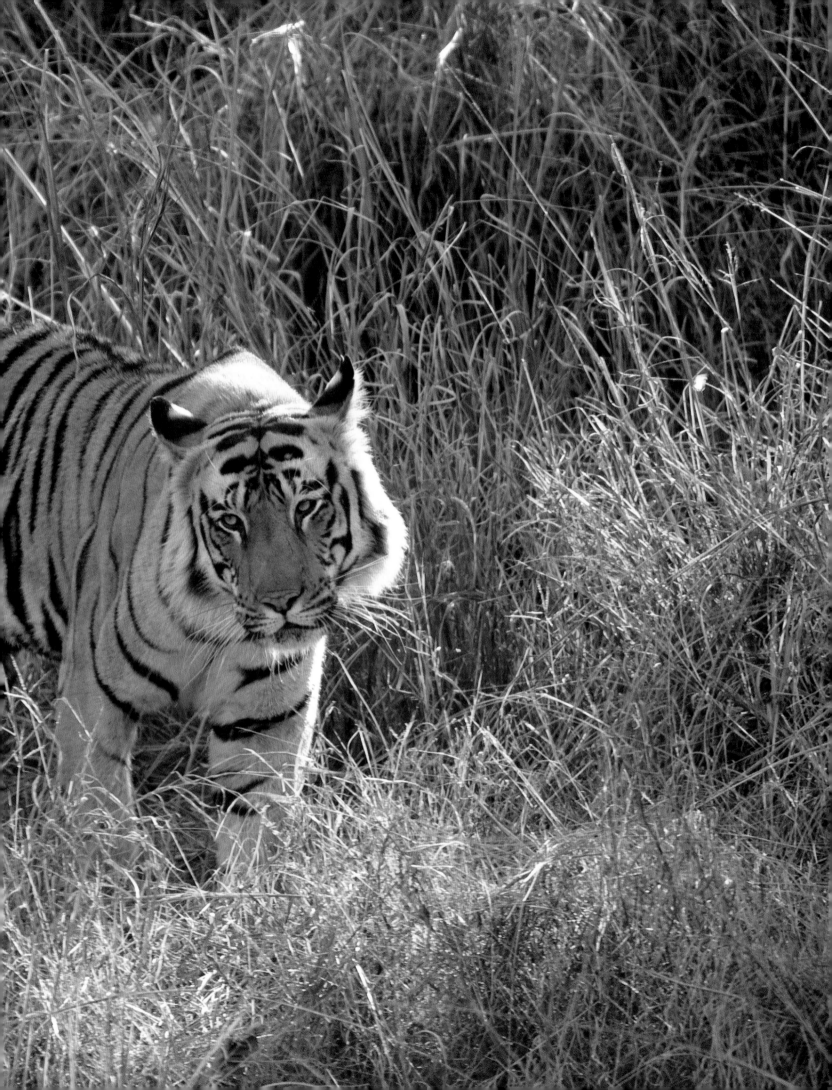

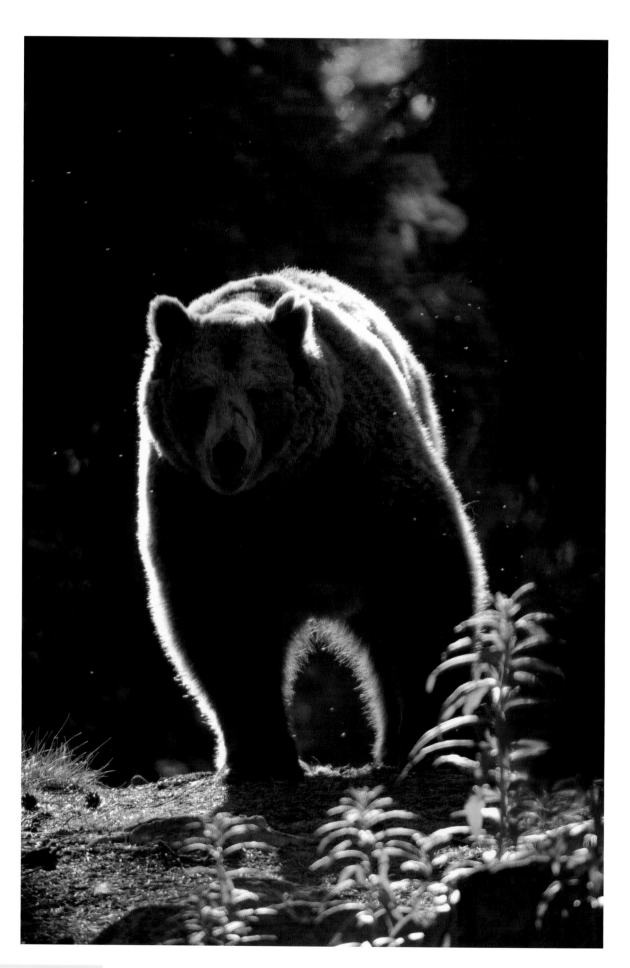

◀ *A Bengal tiger pictured in evening light (previous page).*

▶ *Extreme back light or rim light gives this large male European brown bear a dramatic and threatening appearance. The back light works particularly well against the dark background, even picking out a few mosquitoes, and the texture of the fur produces an attractive bright halo.*

◀ High, direct sunlight gives this red admiral butterfly a hard-edged appearance. Contrast is high overall, while shadows are deep and tending to block in even after 'opening up' in post-production. The bright reflections off the glossy ivy leaves also needed to be controlled.

QUALITY OF LIGHT

Photographers of landscape and nature often expound about the 'quality' of light. This is a fairly subjective assessment, but generally light that has been diffused or scattered by reflection (indirect light) is favoured over direct light from a point source, such as the unfiltered light of the sun or a single flash on camera. Strong sunlight, especially when the sun is high in the sky (for example, around noon in the summer, or almost any time of day in the tropics) produces high levels of contrast with compact, deep shadows and intensely bright highlights. You'll hear it described as 'hard' or 'harsh' light and it isn't usually regarded as terribly flattering to wildlife subjects. For this reason, many photographers desist from doing any work at all in these conditions – an oft-employed rule of thumb is that if the length of your own shadow is shorter than your height, it's time to pack up. You are probably also familiar with the idea of the 'magic hour' – that window of opportunity immediately after sunrise or before sunset. This is much appreciated by landscape and wildlife photographers because of its low angle and low contrast (as well as its warm colouration). However, there are some simple expedients to re-balance the light in your favour when working with strong sunlight. These include using your own shadow to lower contrast in a localized area, using a diffuser material such as a gauze filter or light tent, setting up a portable reflector with a white or silvered surface, or using some fill flash. The flash is probably the only realistic option for mobile subjects like animals and birds. Its effective range can be increased with tele-flash adaptors which use fresnel lenses, and this is a pragmatic way to light subjects in the tree canopy against a bright sky, for example.

▲ An autumn tapestry of elderberry and black bryony in fruit. Soft, indirect light on a cloudy day means shadows are weak and non intrusive, and there is good tonal detail and colour saturation throughout the picture.

Sunlight can be modified naturally in a number of ways, the most obvious of which is diffusion by clouds and atmospheric haze. Water droplets in cloud reflect and refract light rays so that they scatter in different directions and illuminate an object at ground level from many angles at once. Consequently there are no strong directional shadows under dense clouds, so the light has softer and gentler attributes. This diffused light suits close-up photography very well, and especially so with the more delicate subjects such as flowers. Open shade has a similar softening effect, where indirect sunlight is reflected from the surrounding environment, but it can take on unwelcome hues – say from an excess of green foliage.

If shady conditions are just too flat and gloomy, then you might choose to augment the ambient light. Here again a portable reflector is a useful tool, which can either fill shadows or be used to give direction to the main light source and affect modelling. Mirrors will reflect light with least loss of intensity, but will not soften it. Silver foil or white card are preferred for this purpose, and of course a winter snowfall will act as a brilliant natural reflector. Daylight balanced fill-flash may also be employed to achieve a similar effect – the goal here is not to overpower the main light but just to lift the shadow tones on the main subject, so it shouldn't be obvious that flash has been used at all. This fill light will also help to counter any colour cast. Most modern cameras have automated systems for daylight balanced fill-flash, but you will need to vary the exposure compensation to achieve optimum results, and that usually involves reducing the flash element of the exposure by means of a negative exposure value (EV) compensation setting.

▲ A fresh breeze was lifting the flower heads of these snakeshead fritillaries, showing the yellow stigma and anthers. A silvered reflector was used to direct some of the soft, diffused light into the shadowy corollas.

▶ Low angle, early morning sunlight illuminates the underparts of this griffon vulture as it comes in to land (overleaf).

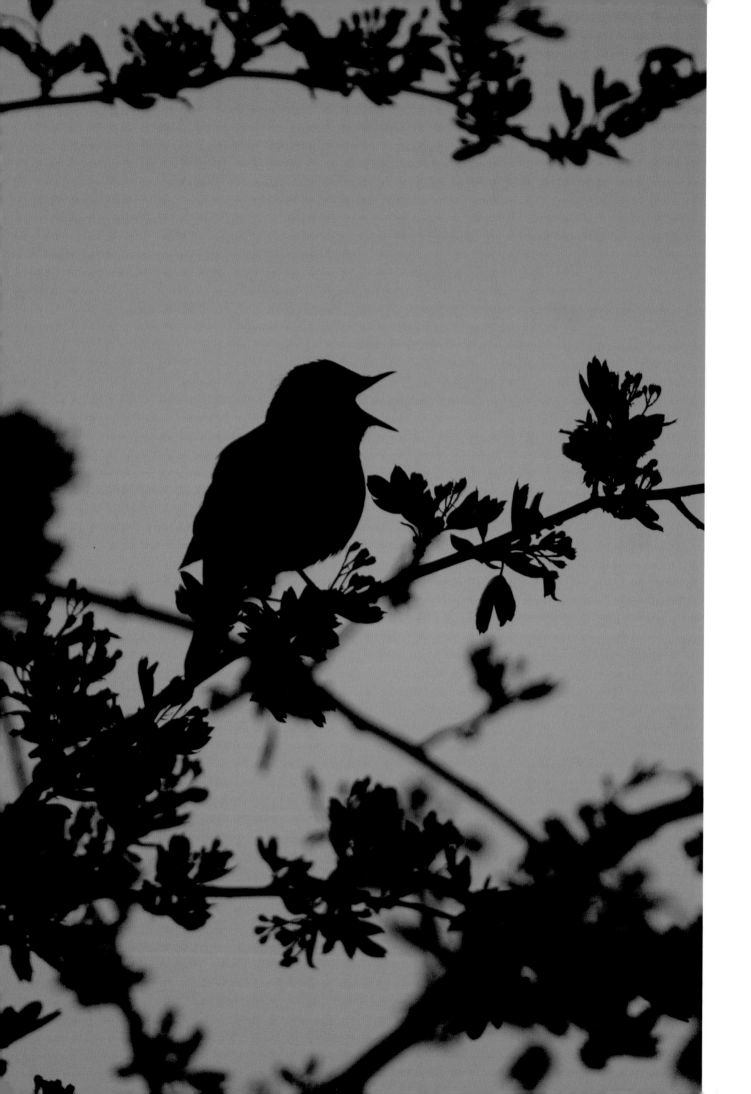

COLOUR TEMPERATURE OF LIGHT

Another property of light we need to take account of is its colour temperature (see box, below left). As nature photographers, we will be most concerned with how this varies according to time of day, and whether or not it has been influenced by reflection off some other body. If you've not previously thought much about the natural fluctuations in the colour temperature of light, just bring to mind the warm, golden hues associated with sunrise and sunset, and I'll bet you've been seduced by it at some time or another. The real danger, though, would be in trying to use this inappropriately across a broad range of subjects and conditions, laying on the schmaltz with an over liberal application of the warming filter. So proceed with caution.

With film photography you need to be much more attentive to colour temperature, ensuring you use the correctly balanced film to light source or the appropriate colour conversion filter. Digital capture makes that all very simple as you can vary your colour temperature setting from frame to frame if necessary. The sunlight setting approximates to midday sunlight, while the shade settings will 'warm up' the picture. Flash light is very close to midday sunlight in colour, so there are no issues about using that in conjunction with daylight. And even tungsten light can be selected at the push of a button, so you can consider using torch light, for example, if you're really pushed or you want to try creative things like painting with light during a long exposure. Digital image capture means that we have much more flexibility in this area than previously when using film.

◄ *A nightingale sings in the dawn chorus – deliberately underexposed in camera, to ensure it reproduced as a silhouette. Absolute silhouettes can possess no depth or three dimensional modelling.*

▲ *Daylight-balanced fill-flash has been employed here, on a different singing nightingale – just enough to fill the shadows. The fill light doesn't overpower the main light source and it's not immediately apparent that flash has been used at all. I usually find that I need to use a negative flash exposure compensation setting, beyond that recommended by my camera system. You will need to experiment with your own make of camera and preferred metering pattern to arrive at an optimum setting.*

COLOUR TEMPERATURE

The colour temperature of light varies according to its source, and is measured on the Kelvin scale. Tungsten lamps have a colour temperature of 3,200°K, while daylight at noon has a temperature of approximately 5,500°K. In the early morning and late evening the colour temperature is actually much lower than midday, even though in every day language we tend to describe this light as 'warmer' because of its reddish colouration. In overcast or shaded conditions, the light has a much higher colour temperature, towards 10,000°K, and appears bluer or 'cooler'.

In order to show colours accurately in a photograph, we need to match our recording device to the colour temperature of the light source. This can be achieved through the white balance setting on a digital camera, or by choosing the correctly balanced film (daylight, tungsten, etc.). With digital capture, if you can't be sure of the type of light source or you are dealing with mixed lighting, then it's best to stick to auto white balance in camera.

Altering colour temperature after the event is a relatively simple matter in digital photography, by adjusting the white balance settings in your preferred photo processing application – whether you had the wrong setting at the time of exposure and want to rectify, or simply to make your own interpretation of the scene. However, it's a somewhat counter-intuitive process, as you have to lower the colour temperature setting to make an image cooler or bluer, and raise it to warm the image. In effect, you are assigning the colour temperature setting that should have been used at the time of exposure to achieve that look.

MANAGING COLOUR

So far, we haven't talked much about controlling colour in our subject matter and as a feature of composition, but we can hardly ignore the wealth and range of colours throughout nature. It follows that we should wish to incorporate them in our recording of the natural world, and you can just imagine the sense of liberation our predecessors must have felt at the advent of colour film after decades of being restricted to black and white. But colours in nature don't just exist for our aesthetic appreciation; they serve many purposes, and life on earth has evolved to exploit them in a multitude of ways. For example, to act as warning signals, to serve as camouflage, to attract pollinators and to facilitate courtship and sexual selection. So when we are shooting the natural world most of the time we will want to do it with a degree of accuracy, and will want the colours in our photographs to look like we saw them in the first place. Older photographers will recall the debates that used to rage over the best colour transparency film to faithfully reproduce the subtle colours of bluebells, which all too often appeared on film with a magenta tinge to them, but that's now a fast-fading memory. Instead we have digital colour management to worry about, and how to calibrate our monitors and apply profiles for our printers. These are topics best dealt with in more technical manuals, but I give a brief history and overview in the accompanying panel.

How we select, combine and juxtapose colours in our photographs will influence the success of our compositions, and can have a significant impact on meaning. As photographers of the natural world, we don't have so many choices to make or options to exercise as say a fashion or studio photographer, since we don't design our sets or dress our models – but it pays to be aware of the theory, and we can still be selective in what we record. The psychological effects and our emotional responses to different colours and combinations may be quite individual and personal, but there are also some well-understood general effects. You only need to reflect on how colourings are used in food technology and how they affect our taste perceptions to appreciate the power of the psychology of colour. More subtly, warm colours are known to advance in an image, while cool colours recede. These observations are based on laws of aerial perspective, but have

▶ *Violet and yellow are complementary primary colours, being opposites on the colour circle, and appear more intense when seen together – here exemplified by wood blewit fungi penetrating the autumnal leaf litter.*

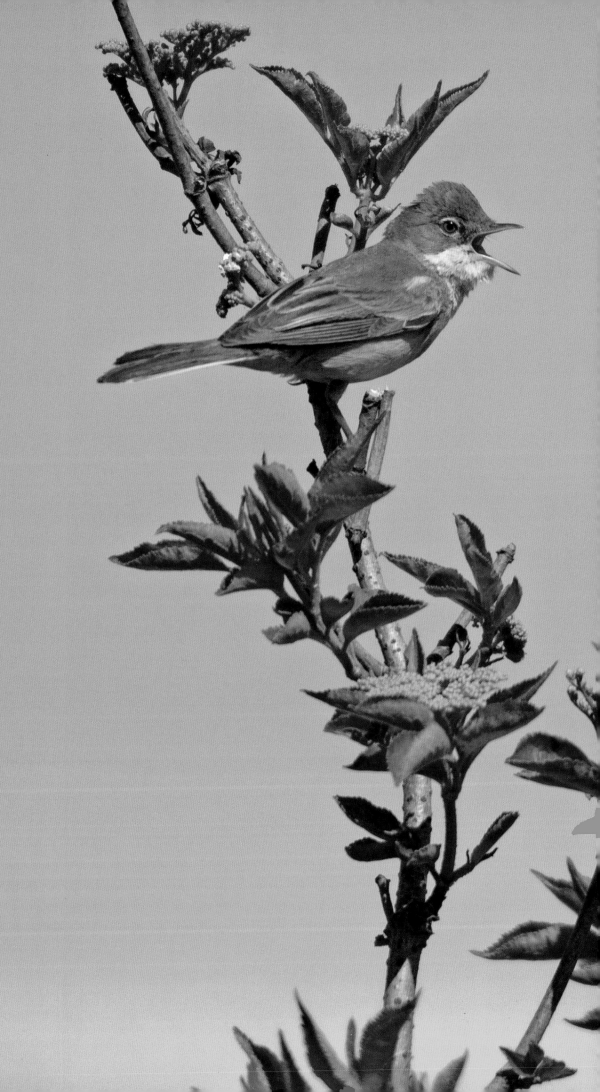

COLOUR SPACES

In 1905, Albert Munsell published a colour classification which described the three dimensional relationship between hue, saturation and brightness. So if the hue is the 'name' of the colour, then each hue could be strong or weak (its saturation or chroma) and light or dark (its brightness or value). The Munsell system referred to opaque pigments rather than light, so was intended for painters rather than photographers. Then in 1931 the CIE (Commission Internationale de l'Eclairage) system of classification was introduced, using the primary colours of red, green and blue light. This is the system we are familiar with today in digital photography, and its terminology persists in our imaging software and elsewhere, though sometimes you'll find brightness described as luminance.

The RGB (red, green, blue) colour space applies to all transmitted light devices such as digital cameras, TVs, computer screens and projectors. Variations within the RGB family include the Adobe RGB colour space, which is the most widely adopted system in publishing and professional photography, and sRGB, which is the default colour space on the worldwide web. Adobe RGB has a wider 'gamut' than sRGB, which means that it can express a wider range of colours, though not every form of output can fully realize them. Professional and serious enthusiast photographers usually set their camera's colour space to Adobe RGB so that they can give their clients the best possible results in their published products. Using Adobe RGB will also allow for the widest range of possible future outputs.

The CMYK (cyan, magenta, yellow, black) colur space is for pigments or ink sets used in printing. The software in an inkjet printer will convert your RGB image file to CMYK automatically, so you don't need to trouble too much about this. If supplying images for print publishing, unless you have studied the science and technology of colour management in great depth, you really don't want to be messing with CMYK conversions in Adobe Photoshop. You would be best advised to send an Adobe RGB file, ideally with an embedded profile.

In the main text and picture captions, colour terminology is standardized to pigment or painters' colours, as in every day usage, and for ease of understanding.

been successfully exploited by landscape painters for generations. And underwater photographers have to cope with the fact that reds and yellows are the first colours to disappear as they dive deeper, due to the way light travels through the denser medium of water, but that's more a law of physics than a psychological consideration. It's consistent with the realization that greens and blues predominate in nature's colour palette, certainly in the temperate world. Perhaps that's part of the reason we're so attracted to anything suddenly different, such as the warm orange glow of a sunset, the transient changes of autumn foliage, a meadow full of colourful wildflowers, or the blanket of white from a heavy snowfall.

There are also cultural influences to be taken into account. For example, in the West we tend to associate the colour red with danger or passion, but in China it is thought of as a lucky colour, while in politics it's linked with Communism. Green might signify Islam, environmental sympathies, or Irish nationalism, depending on your geographical, religious and political standpoint. There might be only rare occasions you can use this sort of information in wildlife and nature photography, but there is perhaps some scope there for metaphor and we always need to be conscious of our audience.

◀ *A common whitethroat on its song perch by a field of oilseed rape. These aren't classic complementary colours, but the pastel blue and yellow have strong associations with spring and seem to combine effectively here in a celebration of the season.*

COMPLEMENTARY AND HARMONIOUS COLOURS

The way colours combine with each other is of particular interest to us, and here it is customary and most convenient to talk about the colour circle of painters' primaries – red, yellow and blue – and the intermediate secondary hues of violet, orange and green. Opposites on this circle (yellow and violet, blue and orange, green and red) are termed complementary colours and have special characteristics in our visual perception. If you look at one colour for a long time, and then at a sheet of white paper, you will always see an after-image of its complementary colour. Showing two complementary colours alongside each other causes both to appear more intense, just as certain pairs of notes played on a violin might reverberate and give you the goose bumps. Georges Seurat employed this knowledge in his pointillist painting technique, so that the colours were blended in the eye and mind of the viewer, rather than on the canvas. In practice, we can use these complementary colours in our nature photographs to make vibrant, eye-catching pictures that will get noticed, not least by hard-pressed, seen-it-all-before art editors. Complementary colours can also help a subject stand out from its background, similar to the way we might use contrasting tones to differentiate.

Closely related hues on the colour circle are said to be harmonious – so green and yellow, or red and violet harmonize. Harmonizing colours also work well together, as the name implies. Most of the time, however, we won't encounter these six strong colours in nature, but we'll see them in their muted or less saturated forms – pastels, or variations of grey and brown with a slight colour tint, that are often

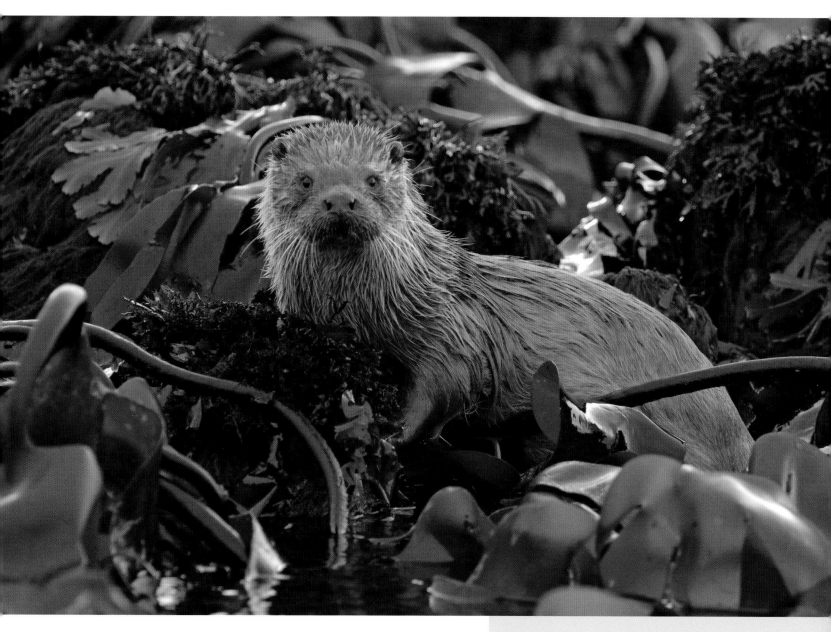

▲ *The muted earth tones exhibited in this photograph of an otter nestling in a bed of marine algae create a more restful ambience than would strongly saturated colours. Reds, browns and oranges are closely related on the colour circle and harmonize well, while the small areas of green act as localized accents of complementary colour – but not so strong or extensive they would draw attention away from the otter.*

popularly referred to as 'earth tones' and generally regarded as more restful than their saturated versions. Photographs in which these muted colours predominate stand up to more quiet contemplation and prolonged viewing, while the injection of small amounts of bright colour as local accents can either arouse interest or create a distraction, depending on how they relate to the subject.

Colour saturation can be influenced by changing the colour mode in your digital camera's preference settings, by selecting a different brand of colour film, or by adjusting the sliding scales for saturation and vibrance in your image processing software. More fundamentally, it can be strengthened by under-exposing or darkening the image, or progressively desaturated by over-exposing or lightening the image. Colour saturation is also decreased by the introduction (usually accidental) of lens flare, or by poor quality lens coatings. There's clearly a big temptation to over-egg the pudding with colour saturation, judging by the over-abundance of terribly gaudy photographs I've seen in portfolios and as entries to competitions. (This, and the over-application of Unsharp Mask, are perhaps the most abused tools in the kit of the modern digital nature photographer.)

◄ *Far from being bland and colourless, this decidedly monochrome scene actually concentrates attention on the design of the image, while the backlight helps the reed warbler to stand out from its background. Uniformity of colour can strengthen composition, and allows us to appreciate other elements in a photograph that might otherwise remain obscure.*

▶ *A black-and-white conversion emphasizes the graphic qualities of this portrait of a preening chinstrap penguin, and give it a certain timeless feeling. It was originally photographed in colour and converted in post-production, making use of the powerful channels adjustments in software to optimize tonal values.*

MONOCHROME AND BLACK & WHITE

Some of the strongest photographs we can create depend on a uniformity of colour – monochromatic images, making use of a very limited colour palette or tonal range. Such treatment can bring other aspects of composition to the fore, drawing attention to shape and form, pattern, nuances of light and shade, and may subtly enhance the beauty of the subject. Monochrome can be very expressive and powerful, and the ultimate manifestation of monochrome is the greyscale or black and white image. Black and white photography records only the lightness value of a colour (grey), not its saturation, whether or not it's shot in black and white or converted from a colour file – and that's now so easy to accomplish after the event you don't need to carry two separate camera bodies with different films in them. Digital photographers are re-discovering the great potential of black and white for a less literal interpretation of a subject, and you can see that I've embraced it in several works in this book where it felt appropriate.

Ultimately, photography is all about managing the light. Sensitive consideration and application of light and colour can transform our photographs from the ordinary to the extraordinary; used sympathetically, it can evoke a mood or trigger an emotion that geometric design alone can't convey. For example, the reed warbler above demonstrates how a dull, brown and exceedingly common bird in a dull, brown landscape can suddenly take on a new dimension, simply by paying attention to lighting conditions. I see this as one of the most creative and spiritually rewarding outcomes I can aspire to in my photography – much rather this than a comprehensive catalogue of identically lit and similarly composed wildlife portraits, however rare and exotic the subject may be.

FILTERS

Digital photographers have less need of camera filters than film photographers. Colour conversion and colour balancing are now routinely accomplished through alterations to white balance, while the effects of coloured filters formerly used in black and white photography have largely been superseded by much more powerful and comprehensive channels adjustments in the software. Neutral density (ND) filters are useful for slowing down shutter speeds with creative long exposure techniques. Various graduated ND filters also come in to play particularly with landscape photography, for toning down bright skies and balancing with shaded foregrounds. However, increasingly we are finding these facilities incorporated in to camera systems and image processing software, so they too may become redundant in time. Special effects filters (star bursts, etc.) are generally discredited as gimmicky, but one type that might have some merit is the family of soft focus filters, most often used in portraiture. The one filter I still regularly carry with me is the circular polarizer, for reducing glare from reflective surfaces and darkening blue skies on sunny days. This is most effective when used perpendicular to the direction of the sun.

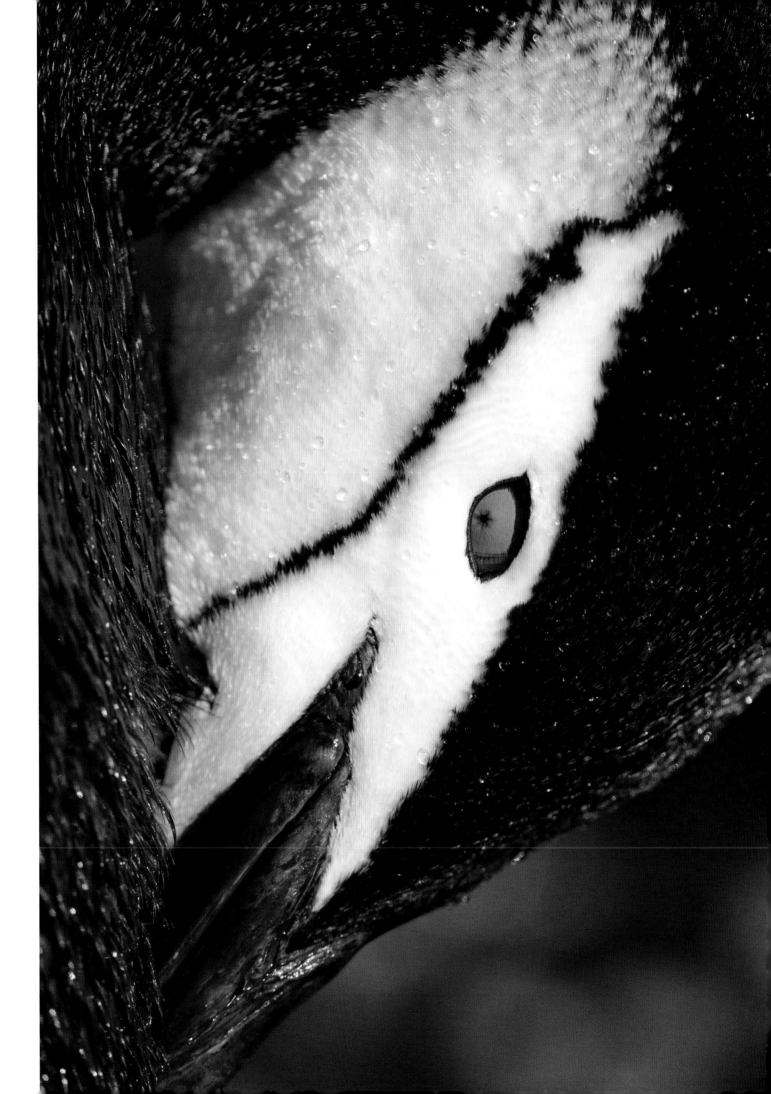

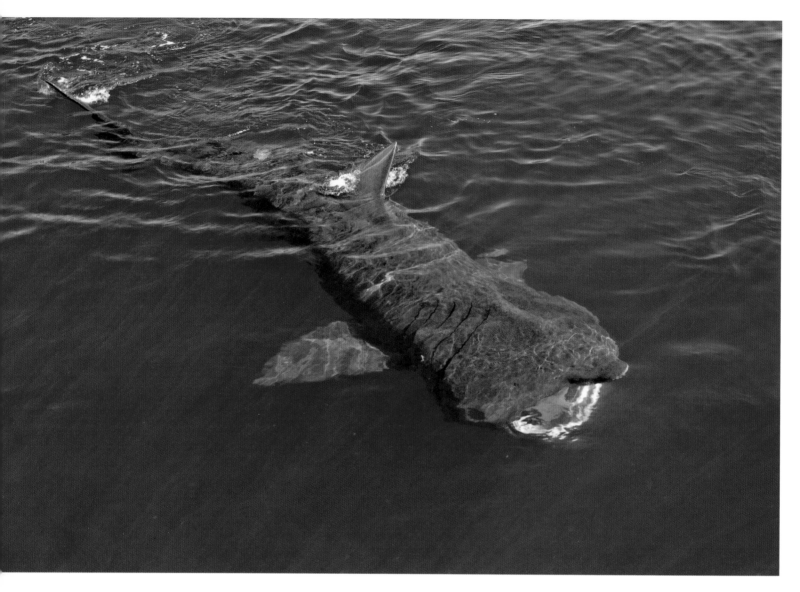

▲ A basking shark filter-feeding close to the sea surface. Reflections have been controlled by using a circular polarizing filter on the front of the lens – one of the very few filters I use in my digital photography.

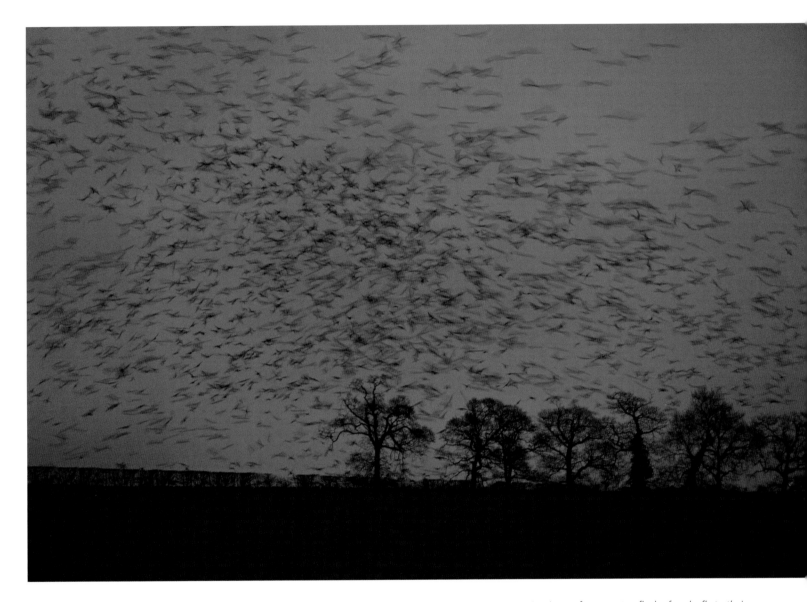

▲ Long after sunset, a flock of rooks fly to their winter roost from the surrounding arable farmland. This sort of low-light photography demands long exposures and high ISO settings, but the image noise and cold winter light help to create a mood. The high-gain capabilities of digital capture are opening up many more opportunities for extreme low light photography.

Seizing the Moment

The creative act lasts but a brief moment, a lightning instant of give-and-take, just long enough for you to level the camera and to trap the fleeting prey in your little box.
Henri Cartier-Bresson

Having considered the dimensions of space and light in photographic composition, we now turn our attention to the matter of time. The timescale that concerns us extends from the brief duration the camera shutter is open and the exposure is made, through the time devoted in total to a particular shoot, to the entire span of a photographer's career – and ultimately to the cultural transmission and influence of photographs down the generations (well, perhaps for a very few of the most memorable). A long time, then.

TIME COMMITMENT BY THE PHOTOGRAPHER

To any photographer of the natural world, time spent waiting can be at least as important as that spent actually making photographs. Waiting for the sun to break through a storm cloud, waiting for the whale to breach, waiting for the best year for autumn colour in living memory. So waiting should never be dismissed as 'wasted' time. As well as being an agent of discrimination, allowing you to take a creative decision about the precise moment you wish to immortalize, those accumulated spells of supposed inactivity translate into experience. This in turn should lead to effective anticipation. It is valuable learning time, facilitating the gradual evolution of fieldcraft through personal observation and adaptation of our own behaviour. Our cumulative experience in the field teaches us to recognize vital signals and cues about seasonal patterns, and therefore how to prepare for our future photography and, crucially, when to go back. We learn when a particular plant flowers at a given location, the typical migration time of a species of bird, or the onset of the rut in a population of deer. At the micro level, we may observe examples of repeat behaviour – perhaps the realization that a bird always takes off into the wind, or that a bathing session will inevitably be followed by a vigorous shake of its feathers. This repetition is the key to us being able to predict an event and prepare for it, anticipating how a scene is likely to unfold.

◀ *Shades of autumn in an aspen woodland in Catalonia. A long wait for the photographer, good planning or fortuitous timing?*

Probability theory also has relevance here, or what some photographers like to call 'luck'. The mountain hare is one of those mammals I've never had much luck with, partly because I don't live near to any mountains. In contrast, some photographer friends seem to do much better with them, and tell me that you just have to find the compliant animal that pretends to be a snowball as its defence strategy, rather than run away. Suppose one in a hundred mountain hares fall in to the compliant category. On average I'd have to encounter a hundred hares to get one photo opportunity. I might actually find that perfect sitter after just a handful of attempts, but on the other hand it might take two or three hundred encounters, purely out of random chance. This will average out when you begin to apply it across the many subjects you attempt to photograph over your lifetime, so clearly the effort you put in is a significant factor. Effort multiplied by skill is the most effective formula, or as some people say, 'you make your own luck'.

We've already seen that skill has to be acquired over time. What all this amounts to is that you have to be prepared to commit your time in order to become a successful, independent and original wildlife photographer. I suppose this is the single most common observation about the personality traits of our kind: 'You must have a lot of patience.' Indeed.

Not everybody feels they have the necessary time to devote to wildlife photography from first principles like this.

Finding wildlife to perform on demand is always going to be an unrealistic expectation, which is why so many people depend on the organized tour or pre-baited, rented site to maximize their photographic output per day of holiday. This is quite understandable, but it's not generally the best route to originality or artistry. Instead, you might consider whether time spent in quiet contemplation of nature close to home can deliver equally interesting photographs. The sheer accessibility and abundance of flower and insect life, for example, allow greater opportunity to make photographs without wasting time on travel. It's a massive and relatively untapped resource for the observant wildlife photographer, and offers great potential to build a portfolio, and simply to be different.

◄ A common curlew feeds in a saltmarsh creek, just as the last rays of winter afternoon sun spotlight the marsh samphire and the curlew's plumage. It helped that I knew this location, the bird's typical foraging routine, and how the light would behave. So the picture had already been taken in my mind before I arrived at the scene. When everything appeared to order, I just had to wait for that split second when the bird orientated itself to the light. But I'd passed here on dozens, perhaps hundreds, of previous occasions without the same luck.

▼ Lucky breaks can happen, but success is much more often proportionate to effort. This is one of those few mountain hares that elected not to run away, but it was only found after many previous fruitless attempts.

CRITICAL TIMING

In the shorter term, capturing the definitive instant (Cartier-Bresson's 'decisive moment') is clearly vital to success in wildlife photography. To preserve the very essence, spirit or 'jizz' of your subject in a fraction of a second is no mean feat – so much more demanding than recording a movie sequence, but so much more eloquent when done well; successfully selecting and plucking out that infinitesimal slice of time, a miniscule extract from the history of the universe that seeks to convey some eternal truth. It gets to the very essence and magic of what we do – and, incidentally, one big reason why I'm not very interested in making movies. Many of the images chosen for my Case Studies demonstrate the significance of precision timing, which is probably why I selected those few out of thousands of possible candidates.

So timing is crucial; making the instant of your photographic exposure coincide with some interesting behavioural activity; such as the moment the eagle's talons strike the prey, the apogee of the wolf's leap across the stream, or the unfurling of the chameleon's tongue. More subtly perhaps, the slightest turn of the head, the tiniest glint in the eye, or the softest kiss of a ray of sunshine. And to achieve this, you need to allow for the delay in your own reaction time, and the additional time lag from when you press the shutter release button, to the mirror lifting and the shutter opening. With lever wind film cameras, this could be very tricky indeed. With many digital compact cameras, there is still a delay between pressing the shutter button and anything actually happening, so they aren't the most suitable for action photography. But the invention of motordrives and digital high-speed bursts have been invaluable to us, while the relatively low cost of digital compared to film encourages us to be profligate when taking photographs. This isn't an endorsement to be totally indiscriminate, or to adopt the machine gun approach in every situation, but there are certainly occasions when a judicious salvo in the continuous high-speed release mode can make the difference between success and failure.

I tend to leave my camera set to continuous high speed release by default, so I'm ready for any action sequence or burst of activity suddenly developing. Then if I want to take a landscape or flower shot, for example, there's plenty of time to switch to low-speed or single-frame mode. Yet even at burst rates of 10 or 12 frames per second, it's surprising how often you narrowly miss that critical moment. You can do everything right, but matters are still out of your absolute control. You manage to catch the moment of the blink, or a wing across the head, or one of a thousand other things that can go 'wrong'. Uncanny!

Some of this can be overcome in the subsequent editing – deleting all the rubbish – but this can be pretty tedious, which is why I recommend being selective about when to use the high-speed setting, and ending the sequence at the earliest sensible opportunity. It should never be used in place of keen observation and fine judgment. Jim Brandenburg's famous response to this perceived abrogation of artistic skill can be seen in 'Chased by the Light', a project in which the photographer allowed himself to take only one frame per day over a period of three months. An interesting concept and self-imposed discipline, which might constitute a useful exercise for many others, whatever their level of experience.

▶ *A Eurasian otter pauses in the kelp at low water, looks over its shoulder and makes momentary eye contact with the camera. This critical engagement with the subject depends on perfect timing of the exposure.*

Other than inaccurate focusing, camera shake is the most common cause of blurry photographs. Conventional wisdom states that to overcome camera shake when hand-holding your camera, you need to use a shutter speed at least as fast as the reciprocal of the focal length of the lens – so with a 500mm lens you would need to use 1/500s or faster to ensure sharp shots, even with a stationary subject. If you are already using the lens at its widest aperture and can't achieve that speed in the available light conditions, then you need to increase the ISO speed or light sensitivity setting in the camera. Other ways to help overcome blur from camera shake include: placing the camera on a tripod or monopod, a bean bag, or other means of solid support; using a cable or remote shutter release in combination with that support; using mirror lock-up facility to reduce vibration at slower shutter speeds; engaging gyro-powered image stabilization technology.

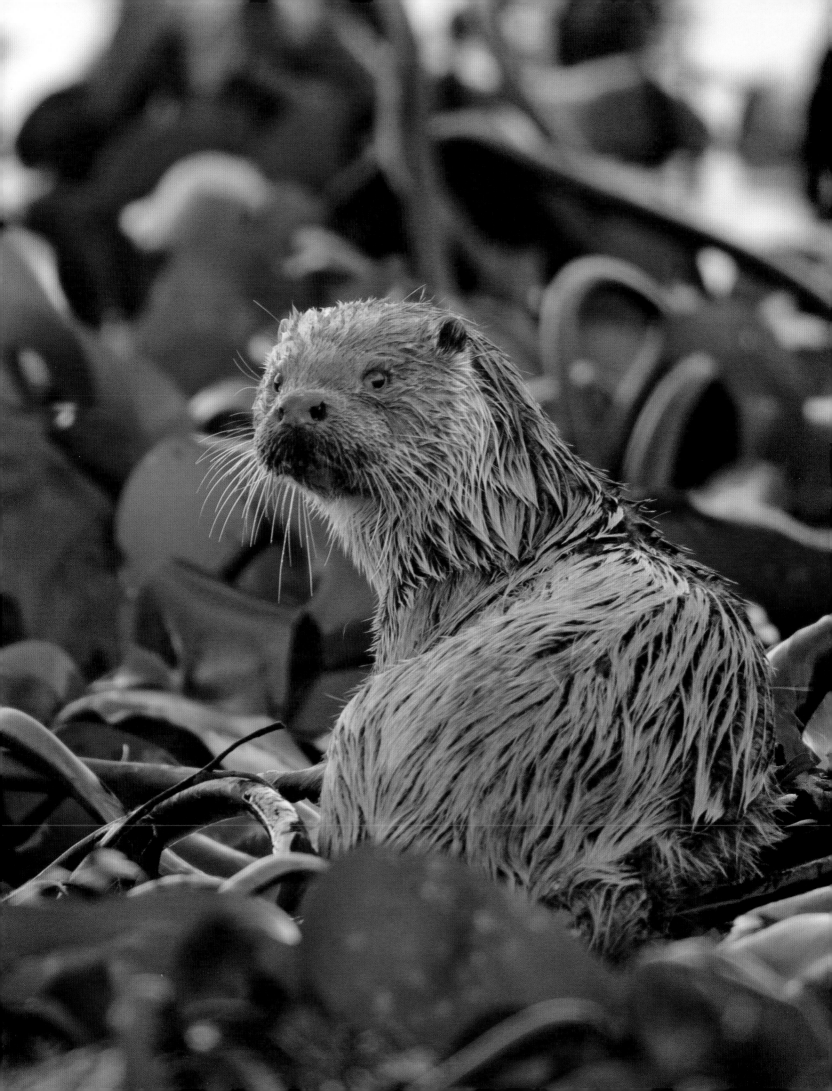

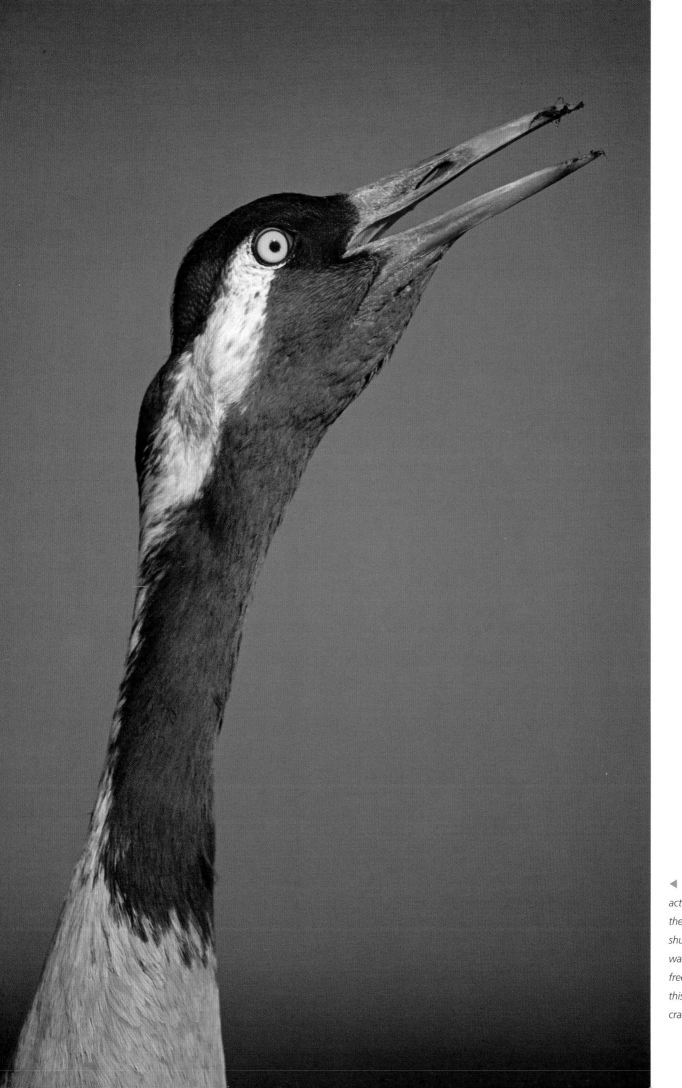

◄ Synchronizing the action with the moment the shutter opens. A shutter speed of 1/250s was fast enough to freeze the action with this bugling common crane.

ACTION PHOTOGRAPHY AND INTERPRETING MOVEMENT

With moving subjects, our most important decision is the selection of shutter speed and how we exploit it to express subject movement in a still photograph. Do you want to stop the action and reveal everything in sharp detail? Then use a short exposure (or fast shutter speed, in other words). Modern cameras can easily achieve speeds down to the thousandths of a second, brief enough to capture most commonly encountered events in nature. The results can be sharp, dramatic and revealing, showing us things we couldn't otherwise see with the naked eye in real time, and allowing us to study them in detail at our leisure. But a living creature suspended in time, and forever frozen in that fixed position, can look pretty solid and lifeless. Some might say it's a cold analytical approach to the subject, lacking in soul or poetry. We never really see things like this, even if we think we do, because the interval is simply too brief to register. Nevertheless, this remains one of the core techniques of wildlife photography and also

one of its great strengths. We just have to be discriminating about whether it's the best choice in a given situation, whether it expresses what we set out to show, and whether it suits the eventual purpose.

To invoke continuity or fluidity in movement you would select a long exposure time – that is, a slow shutter speed. Additionally, you have the choice of whether to keep the camera still during that exposure or to move it – panning with the subject, for example, to preserve relative sharpness in some elements of the picture with motion blur in others. To many, this kind of treatment gives a better impression of speed and movement, even if it's at the expense of fine detail, and perhaps more closely approximates to our memory of an event – a collection of fleeting impressions in which only a few key features are perceived. Freeman Patterson likens it to something seen in a dream.

The motion blur interpretation involves much trial and error, and while you can't be sure precisely how things will record in camera, with experience you can make good, informed

predictions. Expect to face difficult choices in editing, and there will inevitably be discards – but then that's also true for fast shutter speed work. With a flying bird or running mammal, you might typically choose to work within a range from about 1/15s to 1/60s, but much depends on its size, speed and proximity to the camera. This is just a recommended starting point, and you will need to experiment. Assuming your subject is moving at a fairly consistent speed in one direction, then panning the camera synchronously through the exposure should deliver relative sharpness in the moving object. This will give you linear motion blur in the background, and more erratic traces of anything moving across the panning axis. Clearly a good tripod head can assist with the smoothness of the pan and improve your success rate. Image stabilization can also help to eliminate any blur from camera shake, though not of course from subject movement. You also have to discipline yourself not to stop the camera and try to hold it still for the moment of exposure, as you normally would – a difficult habit to break. Such photographs also tend to be more successful with a good tonal or colour gradation in the background, and interesting lighting effects such as bright reflections off water.

In situations where the movement you are interested in is more erratic or of much longer duration, then it's probably best to keep the camera stationary and allow the moving elements to create their own traces. For instance, when photographing a waterfall, the spray created by a bathing animal, breaking waves on a shoreline, trees swaying in the wind, or star trails across the night sky. Now we might be talking about shutter speeds of several seconds or even many hours. And if you can't achieve the length of exposure you'd

SHUTTER SPEED

From the earliest days of photography, it was realized that camera exposures of very short duration could reveal things that were beyond the capability of the human eye and brain to resolve. In the late nineteenth century Eadweard Muybridge conducted photographic studies of locomotion in animals and humans, most famously to demonstrate the sequence of a horse's gallop, and to settle once and for all the argument about whether all of its feet left the ground at the same time. Later, Jacques-Henri Lartigue would pioneer the use of fast shutter speeds to capture scenes of motor racing and make playful pictures of people leaping, frozen in unlikely and amusing mid-air postures. After the Second World War, the development of the focal plane shutter and single lens reflex camera enabled faster shutter speeds to become routinely employed in wildlife photography, so that action photography became a realistic possibility for the amateur and enthusiast. Today we can expect to find shutter speeds as fast as 1/8,000s available on our DSLR cameras. Typically, we might need to use a shutter speed of around 1/250s to arrest a walking animal or singing bird, something nearer 1/1,000s for a bird in flight or a fast running mammal, while it would take at least 1/10,000s to make a sharp shot of the wings of a hovering hummingbird or large insect. For more specialist applications and even briefer effective speeds, high-speed flash techniques may have to be employed. The work of Stephen Dalton from the 1970s onwards remains unsurpassed in this field.

A common dolphin bow-riding alongside our ship, and photographed at 1/3,200s to capture every detail in perfect sharp focus. Many frames of sharply focused sea, but no dolphin, were deleted in subsequent editing.

▼ *The same pod of dolphins a few moments later, here photographed at 1/25s while using the ship's speed to pan the camera through the exposure. I admit I like to have some safe shots 'in the bag' before I risk the more adventurous. Afterwards, the slow speed shot is the one I can look at for longest, and lose myself in.*

▼ *An Atlantic puffin approaches at high speed, but a shutter speed of 1/2,500s was adequate to arrest it in mid-air and preseve all the feather detail.*

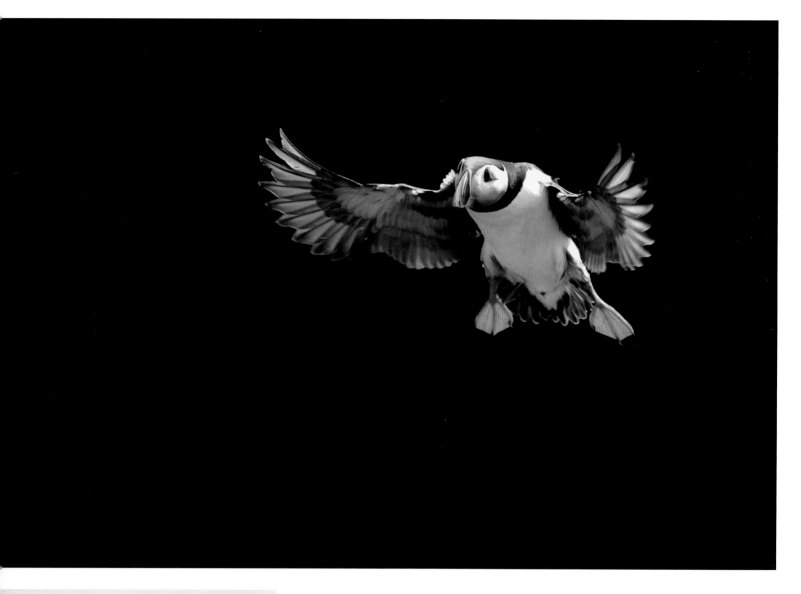

▼ At 1/500s, my chosen shutter speed was fast enough to stop movement in one axis (front to back), but not in the other (up and down) – so the puffin's head is sharp, but its blurred wing tips betray the furious speed of its wing beats. A pretty good compromise as it turns out, although the fussy background isn't as successful as the shadowy cliff face.

We might think of the streaky motion blur resulting from the use of a slow shutter speed as a modern idiom in wildlife photography, but ironically this device was employed by Impressionist painters to express the sketchy nature of movement, possibly as a result of them seeing early blurred photographs made on low sensitivity plates. This was exemplified by Claude Monet's *Boulevard des Capucines* from 1873. More remarkable still, the Chauvet caves in southern France feature some incredible Paleolithic paintings depicting woolly rhinoceros with multiple horns and eight-legged bison, presumed to be the artistic interpretation of fighting and running activity. So we're only 32,000 years behind the game – hardly avant garde!

While the motion blur technique may have been more widely adopted in sports and features photography a little earlier, with wildlife it didn't really gain momentum until the 1980s when the work of some adventurous Finnish and Scandinavian nature photographers began to feature it regularly. Even so, it would be another decade or so before Art Wolfe made it mainstream, most notably in his book *Rhythms from the Wild*.

really like simply by selecting your smallest aperture and slowest ISO speed, then you may need to add a neutral density (ND) filter to extend your range by several stops (or exposure values). A circular polarizing filter is always a good standby if you don't have a set of ND filters, increasing the exposure by about two additional stops, the equivalent of quadrupling the exposure time.

Very long exposure times can also be employed to make some relatively fast-moving objects disappear, if they would otherwise prove distracting or undesirable in the final image. So armed with this knowledge you might make a long exposure in a cave of roosting bats, moving about freely in the image area while illuminating the shadowy crevices with repeated bursts of flash light, but your presence would never be apparent in the photo. Combinations of slow shutter speeds and flash can be used creatively in other ways, most notably with the 'rear curtain' flash technique for moving subjects, whereby the flash burst is synchronized to the end of the shutter opening. This means that if you're using a slow shutter speed the sharp, flash-lit element of the exposure will precede any motion blur rather than the other way around. It would look weird with the streaky bits in front of the well-lit subject, which would be counter to our expectation.

▲ A spotted hyena on the move. It was photographed from a safari vehicle,
so the camera was hand-held and image stabilization switched on, while
panning during a shutter speed of 1/30s. The hyena is acceptably sharp, and
crucially so around the head, though there's obvious movement in the legs and
hindquarters, with most of the motion blur occurring in the background.

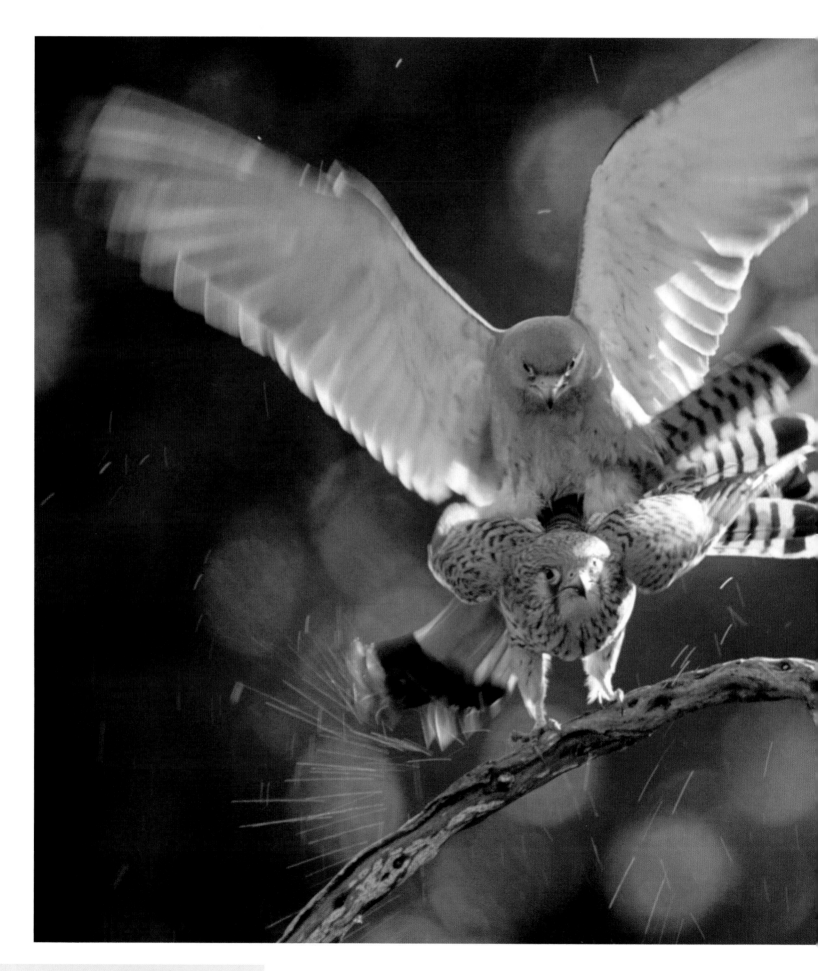

◄ A pair of lesser kestrels mating at first light, photographed from a hide with the camera on a tripod, and using a shutter speed of 1/15s with the intention of blurring the wing movements. However, with this old image shot on film I wasn't aware of the droplets of morning dew until after processing, a couple of weeks later. A pleasant surprise.

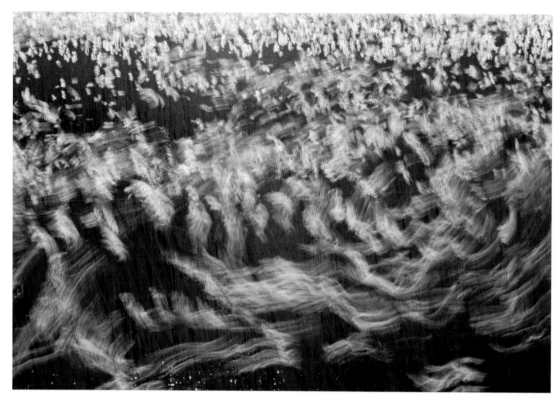

◄ On a very windy day, I kept the camera perfectly still on a heavy tripod and allowed the reeds to etch their own traces and pathways on the film, during an exposure time of around one second.

▼ Another windy day, and another occasion for a slow shutter speed in the beech forest – here about 1/15s.

IN THE FULLNESS OF TIME

After the event, we devote time to editing our pictures and post-production work. It generally pays to allow some time to pass before making that final call about what to save and what not. That distance can allow you to be more objective and less emotionally attached to images that really aren't as good as you hoped they would be. That can be difficult if you've just blown a lot of money on a long-haul foreign trip, or spent ages and ages on one subject that never really lived up to its promise. But sometimes it works the opposite way, and we later discover some hidden treasure that we'd somehow overlooked at the time – perhaps because of changing tastes, or our own natural artistic evolution. So don't be too ruthless in your editing too soon, and revisit your old image folders from time to time to review their content, and make a fresh cull if necessary or elevate that forgotten nugget to the favourites pile. Of course the other thing that happens is you get better at processing images with practice, and software developments will inevitably extend our future capabilities. Maybe in five or ten years on we can do a better job with the same raw material. It's a never-ending challenge.

There is a special durability about photographs of nature that transcends most other genres, because by and large they can't be identified with any particular epoch in the development of human civilization. Technology aside, the content is essentially unchanged. Attraction to that timeless quality is a huge part of why we do this. It might sometimes be confused with nostalgia, but it need not be backward-looking or sentimental. Rather, that very timelessness connects us to our ancestors and our need to re-connect with wild nature. It reminds us simultaneously of our responsibilities to the environment and to our descendants. Herein lies the power and appeal of nature photography.

The French philosopher Roland Barthes proposed the concepts of 'studium' and 'punctum' in photography. Good studium can be found in most well-crafted photographs; they can be perfectly well composed in the conventional sense, they can interest the viewer, but still be lacking in emotional engagement. Punctum (literally 'to prick') has the unique power to move the viewer because of some personal relevance or memory evoked, and may be found in some tiny and seemingly insignificant detail of a picture. This idea arose because Barthes recognized, in a very old photograph of his mother as a child, various elements that revealed her personality; certain mannerisms or a particular way of posing. The photographer could not have identified those very personal traits in his short meeting with the young girl, or calculated the effect it would have had on her son many years later. The lack of definition (the photograph was taken in 1895) was unimportant, and did not diminish its power. Punctum allows us to discover rather than simply recognize the subject, achieving what Barthes described as 'photographic ecstasy'. I'd like to be able to bottle some of that!

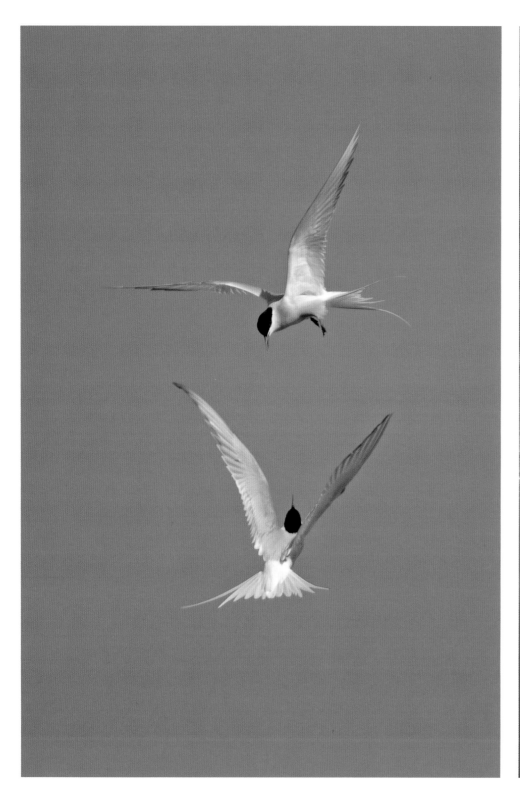

▲ *This elegant aerial ballet of a pair of arctic terns is one carefully chosen frame from a long sequence of awkward overlaps, headless birds and unfeasible wing positions.*

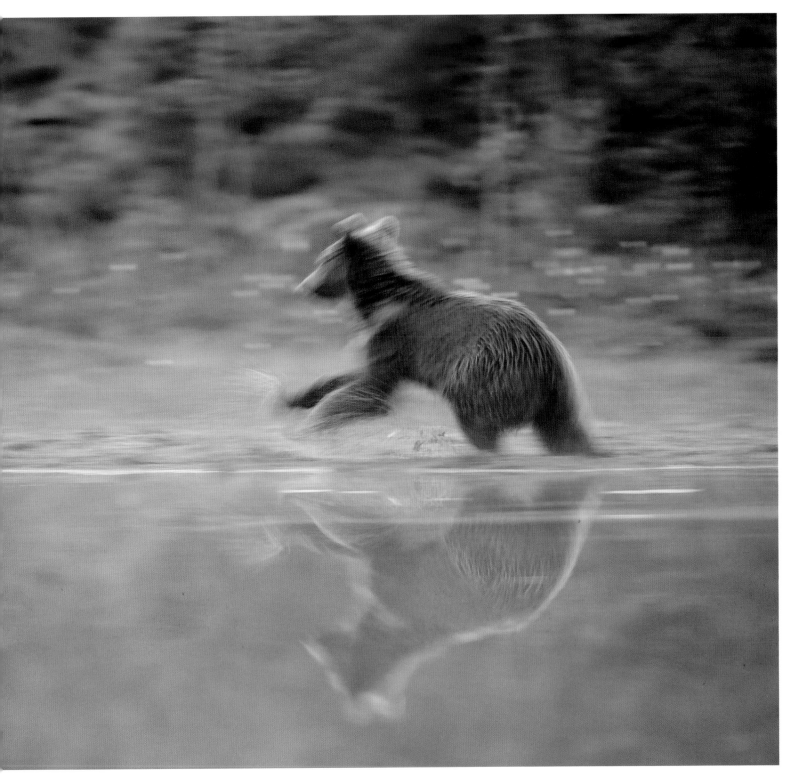

▲ A European brown bear cub runs alongside a
forest pool in the Finnish taiga – at about midnight.
With the available light, 1/13s was the fastest
attainable shutter speed even at ISO 1600. But it
would still have been a good decision, even if the
light had allowed for a faster shutter speed option.

Finding Your Voice

Fortunately, somewhere between chance and mysteries lies imagination . . .
Luis Buñuel

We have looked at ways of improving our basic fieldcraft, compositional technique and lighting skills, but what is it that really makes some photographic images of nature stand out from the crowd? How is it that we can sometimes identify an individual photographer from a quick glance of a previously unseen work? Think how many photographs must have been taken of, say, African elephants, over the years, and yet how many do we actually remember as being something special? And more to the point, can we identify what makes them so?

On the face of it, you'd think there weren't that many things you could do differently, given that we all work with very similar equipment. Yet put a hundred different photographers together in the same place for a finite period, and you'll get a hundred different visions and interpretations. It is true that the camera imposes technical limitations not faced by a painter or conceptual artist, but equally you could say that a composer only has twelve basic notes to work with, and that doesn't seem to have been any barrier to musical creativity throughout human history. Witness the formidable range of amazing compositions in that time, and the very different styles and movements that are still evolving.

Some years ago I used to edit the contributions of many of the UK's leading wildlife photographers to a well-known photographic agency. After a while, it dawned on me that I could distinguish the work of some of the individual photographers, even if the transparencies were face down on the lightbox, without the benefit of captions. I'm sure I was able to take some cues from the subject matter and locations, but let's be clear: these were recognisable authors with their own signature styles. Their personalities shone through even if I couldn't put my finger on the precise characteristics that betrayed them. It wasn't that one was clearly 'better' or 'worse' than another, but the fact that they had managed to establish a unique identity that fascinated me. The one thing that united them though, was an empathy with their chosen subject, and that's something you really can't fake.

So even if camera technology stood still, there would be an infinite number of ways to make fresh photographs. Even if you had only one species to photograph for the rest of your life, there should be no excuse for running out of ideas. The odd thing is, we photographers, nature and landscape photographers in particular, are more hampered by convention than

▼ *A barn owl hunting at dawn. Others tell me that the proportionately small subject is something of a trademark, or at least a recurring trait, in my photography. It's not an approach that's exactly ground-breaking and I can claim no monopoly, but it's gratifying to be recognized for it. And I hope that doesn't make me a one-trick pony.*

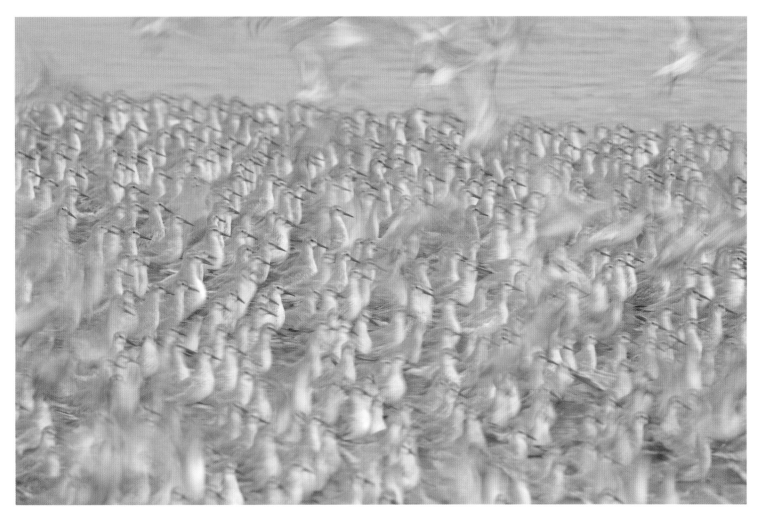

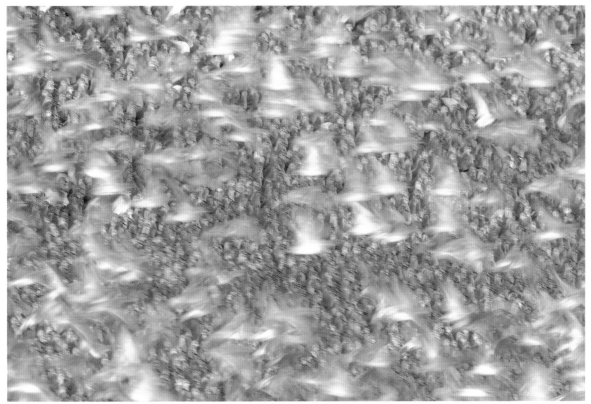

▲◄ One of my 'potboilers'. This roost site of red knot always seems to offer fresh possibilities of new photographs, and I can never exhaust my ideas before the next ones suggest themselves. It appears to have become a lifelong quest.

◄ *I love working at sea and have managed to create plenty of opportunities for it in recent years, so I've gradually built a collection of images of some recurrent wildlife subjects, like the common dolphin. This allows me to become more adventurous with each fresh encounter, and to take risks with some of those slow pan-blurs.*

most other visual creators. We tend to conform to stereotypes in an effort to gain the approval of our peers, achieve some spurious accreditation, or try to anticipate the needs of the market. An all-too-familiar consequence is that we are constantly re-inventing the same few photographs. Sometimes they can be almost indistinguishable from one another, and the original creator is long forgotten amid the plethora of imitations. So if we are to reveal something new, or depict something familiar in a new way, we have to shrug off some of those historic burdens and explore the possibilities of a fresh approach, have some ideas of our own, discover our expressive intent and ultimately aim to evolve a personal, distinctive style. In the end it's all about having original ideas, and seeing them through to their successful conclusion.

Not long ago I had to lead an elementary nature photography workshop for a class of seven-year-olds. It was a daunting prospect for me, not having any formal teaching experience, but their enthusiasm soon put me at ease. Unfortunately there wasn't much time for the field excursion to a local park, and all of the children had the same very basic digital compact camera set to 'programme' mode, so my expectations weren't high. But the results were quite remarkable, and considerably better than I would have thought possible. They just got on with the task in a completely unselfconscious way because they had no preconceptions of what was required of them. No social conditioning, nothing to un-learn, no stigma about having the wrong brand of equipment, no fear of making mistakes – just a fresh eye and that boundless curiosity of young minds. If only we could recapture some of that as adults.

The moral of this story is that the camera can get in the way of a good picture. If you're so absorbed in the mechanics of how to make the shot, you can be blind to the greater opportunity. You are distracted from what your subject is doing, you are not anticipating effectively, and not giving sufficient thought to your composition. For this reason, it is imperative that you attain a level of familiarity with your camera system so that you are in total command. It doesn't matter if you don't use every function available to you, as there are always many 'correct' ways to achieve the same end result, but it must come quickly and easily; it needs to be second nature. Cartier-Bresson quipped that your first ten thousand photographs are your worst. He also said that the camera is an instrument of spontaneity and its use should be automatic, like the changing of gears in an automobile. All different ways of emphasizing the old adage that

practice makes perfect, I suppose. But it's still only the first step on the road to innovation.

True originality comes with time, and reflects many life experiences: jobs you have done, people you have known, places you have been, books you have read, your interests outside photography, and so on. All will shape your ultimate output and stylistic development, whether consciously or not, so I'm not suggesting that you try to change life's natural course. The differences between us and our very individuality are what keeps it interesting. However, there may be ways to help accelerate the process of finding your voice, and to that end here are some suggestions for strategies you may care to adopt:

Draw inspiration from other wildlife photographers

We have all been inspired and influenced by other photographers in the course of our lives, and it does no harm to pay tribute to our mentors. If we can see further, it's because we stand on the shoulders of giants. However, we mustn't let it stop there, and we should continually be realigning our sights, always ready to learn. Humility is an important factor here. We mustn't let envy or professional rivalry prevent us from seeing good in the work of our contemporaries, and according it due respect. Similarly we need to be on our guard that the complacency and cynicism that naturally come with age shouldn't blind us to the fresh ideas and accomplishments of a younger generation of photographers. Allow yourself to get excited about the achievements of others, and keep that flame alive. One way to do this is by attending one of the many international wildlife photography festivals and symposia that often feature top professionals as guest speakers.

Research the existing body of work

Choose a wildlife subject you might like to work on, then proceed to seek out every photograph you can find on that subject. Go to the exhibitions and galleries, scour the online image libraries, browse the books, magazines and the competition portfolios. Which aspects of your nominated subject's life history are not well documented? Have all possible concepts, angles and perspectives been exhausted (I doubt it!), or can you think of some new approaches? Whose work do you most admire? It's almost inevitable that you'll find somebody has already made it their own life's work long before you came along. Don't despair and don't set out to emulate, but think of ways you might do it differently, how you might improve on it.

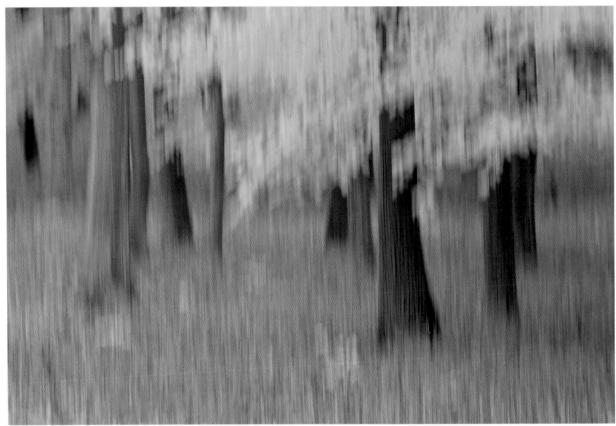

Three studies of a bluebell wood in spring. The first is purely representational, and the kind of shot which might be used to illustrate a practical handbook on the management of broadleaved woodlands. Using various abstracting devices, we might wish to explore ways we can corrupt the straight picture, for better or worse. These might include, but aren't limited to: the use of a soft focus filter; applying Vaseline or hair spray to a skylight filter; stretching a piece of sheer black silk stocking across the front element of the lens; making multiple exposures on a single frame (perhaps refocusing or moving the camera between exposures); moving or rotating the camera during an exposure; zooming the lens during an exposure. It's best if I don't say exactly what I've done in each case here because it will be much more meaningful if you work it out for yourself. These new versions are somewhat more abstract and emotional expressions, which say more about what it felt like to be there and experience the forest and the atmosphere of a spring morning – infused with the scent of a million bluebells and the remembered song of willow warbler and blackcap.

▲ *A miniature forest of moss capsules. Looking local and working in close-up can reveal whole new worlds and a great (largely untapped) resource for creative photography.*

Study other genres of photography

Always stay alert to what's going on in other fields of photography, and how the news, fashion and sports photographers for example like to compose their images. Can you learn anything from them? Do you like that jaunty angle and tilted horizon, or the after trace caused by the rear-curtain flash? And if so, is it a technique that is transferable to the nature genre? Just because others in your field don't seem to do it isn't sufficient reason not to try. Adapt, refine, improve.

Embrace new technologies

Nothing stands still for very long in the field of camera technology, and we're frequently gifted with fantastic new devices and features. Welcome these developments and waste no time investigating how

they can be put to good use – not to make life easier for yourself or to take shortcuts, but to test the boundaries, to find out what's achievable. For instance, advances with auto-focus systems, noiseless high ISO performance, and faster focal plane shutters were all welcomed for their more obvious singular benefits to wildlife photography. But it took a few perceptive and adventurous individuals to realize that the combination of these features suddenly allowed them to contemplate flight shots of butterflies and dragonflies in the wild. Of course it's still not easy, but it was previously impossible without high-speed flash and studio conditions. However, just because you have the technology doesn't mean you have to use it – you should still be discriminating.

Explore the process of abstraction

Try to look beyond the purely representational approach to wildlife photography and experiment with those long exposures, black and white conversions, multiple exposures and suchlike. Do the results express what you feel any better, or come closer to what you want to

say? The series of photographs of bluebells on pages 118–19 gives some ideas of techniques you can try, but there are no rules here and some approaches might work well with certain subjects but not others. Adapt and develop them to suit your own methods of working. Don't just jump on any bandwagon, and don't confuse gimmicks with creativity – the usual round of wheezes that are often hyped as 'tricks of the trade' in the magazines can so easily appear superficial and insincere.

Play to your strengths

It might just be that you live in a remote group of islands or in a national park, and you therefore have fantastic access to some unique wilderness, outstanding scenery and charismatic wildlife – but most likely you won't, so you'll have to find another way to carve a niche. Rather than curse your bad luck or try to swim against the current, look to your undoubted natural advantages and strengths. Perhaps you have some specialist knowledge or training, your job takes you to interesting places, your family has a farming connection, or there's that place you always go on holiday. Maybe your employer has an environment programme or supports some corporate responsibility conservation initiative – and if they don't, perhaps you could persuade them to start one. There are surely some personal circumstances that make you well placed for obtaining certain types of photographs others can't reach so easily. And if they're not immediately apparent, start work in the garden or local park.

Adopt a home patch

As a natural adjunct to the previous section, and at the risk of repeating myself, look local. It's the cheapest place to make mistakes, for a start. The familiar is so often overlooked and neglected; you'll be amazed how a little time spent photographing in your backyard can open your eyes, and teach you how to see rather then just look.

Embark on some lifetime projects

Some combinations of subjects, locations and creative ideas persist in our imaginations for years, waiting for the opportune moment to realize that 'perfect' image. These potboilers tend to be among our most ambitious undertakings, but their demanding nature means they have to be periodically set aside and then revisited later. Build on your successes, learn from your failures and adapt your plans accordingly, always working towards that final goal. You never reach it (or if you do, that's the time you've given up!), but sometimes you may come close.

Keep an open mind

Take an interest in cinema, music, literature, dance, poetry or Japanese Noh theatre – it doesn't matter what, but try to be open to new influences and creative ideas from all kinds of artistic disciplines which don't on the face of it have any connection with wildlife photography. It's surprising where you may find relevance and inspiration. And consider working with other artists from time to time – painters, writers, poets, sound-recording artists, composers – who share your interest in nature and the environment. It's more likely that you can work together as equals and cross-fertilize ideas, rather than view each other as rivals as you might if working with another photographer.

Plough that lonely furrow

Have the courage to work alone sometimes, follow your own path, and take pictures for your own enjoyment rather than to fit the expectations of others – so you're not always working to competition criteria, the rigours of some formal qualification, what you think might sell or what you know your mates in the camera club will like. Learn to trust your own judgment. Don't believe your mum! If you can obtain some objective feedback on your work from a professional photographer or picture editor, or from a fellow artist, then this might bolster your self-confidence and help you to evaluate your progress.

When life deals you a lemon – make lemonade

None of us enjoys being stuck outside in the cold and wet, and we can get precious about our expensive equipment, but it's all too easy to give up in the face of adversity. Try to turn prevailing conditions to your advantage rather than blame the wind, rain, light or whatever. For example, a breezy day might have put paid to your plans for close-up flower studies, but why not exploit it by making some slow shutter speed shots of windblown flowers, trees or reeds? On another day, low cloud has shrouded the mountains you'd hoped to photograph, but the soft light might be ideal for some well-saturated close-ups. Sometimes it's more about spontaneity than careful planning, and being alert to opportunities that present themselves quite suddenly. The chance encounter can be a blessed moment if you're at least half prepared for it.

Take risks

Sometimes you have to allow yourself to make mistakes, and that's a healthy thing in any creative pursuit. As the educationalist Ken Robinson puts it, 'if you're not prepared to be wrong, you'll never do anything original'.

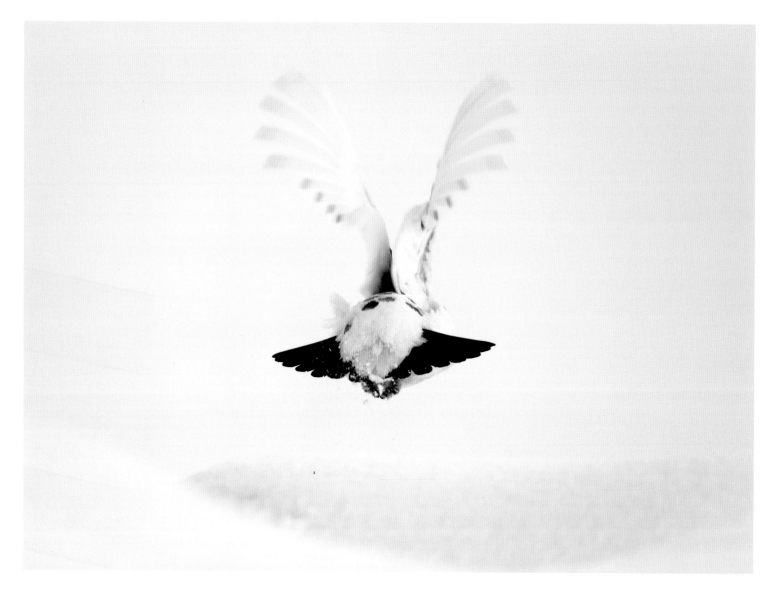

▲ *Snow angel. Back end views of fleeing birds
and animals tend not to make terribly successful
photographs. This rock ptarmigan exploding in
to flight seems to constitute a rare exception,
resembling as it does the shape a gleeful child might
make in a fresh snowfall.*

Do what you love

This is one you just can't duck. I'd be useless at photographing American football, aeroplanes, or ancient buildings – because I'm just not interested. Those who are will always do a better job than me. You'll probably end up with a specialist subject area whether you intend it or not (guess what mine is) and hopefully there will be people who admire your work and forever associate you with that specialism. This shouldn't prevent you from trying to re-invent yourself and exploring related subjects at intervals, but always remember your first love.

In the end, the act of expression will come down to your own personal vision and an extraordinary amount of self-belief, often in the face of criticism and disapproval. We all experience sporadic crises of confidence, and in such moments I like to take comfort from the words of the artist JMW Turner. When confronted by a woman at one of his exhibitions who remarked 'I don't see clouds and water like that'. Turner replied, 'Don't you wish you could, madam?'

▼ *Actually a telephoto view of a mountain side, but at first glance there are similarities with the pattern of a butterfly's wing. The loss of apparent scale leads to a level of abstraction and therefore makes demands of the viewer. See Exercise 7 overleaf.*

PRACTICAL EXERCISES

1 It can be difficult to imagine how a three-dimensional scene in real life will translate into two dimensions once photographed. Try closing one eye to flatten the landscape, so that you temporarily lose stereo vision. To further train your eye in making selections in 2D, adopt an old slide mount or make a card cut-out with a rectangular aperture in the 2:3 aspect ratio (or whatever ratio your camera employs). Held close to your eye, it will simulate the picture taking view of a wide-angle lens. Held at arm's length, it will approximate to a long telephoto.

2 For one day's field outing, discipline yourself to shoot everything with the same, fixed focal length lens. It's probably best to start with a standard 'kit' lens of 50mm or its digital equivalent. Repeat the exercise with lenses of different focal lengths. Then again, see what you can achieve with a simple compact camera – explore its strengths, such as its ability to get into tight corners, close focusing potential, extended depth of field – and exploit these to the full.

3 Find a compliant subject, which needn't be a wild animal, and experiment with different camera viewpoints. Take ten shots of the same subject on a telephoto lens (say 300mm or greater), each from a different camera position, paying particular attention to the effect on the background and foreground.

4 Shoot a series of subjects against the light, both with and without a lens hood. How does the lens flare behave in each instance, and how does it respond to different lens apertures. Does it add to or detract from your picture? Where the effect is particularly strong you will need to find a way to cast a shadow over the front element of your lens, if you wish to reduce it. (Take care not to point your lens directly at the sun.)

5 Select a small study area at random – say a small garden, or an area of shore or park land, but no larger than the size of a tennis court. Then in a fixed time period of one hour, make as many different photographs as you can of as many different subjects as you can find, without leaving the study area. Stick at it, and don't give up until at least an hour has passed. Lie on your back, climb a tree, jump in the air – do what you think is necessary to bring variety to your portfolio.

6 Point your camera at a flower meadow, reedbed or woodland scene. Then gradually de-focus your lens and explore the potential for wacky, abstract photographs. A good tip would be to try shooting into the light. How about multiple exposures on the same frame, maybe altering the focus points between exposures?

7 Take a series of landscape photographs with no sky in shot – 'inner landscapes' if you like. You will probably need a 200mm focal length lens or greater for this task. Try with both hilly and flat landscapes. By excluding the horizon, you are forced to look for pattern and form and what's visually significant in the scene, rather than default to the cheesy snapshot.

8 Discipline yourself to use an 'unconventional' lens for a given subject. For example, try using a telephoto for a flower or butterfly, a wide-angle for a bird or mammal.

9 Break the classic rules of composition. Make some photographs with a tilting or centred horizon, place your subject right in the corner of the frame, include lots of out-of-focus foreground or 'empty' space, or focus selectively on the unexpected. And then think of some more bad deeds.

10 Set out to find and photograph six naturally occurring subjects in the wild which exhibit the three primary and three secondary colours – red, blue, yellow, violet, green and orange. Once you've done that, move on to look examples for the three complementary pairs of red/green, blue/orange and violet/yellow.

11 Look within the outline edges of your plant or animal subject. Move in progressively tighter, perhaps rotating the camera, and varying the lens aperture, until you achieve a satisfactory composition. How many interesting variations can you make?

12 Move your camera during a series of long exposures of a static scene, varying the shutter speeds. What effect does this have on horizontal and vertical lines, multicoloured versus monochromatic scenes, or specular highlights? Are the results better with or without the camera mounted on a tripod?

13 Shoot a series of moving subjects with slow shutter speeds (say 1/60s down to 1s), both panning with the subject and keeping the camera still. For the purposes of this exercise, your subject may be a pet dog, a friend on a bicycle, a high-speed train – use your imagination – but vary the size, distance and speed of the subjects.

14 Make a portfolio of all twenty-six letters of the alphabet, by exploring the environment for naturally occurring examples that depict each capital letter form. These might be found in geological formations, the branches of a tree, the veins on a leaf, or the eye spot on a butterfly wing. You will need to consider all sorts of focal length lenses and viewpoints, cropping options, light conditions and so on to get the most convincing results. Don't expect to complete this in one day!

◄ Another angle on the bluebells. Here I have taken an old manual focus macro lens and deliberately pointed it in to the light and de-focused, while the lens diaphragm was set at its maximum aperture. I confess I have no idea as to the technical explanation for the strange ghosting effect – except that it looks to me like shadows being cast on the internal lens elements – but I know I am excited by the resulting image. See Exercise 6.

▶ *Looking up towards the tree canopy in a beech woodland in autumn. The pattern of branches I saw reminded me of forked lightning, so I looked for a composition to emphasize that and enhanced contrast to reinforce the similarity.*

Telling Stories

Soft as some song divine, thy story flows.
Homer

THE SINGLE IMAGE

So far we have been largely preoccupied with the creation of relatively straightforward still images of nature and wildlife. Many of them are purely representational and illustrative, some tending more to the abstract. The best can act quite powerfully at an emotional level, and I wouldn't want to diminish them or the valuable rôle they have to play, but they're not necessarily good at communicating more complex messages. The critic who doesn't get wildlife photography might justifiably remark 'Yes, it's a pretty picture, but so what?'

Practitioners in other genres of photography are quite used to discussing the subject of semiotics – the opportunities for incorporating meaning and connotation in to our images. Now admittedly it's much easier to be ironic or allegorical if you're photographing people and working in the field of social documentary, but that's not to say that we can't introduce some of these ideas in to our wildlife photography. Especially if we want our pictures to be noticed and have an impact, and especially if we want them to be relevant to people and to what's going on in the world.

Although we naturally lean to the celebratory image because of our love of nature, there's a definite temptation to idealize our subjects and this might sometimes be at the expense of a greater truth. You'll see that in all the photographs I've used to illustrate the preceding chapters, there's almost no evidence of the influence of Man on the environment. Surely this misrepresents the true state of affairs? Are we just being escapist, seeking refuge in some mythical, unspoiled world? Do we really have nothing more to say on the matter? We'll return to this topic in 'Saving the Earth'

(pages 138–45), but as an illustration you can see how the photographs of the yellow wagtail on the midden heap and the tiger with the tourist jeeps work to engage the viewer and to introduce topical issues. Making reference to human society in our wildlife photographs is the most obvious way to add connotation. It makes us think and prompts enquiry; in these examples, about farming practice and ecotourism.

You can also see how many of the photos selected for the Case Studies (for example, the puffin, the tiger, the rook, the snails) leave a question hanging in the air that arouses the curiosity of the viewer. You look for some explanation, and if that's not immediately apparent in the photo this leads you to the caption – and if it were a newspaper or magazine you might then want to go on to read the main article. This is perhaps the simplest way to introduce a story when there's only room for one photograph, but that's not to say it's easy to spot the opportunity at the point of taking the picture. Certainly you can use composition and intelligent framing to spark an interest, often by leaving something out – bestowing your pictures with the power to intrigue.

CONTEXT AND AUDIENCE

A well-recognized limitation of the single still photograph is that it lacks context; we don't know what happened before and after the photograph was taken, and we can't see what was going on just out of frame. While this can be viewed as a creative tool when taking photographs as stand-alone works, if the purpose of the photograph is to illustrate an article in a publication then we must be much more attentive to context and its bearing on truthful reporting. There was a good example of this in the British

▶ *People have felt the need to share their tales and impressions of the wildlife around them since long before the advent of written language. These ancient rock engravings at Twyfelfontein in Namibia are thought to have been carved between 5,000 and 6,000 years ago.*

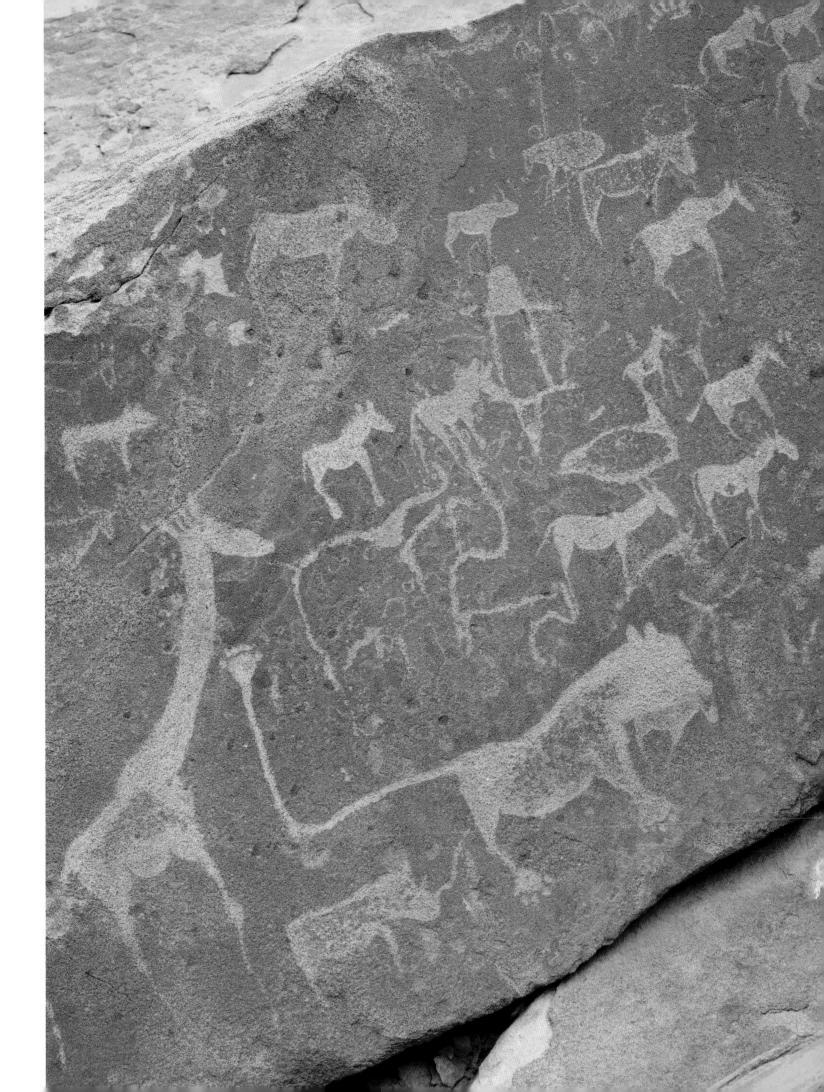

press recently, after a visitor to the island of Mull photographed a golden eagle carrying a dead lamb. The farming lobby immediately took this as evidence that golden eagles were killing lambs and needed to be 'controlled', whereas the conservationists were quick to point out that this photograph didn't prove that the lamb was alive when the eagle took it. In this case, the photographer couldn't enlighten us – or at least, we weren't told. We might suspect a political agenda, and we can safely assume that the newspaper's picture editor knew what they were doing when they chose to use the photograph out of context in this way.

Often we can help to add context by the accompaniment of a few explanatory words – through a caption. However, it's not always possible to ensure that a caption is read. Even if it survives the editing process, a simple factual caption can be interpreted in many different ways depending on our audience and its expectations. For example, the same photograph of a deer in the forest, with the same caption, will take on a different meaning depending on where it is published because the readership already has preconceived ideas of the editorial positioning. So where most readers of a wildlife magazine would see an innocuous pastoral scene, the readers of a hunting journal might think venison, while a professional forester would just see vermin. Generally speaking, these things are out of the control of the photographer, but it's worth thinking about when supplying pictures to publishers and whether they're likely to be sympathetic to your own point of view. Since more and more photographers are uploading images to online picture agencies, or making them available for blogs and newsletters, for example, then this is becoming a very real issue for the semi-professional and amateur photographer.

▼ *A yellow wagtail on a farm midden heap, surrounded by dung flies. This was once a common sight in the British countryside, but changes in farming practices and the widespread use of antibiotics has seen a decline in the availability of insect food, which in turn has had a negative impact on the populations of insectivorous birds. Somebody once commented on this picture 'it's a shame it's spoiled by all the flies' – spectacularly missing the point!*

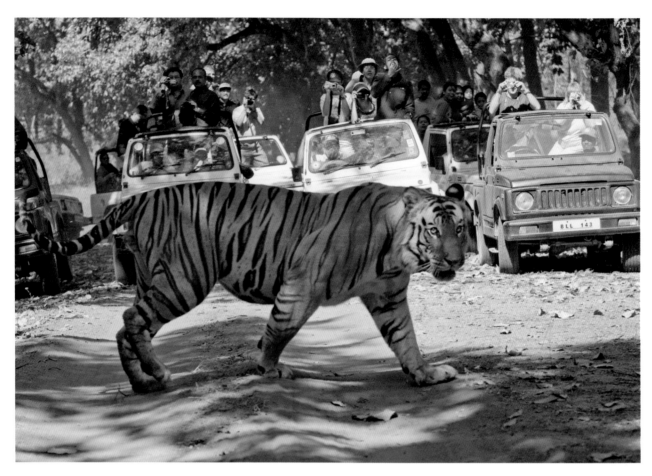

▲ Wildlife tourism in action. This view of a Bengal tiger at Bandhavgarh National Park in India, and the tourist jeeps surrounding it, gives an altogether different perspective on the animal than the other pictures of the species in this book. While it might have lost something of its image of wildness and majesty, perhaps this is a more realistic appraisal of the status of the tiger in India today.

▶ A red deer stag in a forest of Scots pine. Depending on the editorial prism of the publication in which it appears, this same photograph might be seen to represent a handsome and innocuous wild creature, an attractive target for the gun, or a pest to the forest economy. Context is everything.

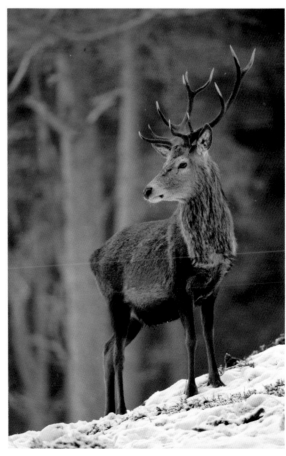

THE PHOTO ESSAY

As much as we love and aspire to make those telling, all-encompassing still images that get to the heart of the subject and tell us everything we need to know in one short glance, these are relatively uncommon over the course of any photographer's career. Furthermore, I suggest that it's slightly easier to accomplish with stories about the human condition, because we can more easily relate to the subjects emotionally. Who can fail to recognize the beauty and dignity of the Afghan girl refugee in Steve McCurry's famous portrait from 1984? Most of us would be ecstatic to achieve even one photograph of that stature in our lives. This one image has come to symbolize the whole conflict, out of the many thousands that were published. But we still needed the thousands to help fill the gaps in our information, to fulfil that less glamorous rôle of reporting the facts and enabling us to understand a little more of the background.

We very often need to group photographs together to tell a more complex or in-depth story, and a common format is the photo essay; a short series of photographs with some supporting text, or extended captions. This might ultimately be presented as a slide show, printed article or blog, but the principles are broadly the same. We are talking about photographic realism here, where the purpose of the pictures is to bear witness, and not to exaggerate or be selective with the truth. As far as we are able, we need to remain objective, and to present the facts as we find them, not to colour with our own opinion or prejudice.

I offer as an example a story I covered in India, about the devastating population crash of wild vultures in recent years, due to poisoning by the anti-inflammatory drug diclofenac. On the face of it, the pictures are quite straight and unremarkable when viewed separately, but together they afford visual evidence and reinforce the points made in the accompanying text. And you have to remember that many more people might browse an article and take in the pictures than actually read the full text, so the photographs need to act as a concise summary of the main points.

I could have included many other aspects of the vulture rehabilitation programme, such as the quarantine and hygiene procedures at the aviaries, the controlled herding of goats to provide a clean source of food for the birds, and the efforts made to minimize human contact and the associated dangers of imprinting. These pictures are all available for a more specialist audience, if required (say in a training manual), but they are not that interesting in a more generalist publication. There is one obvious omission though.

▼ *There were more than 40 million vultures in India in the early 1990s, but their population has crashed to just a few thousand today. Three species – the oriental white-backed, long-billed and slender-billed vultures – all face possible extinction. This photograph shows an adult long-billed vulture in flight.*

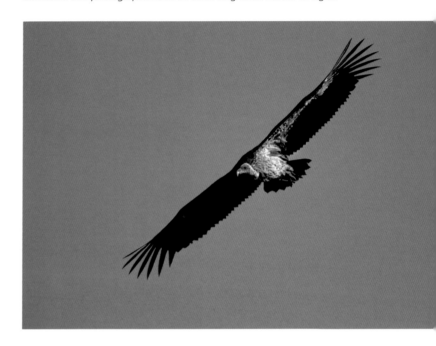

Unfortunately I arrived on the scene a few years too late to be able to document the vast flocks of oriental white-backed vultures that once congregated at the municipal dumps around Delhi and other Indian cities – in the 1980s it was thought to be the commonest large bird of prey in the world. A good editor would source a library picture to fill that gap, though I trust you can excuse it in this publication. Hopefully, I'll still be around to go back to cover the happy ending, with scenes reminiscent of those earlier times.

After the shoot, my responsibility further extends to ensuring that the captions are properly researched and factually accurate, and embedded in to the image file's IPTC metadata field so that the information is readily available to all sorts of potential picture users. On the visual side, I need to make sure that I can present a diverse mixture of wide angle, mid-shot and close-up views to hold people's attention. I must leave a graphic designer with opportunities for cropping the photos to fit available space on the page, so they mustn't be framed too tight. I'll probably want to mix landscape and portrait formats to maintain variety – though if it were an AV show it will likely be restricted to all landscape format. And I might want to consider colour combinations – which pictures work well together – though that's hardly an issue with respect to the vulture story.

▼ The carcass of a cow is attended by ravens and a feral dog. The population crash of the vultures has caused concerns about the proliferation of feral dogs which are quickly replacing wild vultures as the natural scavengers in the environment, leading to fears about the spread of disease and increased risk of rabies in the human population.

▼ Long-billed, oriental white-backed, and Himalayan griffon vultures removed from the wild and kept in captivity at the Vulture Conservation Breeding Centre near Pinjore, Haryana, India. Through a successful captive breeding programme at a number of such centres, it is hoped to be able to re-release these birds and their progeny in to the wild as soon as conditions are safe.

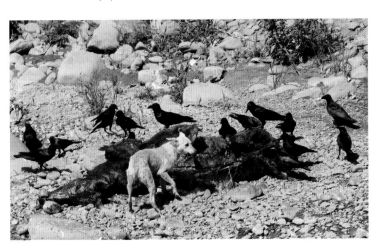

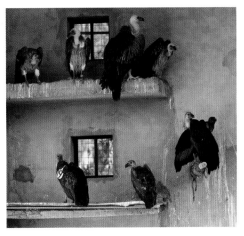

▼ The anti-inflammatory drug diclofenac used in veterinary medicine, shown here with some of its aliases, has been identified as the cause of the catastrophic decline in the vulture population throughout the Indian sub-continent.

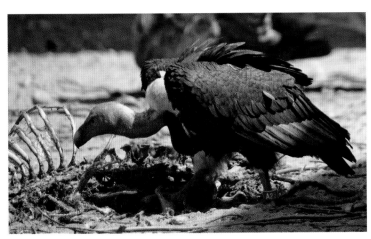

▲ An oriental white backed vulture adult in captivity and feeding on clean goat meat at the Vulture Conservation Breeding Centre. Vultures play a vital rôle in the food chain, providing a natural recycling service.

► Although production of the veterinary drug was banned by the Indian government in 2006, and although there is a proven safe alternative called meloxicam, unfortunately human diclofenac is being used illegally by many vets. Further measures are still needed for the vulture food chain to become entirely free of contamination.

◄ Project veterinarian for the Bombay Natural History Society, Dr Devojit Das, conducting a post-mortem examination on the corpse of an oriental white-backed vulture at the Vulture Conservation Breeding Centre near Pinjore, Haryana, in India. The bird was found to have died from visceral gout, the result of diclofenac poisoning after having fed on treated carrion.

THEMED PORTFOLIOS

We have seen one possible way to use multiple images creatively in the photo essay, but there are other opportunities and outlets for telling stories with pictures – for example in web galleries, AV presentations and exhibitions. So at some point in the planning process, and the earlier the better, you need to think about how your finished photographs might be displayed. The end use will generally dictate the type and format of pictures you need to tell your story.

While any loose collection of images might be termed a portfolio, the strength of that portfolio will depend on the rationale behind it as much as the quality of the individual images. If you find it difficult to conceive a picture story from scratch, explore your existing image library to assemble meaningful collections and sequences, and look for themes that link your pictures in some cohesive way. Once you start to amass a series of images on the same topic, you very quickly begin to notice the gaps and are then able to identify the photographs you still need to make to complete a coherent story. In this way you are able to plan future photography and related stories or new themes should begin to suggest themselves. This is another reason why having one or two pet projects on the go is such a successful strategy for building stories.

So what should you look for to make those vital connections between pictures? Chronological change is one obvious way; for example, photographing the same tree from a fixed position over the twelve months of the calendar year, the metamorphosis of a dragonfly from nymph to adult, or a series of frames of a cheetah running down an antelope. There are other ways to impart a sense of direction or narrative. You might follow the course of a river from source to estuary and photograph the wildlife associated with it, or you could document the creation and evolution of a garden pond. Plant and animal life-cycles and ecological interdependencies often make suitable stories – cuckoos as brood parasites of host birds such as reed warblers, the symbiotic relationships between many flowering plants and fungi, or the nocturnal activities of the urban fox are the sort of things that spring to mind. And think laterally. Your unifying theme can be a season, some behavioural trait such as a method of feeding or communal roosting activity, or something more abstract or conceptual, such as the colour red or 'aggression'. Vincent Munier's book *White Nature* is an excellent example of how to take a very simple concept and run with it.

PRESENTATION

If one of our primary motivations for taking wildlife photographs is to share them with others, then it follows that we should want to present them in the most effective and sympathetic way. Thankfully, we are no longer restricted to the time-honoured 16 x 12 inch dry-mounted print, and there are many more exciting avenues open to us. Through online web galleries, photo-sharing websites, blogs, and other social media we have the ability to reach a large worldwide audience, at relatively modest expense. With laptop computers, tablet PCs, smart phones and media players our portfolios are easily transported and shared with small groups of people, and with the addition of an external monitor or digital projector we can readily extend that group size. And when we do want hard copies of our pictures, we can either print our own or take advantage of professional labs to provide us with archival giclée prints on art papers, canvas wraps, or print on to durable materials such as perspex, acrylic and aluminium. Digital printing has also made short-run publications economically viable, and the digital photo book is a wonderful innovation for both the professional and amateur photographer – a compact, elegant way to package, archive and present that photographic safari or special project.

The low cost and ease with which we can do all these things shouldn't lead us to cut corners or become any less rigorous in our editing. Five well-chosen photographs are better than ten indifferent ones, and a ten-minute, punchy slide show is preferable to one hour of mind-numbing, sleep-inducing repetition. Be critical and selective, and remember there's absolutely no need to show your second-best work. You should never feel like you have to apologize for anything you show, and if you're leaning that way then take it as a warning that you need to go back and prune more severely. Even your normally indulgent friends and family may be too polite to say they're bored, so it's up to you to exert self-discipline in your editing.

There will come a point when you're sufficiently pleased with some of your work that you will be confident enough to display it; initially, perhaps, as a framed print in your own home. With the benefit of positive feedback you might then feel emboldened to offer prints for sale at a craft fair, in a gift shop or through a gallery. If you've completed a particularly successful portfolio project, you might even stage your own exhibition. In any of these eventualities, be sure to put as much effort and imagination into the method of presentation as you did in to the creation of the original photographs – it's surprising and disappointing how often you see perfectly good photographs let

▲ *Three detail studies of autumn colours in maple leaves, photographed in my back garden. These basic building blocks can be used in a range of possible outputs and presentations, shown here as a classic triptych.*

down by inadequate attention to the finishing. So think carefully about your choice of print medium and its surface texture – what material best suits the mood of your pictures, the needs of the 'customer' and the ambience of the viewing space. Does the addition of a border, vignette, or drop shadow enhance or detract? Must you conform to the conventional rectangular print, or is there a case for experimenting with different shapes? Block mount, picture frame, glazed or unglazed? Does that gold, rococo moulding really complement your photographs or is it gilding the lily? Look for theme and consistency throughout your presentation to lend that essential continuity, just as you did with the original photography, but don't let that stop you being adventurous. Think of it as dressing for the occasion, and creating a good first impression. Be proud of your work, and thereby inspire confidence in your audience.

In the interest of effective story-telling, there are often good reasons to display two or more photographs alongside each other. A pair of images may be used to highlight similarities, present two separate viewpoints, suggest a paradox or document change (before and after pictures). Taking this a little further, compositing several images might demonstrate a chronological sequence or reveal the many aspects of a multi-faceted subject.

To illustrate this, as a very simple project, I set out to photograph a series of details of autumn leaves found in my garden. The individual images were easy enough to acquire and have some limited interest – in their colour, texture and pattern. Yet taken on their own they don't adequately summarize the breadth and variety of hues, or the idea of seasonal change. You can't hear the crunch of the dried leaves, smell the decay, feel the wind on your face. In combination, however, they take on a fresh new dimension; the whole is greater than the sum of the parts. And with these basic elements now in hand, I can recombine them in lots of different ways. Select any three to include in a triple aperture mount or hang as a trio of canvases. Or maybe as a group of nine. Suspend multiple panels from the ceiling at different heights, or show as backlit transparencies on lightboxes. Or perhaps they could be cropped in triangles and pasted on to the surfaces of a giant polyhedron? Lots of creative possibilities suggest themselves. And this principle can easily be extended to many new scenarios, featuring different seasons, habitats, life forms and pictorial elements.

This is really just a variation on the theme of the collage, with its long artistic tradition. Incorporating photographs in to collages is hardly a new idea either (David Hockney being one of its most successful practitioners) but we've rarely seen it applied in nature and wildlife photography and I do wonder why not. Could it be that creative conservatism again, or is it that we fear the composite or photomontage might be seen as somehow dishonest, an unacceptable distortion of the truth? When it's done with such obvious intent it's unlikely to mislead anybody, but composite images made in computer may arouse suspicion on the part of the viewer because of the well-known ease with which you can disguise the cuts and pastes. What's acceptable in the gallery is very often inappropriate for editorial. We'll return to this in 'Ethics, Truth and Integrity' (pages 146–52).

MULTIMEDIA

It is also well worthwhile looking at ways to combine photography with other media in order to be able to tell a story more effectively, and to hold the attention of an audience. Investigate the potential for synergy. For example, film-makers have long been aware of the power of the music soundtrack in influencing our emotions, and live rock music concerts increasingly rely on the spectacle of light shows, costumes, dance and theatre to provide a complete entertainment package. You may not have your pictures used by the Rolling Stones on their next world tour, but that's not to say you can't take the initiative and conduct your own cross-arts project, albeit on a smaller scale.

One increasingly popular solution is the 'son of slide show' or audio-visual presentation. Those AV shows that formerly involved a massive bank of Kodak Carousel slide projectors, a specialist computer programmer and an enormous production budget are now easily put together through quite inexpensive and intuitive software packages, such as Fotomagico and ProShow Gold. And they are so much more powerful than their analogue predecessors. Your still images can be animated with zoom and pan actions, changed and progressed through a variety of cuts and transitions, and you can incorporate music, sound, graphics, text and video clips if you so wish. The combination of a few simple editing tools soon leads you to realize how you can be still more creative if you work to a shooting script; for example, through building time lapse sequences. It also becomes clear that you have the opportunity to use very much more abstract shots as part of a sequence, when the images either side help to make sense of the wackier ones that perhaps wouldn't work well on their own. This in turn informs your editing process, so that you need to remain conscious of the possibilities of still images within animated shows and not be in a hurry to delete all your more ambitious experiments, or indeed all your similars. There are technical considerations, such as the need to frame loosely in order to leave room for the zooms and pans within the 'action safe' zone. And there are legal considerations, such as the need to clear rights if you're intending to use the work of other creators (such as music recordings). But it's an exciting way to extend your creative ambitions and to showcase your talents, and it's quite addictive. Once you start an AV presentation, you never really finish it – you're always returning and looking at ways to improve it.

Of course there are many and various ways to marry photography with other art forms, both contemporary and traditional. By definition, they're not easily illustrated in a book. Wildlife sound recording and live musical performance are just two that appeal to me, but you might be more inclined to poetry reading and dance; it's your choice. If you are still looking for inspiration though, look at the way the photographer and writer Niall Benvie combines photography with written word, graphic design, digital painting, and sometimes performance art to produce his unique form of wry comment and parody. Truly, the possibilities are endless.

▶ *A multi-image panel (or polyptych, to describe it more formally) created from the same series of autumn leaves, and designed to be reproduced on a white background. This composite image shows the range of colours and patterns to be found in the leaves after the chlorophyll has been re-absorbed by the parent tree, and simultaneously invokes the action of leaf fall – something that couldn't be achieved in any single frame. I worked in layers in Adobe Photoshop to build the panel from its constituent frames, used the warp tool to bend some of the rectangular tiles, and added drop shadows to give a sense of depth, before flattening.*

Saving the Earth

The world is going to pieces and people like Adams and Weston are photographing rocks!
Henri Cartier-Bresson

Of all the many millions of photographs that have ever been published, it is difficult to think of many whose message has been so compelling and their impact so powerful that they changed the course of world events. The frequently cited ones are Huynh Cong 'Nick' Ut's haunting photograph of a naked North Vietnamese girl fleeing a napalm attack – sometimes said to have hastened the end of the war (but it didn't actually finish for another four years) – and Lewis Hine's portrayals of children at work in America's mills, mines, factories and fields in the early part of the twentieth century – that are popularly believed to have been instrumental in reforming the US laws on child labour. While these photos possibly played some part in those changes, it's impossible to ascribe a single cause and effect. More likely, they formed part of a broader, popular movement for social and political change – and there must have been lots more photographs we don't remember so well or history doesn't record. In retrospect we associate a few iconic images with those issues of the period, and so they become emblematic.

In the field of environmental photography, I suggest it's even more challenging to identify any specific photographs that have brought about significant and lasting change. I remember being shocked by photos of the Torrey Canyon oil tanker disaster from 1967, but the scourge of marine oil pollution has hardly diminished since then and many larger oil spillages have followed. Rainforests continue to be felled at an alarming pace, industrial whaling refuses to roll over and die, and we haven't even begun to try to deal with the issue of climate change. The sheer scale of these problems makes the idea of photographing a polar bear on the arctic pack ice in the name of conservation feel like a pathetically inadequate response. So can our photographs really make the slightest difference?

Many people clearly believe so. Some make it their life's work and go to great personal risk to raise awareness of global environmental issues that concern them; prize-winning photographers like Karl Ammann and Mark Edwards. This hard-hitting work is what most people would usually think of when we refer to environmental photography – documenting many of the most terrible things that are done to the earth. It's difficult, sometimes dangerous and often distressing. As with journalists covering natural disasters, you have to remain professional and detached and carry on shooting when your first instinct might be to get involved and try to offer help on the ground. However, in most circumstances you'll be in the company of other people whose job it is to intervene. Your primary rôle is to report.

NICE COP, NASTY COP

Not everybody will be able or willing to take on that mantle of the crusading eco-warrior. In any case, there's a limit to how much bad news the public can endure. Photographing all the awful things that Man does to the environment, and then hitting people over the head with them, rarely works. Charities in both environmental and human sectors are well used to the syndrome of compassion fatigue. We simply can't go on using shock-and-awe tactics and the extinction message in all circumstances to get our message across. If you've ever tried lecturing your teenage kids about switching off the lights in the house, you'll understand how futile this is. The louder you shout, the less attention they pay. The big stick approach certainly has an important part to play, but there is a danger that it might be preaching to the converted, while everybody else simply turns off because they resent being lectured, and the implied blame that goes with it. The problem is, it can inspire guilt and apathy rather than action.

I am of the conviction that the constant drip feed of positive imagery does have more long-term benefits in converting people to the conservation cause. This view is supported by the findings of a report entitled 'Branding Biodiversity' by Futerra Sustainability Communications, and in principle by such projects as Wild Wonders of Europe. Celebratory photographs shouldn't be simply dismissed as superficial or head-in-the-sand; they might actually represent good

▲ *The oil tanker Braer aground at Garths Ness in Shetland, January 1993. An ecological disaster image typical of the widely perceived notion of environmental photography. But does it change anything?*

psychology. Show how wonderful nature is, but at the same time remind ourselves of how far we still have to go to attain that ideal in some areas. Who knows, maybe that way we stand a better chance of capturing the imaginations of a lot more latent supporters. Rather than aiming to shock the world out of its complacency with a single, sharply observed horror photograph, why not seek to spark a life-long fascination for the natural world in a thousand young minds?

To be fair though, that superlative, awe-inspiring, all-conquering wildlife photograph is just as rare as one that still has the power to shock. We'd all love to take it, but the viewing public is well served with a feast of such images through Wildlife Photographer of the Year and a host of other outlets, and the bar gets higher all the time. How do you tempt somebody who is already stuffed, with yet more food – however tasty?

While most of this book has been devoted to the pursuit of excellence and originality, there is a small case to be made here for the dubious value of the cliché. There are certain stock shots that are trotted out with depressing regularity, to illustrate the issues of our time. You know the sort of thing. Oil crisis equals photograph of a car being refuelled at a filling station. A dripping tap denotes the topic of water conservation. And while it might be lazy photography in many ways, this does act as convenient shorthand – the message can be instantly assimilated and doesn't require any special visual literacy. So much so that these sorts of pictures have become an important part of our lexicon. And I have to grudgingly concede that they do perform the task intended, when you see them flashed on TV behind the news anchor, or made semi-transparent and overlaid with type.

WORKING AS PART OF A TEAM

Perhaps we shouldn't expect too much from one photograph, and always try to do it all on our own. I know for sure that a great many quite prosaic photographs serve a very useful purpose, in the right hands – but they often go unseen or unappreciated by the mass audience (partly because they are well targeted). They may not be competition winners, and they probably won't glorify the photographer but they get a job done, quietly. For instance, as well as their flagship magazines and high-profile campaigns, conservation NGOs will use photographs in local news and media releases, scientific journals and conferences, fund-raising appeals, grant applications, membership recruitment, evidence at planning enquiries, lobbying government ministers and committees, practical management handbooks and many other behind the scenes activities most people probably wouldn't think of. Good outcomes might include: reforms to government policy or law, rejection of a damaging development, more funds to resource nature reserves and research projects, more members and supporters. But the photographs will only be a small part of a much greater team effort, and it's hard to measure their usefulness – or indeed why one picture would be better than another. A virtuoso solo performance is not always what's required, and sometimes it's necessary for us to suppress our egos. You don't always need a masterpiece, and you don't always need to be 'creative', but you will have to provide documentary realism that the audience can trust and depend upon – just as I discussed in 'Telling Stories' (pages 128–37). So be happy to accept lots and lots of small victories, rather than pinning all your hopes on that elusive blockbuster.

As a former staff photographer for a conservation charity I found my photographs being used in a whole range of unexpected ways, and often not what I might have considered my best work either. One good example I like to recall is the way many of my bird portraits were used in field identification guides in a number of developing countries, where none previously existed in the local language. Once again, it's impossible to quantify the success of these publications, but they did seem to be highly valued by the communities they served. The photographs were technically competent but otherwise quite basic, and that is all they needed to be. And the reason my photographs were used rather than the very best available was simply that my employer owned the copyright already, so it was the most cost-effective solution.

I also took a lot of photographs that deserve to be forgotten, and mercifully most of them have been. The pictures of cheque presentations and VIP visitors that seemed so important to somebody at the time have largely vanished from the archives. In contrast, some of the 'celebratory' bird photographs I took twenty-five years ago, largely unsolicited, are still being used in membership recruitment advertisements and other marketing and publicity material – so somebody believes they're effective. Anecdotal evidence maybe, but I choose to take this as vindication for the claim that positive wildlife imagery is the most useful and effective in the long term, when your business is promoting wildlife conservation and biodiversity.

Lest any of this be misinterpreted as an apology for mediocrity, of course there is a need for the satirical, the perceptive and the clever pictures. Just as there must be photographs that can inspire awe and wonder, and a lot more good news stories. It's about knowing your audience. What will work for the policy maker won't necessarily suit the wider public. While the former might respond well to the rational argument and gritty photo realism, the latter needs emotional reward and motivation. That could be achieved through reporting success, showing a lot more good outcomes from existing conservation programmes. Or by illustrating the benefits of ecosystem services, and what's in it for people. Look at the 2020VISION project for a good model of how this could be applied.

▶ *As recently as 1984, the people of the Azores still hunted sperm whales from open canoas using hand-launched harpoons. You could buy scrimshaw (carved whale ivory) in the tourist gift shops. Over the space of a single generation, that culture has changed radically and the archipelago now boasts an exemplary whale-watching and ecotourism industry – and its value to the local economy far exceeds that of the former whaling activities. This photograph was merely a tiny part of a massive international effort, a groundswell of public opinion, and no doubt a strong economic imperative that eventually led to those welcome reforms.*

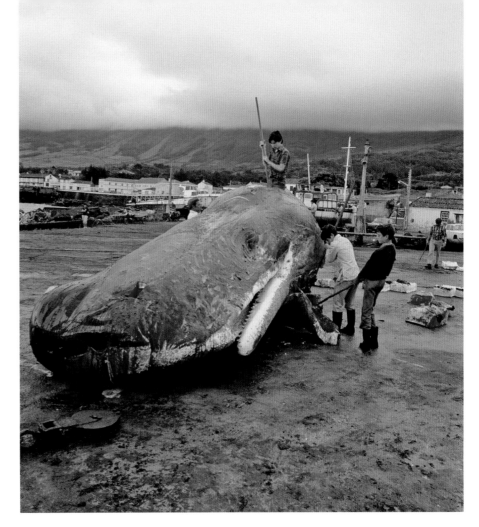

▼ *More than forty years after the ending of commercial whaling in South Georgia, whale bones still litter many of the beaches. The quizzical looks of these chinstrap penguins bring a certain poignancy to the photograph. While raising the same issues, it's an altogether more subtle approach than the image of the butchered sperm whale, and perhaps a little less likely to switch off the viewer?*

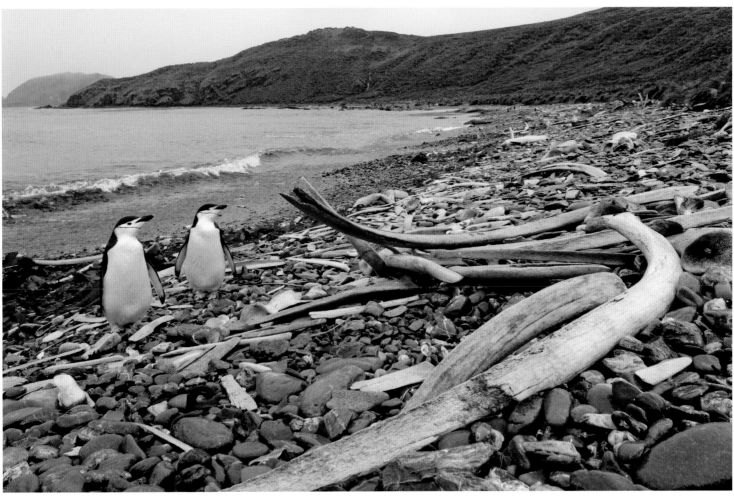

SPREADING THE WORD

The next step is to figure out how to put your photographs in front of the right people. You can hardly find a wildlife photographer who doesn't at some time proclaim their commitment to biodiversity and the environment, but it's not enough to post a few pretty wildlife images on a web page or with a photo library and declare yourself an ardent conservationist – these pictures have to be put to work, and to be seen in the right places.

Given that there aren't many employment opportunities for environmental photographers, and precious few paid commissions, that leaves us with the self-generated project and good old personal initiative again. By all means explore the possibilities of working in consort with a conservation NGO, university, natural history museum, research institute, or campaign group. They should be interested in your ability to document their work and help disseminate their message, but you probably won't be the first to offer your services. Expect to be told that funds are tight and find ways to make your offer attractive to them. For example, if you're already travelling to a country or region on holiday or for other business, you might be able to combine the activities in one trip and offer the client savings on travel costs. By approaching a newspaper or magazine in advance, you could establish that there's a willing buyer for a feature story that would not only help offset costs but also provide a prized publicity outlet. You might also consider donating rights in the use of your images for the organization's internal requirements or in certain well-defined territories – say in the country where they were taken, if that's where they would be most effective – but set clear limits. I am most definitely not advocating

giving all your rights away, since that could be undermining somebody else's profession and livelihood, as well as your own future work prospects. Anyway, if the work is worth publishing it's worth paying for, and if you don't put a value on it nobody else will.

Should all that sound too ambitious, on a slightly less grandiose scale but no less important are all the local conservation groups, campaigns, petitions, opposition to controversial developments and so on that are crying out for good photographs. Web publishing and social media are ideal vehicles for these sorts of communications, and you don't need to convince a hard-nosed, sceptical editor: you are the editor! There are so many options open now – home-produced posters and newsletters, picture messaging services, online discussion forums, photographic competitions, to name just a few – and there are more coming on stream all the time. Exploit them to the full.

While we're talking local, I guess we should also debunk any notion that conservation and environmental photography is something that must always be practised on the other side of the world. So always question your need to travel and examine your motives; is it more self-gratification than altruism? Quite apart from any green considerations, this attitude could easily be viewed as arrogant and neo-colonial – Westerners travelling to developing countries to teach them how to behave. People there might well ask what happened to your forests, wetlands and large predators? And what's your relative energy consumption? So is it a job that a local photographer should be doing? Might you be more useful in fostering links with local photography groups and helping them to get their images used over here? Travel is not necessarily a bad thing.

▼ *Photographs that can inspire awe and wonder should probably be used more often to promote the conservation message to the wider public. A wandering albatross soaring above the mountains of South Georgia might hit the mark better than a dead one on the end of a fishing line.*

Ecotourism managed properly will bring much needed foreign currency to poor communities, at the same time increasing the perceived value of their natural resources – which in turn should lead to appreciation and help the wider conservation effort. But what else can you do? If you do decide to travel, perhaps you could offer to talk about your work to a local school, run a workshop or donate some of your old camera equipment to a promising young local photographer? Don't let your involvement end at the pressing of the shutter.

In the end though, perhaps we shouldn't beat ourselves up too much over which is the best strategy and who is making the more worthwhile contribution. The important thing is that we're trying, in the belief that the cumulative effect of all our photographic efforts must amount to something worthwhile. The alternative would be not to try and not to care, and I'm not about to countenance that.

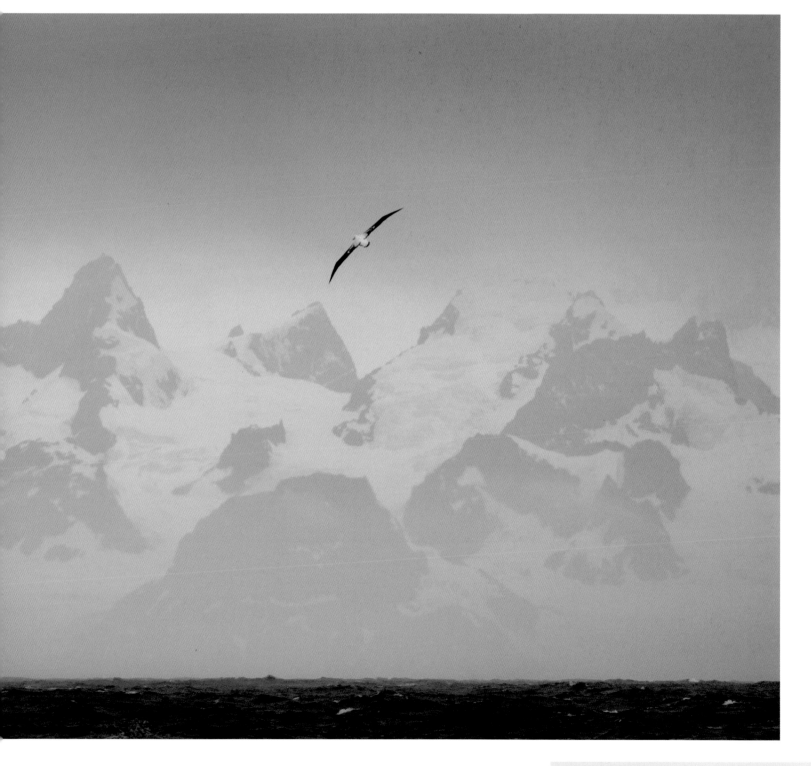

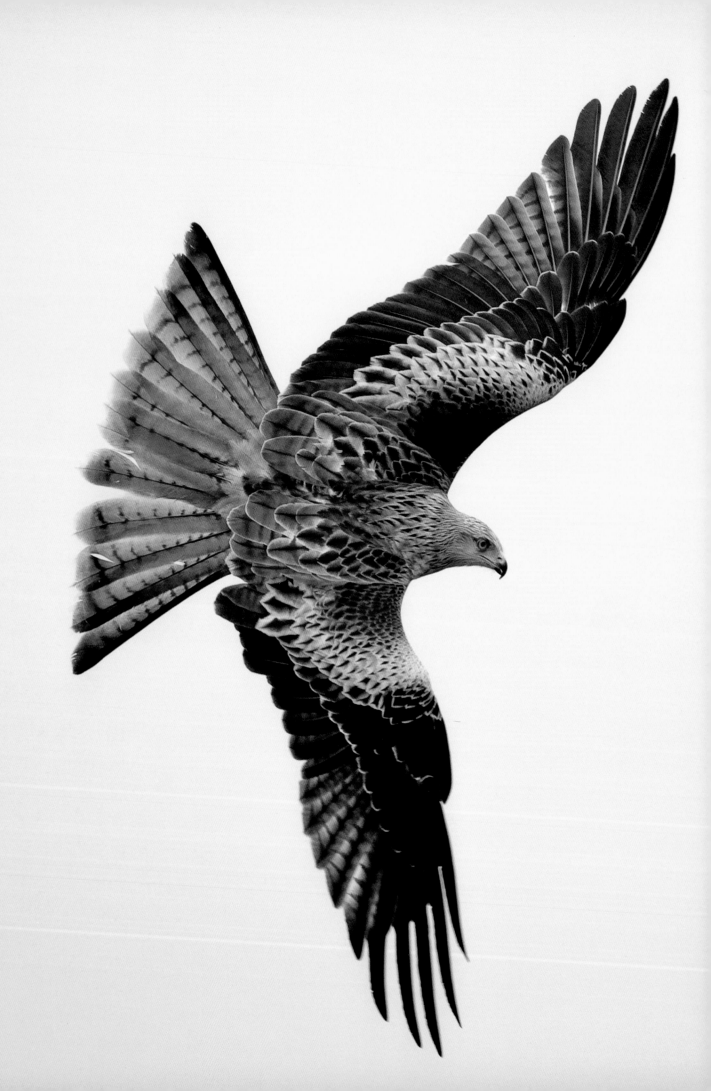

◀ The reintroduction and return of the red kite to the British Isles has been a major conservation triumph. We ought to shout about it more loudly.

Truth, Ethics and Integrity

All photographs are accurate. None of them is the truth.
Richard Avedon

In this final chapter, I'd like us to spend a little time considering the consequences of our actions as wildlife photographers. Most people would agree that we have a responsibility both to the subjects we photograph, and to the consumers of those photographs. And if you don't agree, I'm here to persuade you otherwise. With this in mind, a number of reputable organizations have published their own guidelines and I commend to you particularly the Values and Ethical Code of the International League of Conservation Photographers, and in the UK, the Royal Photographic Society Nature Group's Code of Practice. Both publications can be found easily online. I am sure that there are many other worthy publications in other countries and languages, and confident that they will be broadly similar in their recommendations. Where they all tend to agree may be summarized as follows:

- There should be no intent to deceive or to mislead the intended audience.
- The welfare of the subject is paramount, even if that means taking no photographs.

The first applies to all photographers; the second is particularly relevant to those working with nature and wildlife (but would also apply to people of course, especially those who can't easily speak for themselves). There is still plenty of room for interpretation, so please allow me to elaborate.

FROM ENHANCEMENT TO DECEPTION

It's not so long ago that Susan Sontag wrote, 'a photograph passes for incontrovertible proof that a given thing happened' and that there is associated with it a 'presumption of veracity'. In a similar vein, Roland Barthes asserted, 'every photograph is a certificate of presence'. While these observations are not so unequivocal as that old adage 'the camera never lies', they do strongly attest to the notion that people wanted to be able to believe what they saw in photographs. There

might have been some allowance in the collective mind of the public for the possibility that fakery could and did occur, but that was only in rare and exceptional circumstances – say for the nefarious political ends of the old Soviet regime, or the odd mischievous hoax such as the famous Cottingley Fairies. For the most part, however, a photograph could be taken at face value, and it had further credence if it was seen in a printed publication.

In recent years we've been obliged to readjust our sense of belief in the idea of photographic evidence. The ease of altering photographs after the event, and the liberal application of these practices has led to widespread mistrust and undermined public confidence in photographers generally. Indeed, it's become commonplace to hear people voicing suspicions about the provenance and truthfulness of a photograph even when they have no grounds for doubting its authenticity. Their first thought is very often that it looks too good to be true, therefore it must be digitally altered or enhanced. Could it be that we only have ourselves to blame for this sad state of affairs; that too many photographers have found it expedient to conceal their digital doctoring in pursuit of glory and a quick buck? On the face of it, it's going to be difficult to put the genie back in the bottle and recover that lost public confidence.

However, it would be a mistake to underestimate the sophistication of our audience, and assume that they (we) are unable to make educated judgments about contemporary photography. In truth, we are all photographers and visual artists and there's a growing appreciation of the capabilities of digital enhancement available universally. The boundaries of the acceptable may be changing, and a little too rapidly for comfort, but we can and will adapt and be able make sense of it all. There is already a widespread and growing acceptance of certain basic digital re-touching techniques. For example, we are happy to tolerate most actions that have their origins in the chemical darkroom: erasing dust spots and hairs, adjusting tone and colour in moderation, and localized 'dodging' and 'burning' – because we have had a long

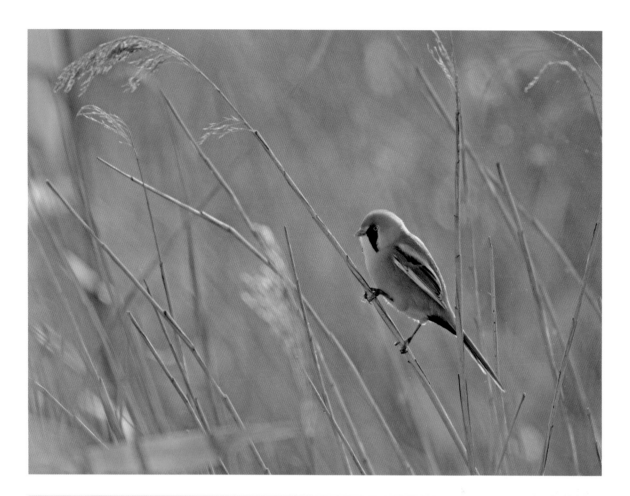

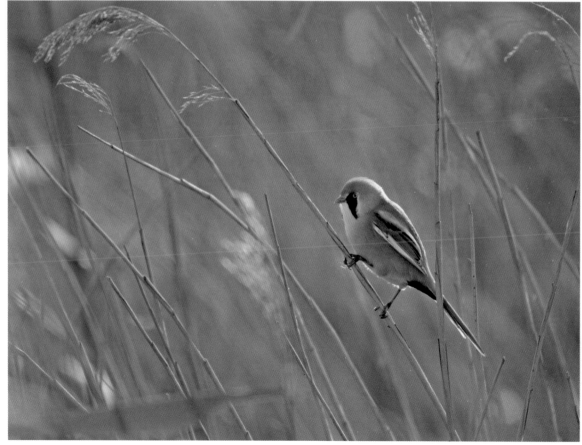

► A bearded tit, shown with its background of natural colour alongside a partially desaturated version. The top view is the one I would normally expect to supply to agencies and editorial publishers, while the bottom one I have presented in exhibitions and slideshows and offered for sale as a limited edition print. The treatment is so obvious, it can hardly be thought of as an attempt to deceive. Even so, I would be careful about where I chose to make it available and how I described it.

time to get used to them. Practices that have only recently become possible or made much easier through the digital darkroom, such as cloning pixels and the creation of montages tend to be regarded much more cautiously, and rightly so, but there is a growing number of techniques occupying that grey area of borderline acceptance. For instance, removing minor distracting elements from a photograph such as a bright highlight or intrusive twig, or parts of animals encroaching at the edge of the frame. And what about extending the canvas by extrapolating an area of plain sky or out of focus background to change the shape of the overall picture? These practices can hardly be said to alter the meaning of a photograph, and yet there is so far no universal agreement on whether they should be welcomed or discouraged. But they can't be un-invented, so the pragmatic solution, if in doubt, is to declare your alterations – and certainly to acknowledge any significant additions or deletions. This voluntary code of declaration will probably have to serve us for a while, even though it could get pretty tedious explaining every adjustment to every photograph to the audience of a digital slide show.

While at first glance there might appear to be a very fine line between genuine artistic interpretation and outright fraud, in practice much will depend on the context in which the photograph is seen and the audience it is meant for. In editorial, particularly, it is still important to be able to place trust in what we see. So in a newspaper or non-fiction book the criteria should be most rigorous of all, with the highest standards of editorial integrity with regard to how photographs are used. And it's in the field of news journalism that we witness the greatest outcries when

transgressions are discovered. It's a different matter with advertising, however. Here, our experience tells us that liberties will be taken with the truth, that visual metaphors will be employed and our credulity stretched to the limit. Not only do we not seem to mind so much if photographs are radically altered; we can actually enjoy the inherent ambiguity present in much advertising. It's not that we have double standards in any hypocritical sense, but we are capable of discriminating between these two very different media, and apply different demands as befits the purpose.

Since it's entirely possible that the same photographs may be used in different contexts at different times, we as photographers have to be on our guard and cover all possible eventualities. We must make it easy for the end users of our photographs to take the appropriate decisions and supply them with all the information they might need to make those decisions, and what they choose to pass on. So as well as declaring any digital re-touching in the 'file info' text field, this is another good argument for archiving our raw files, so we don't forget what's been done to the derivative images and can prove authenticity should it become necessary. Most photographic competitions tend to be very strict in their rules about digital re-touching (if only to make sure those rules are easily understood and fairly applied), and some demand to see raw files of short-listed pictures for that very purpose.

As we have discussed in previous chapters, truth and meaning in photography is not only about what we do in the computer after the image has been recorded, but also about how we frame the scene in the camera, and how we choose the exact moment we want to preserve. It even comes down to what lens

we use and the aperture we set. I was once accused of 'trick photography' by a local politician at a planning enquiry because I'd used a 300mm lens to alter perspective to make a site look 'worse' and more developed (with a greater apparent density of advertising signs, electricity pylons, etc.) than it really was. There is an element of truth in this of course, but it's an extreme view to take and only a lawyer would want to pick the bones out of that one. Few people would agree that we should be forever restricted to using only a standard view lens of 50mm focal length or its equivalent, in defence of 'truth'.

More controversially, subjects may be re-positioned, scenes may be staged or events reconstructed for the camera. If you were a news journalist you'd have to be pretty careful about that sort of thing (Robert Capa's *Falling Soldier* from the Spanish Civil War is the subject of a long and famous dispute) but it might not matter a jot if you're photographing kittens in a basket for a greetings card. In wildlife photography there are some well-documented cases where dead and stuffed animals have been modelled and photographed as if they were living. It's easy to laugh at and condemn such blatant fraud, but more seemingly innocent staging could result in quite serious consequences, and even legal action if there is any implication of guilt or damage to someone's reputation. For example, if you were to relocate a dead, protected animal and photograph it, and the picture was later published in an article to illustrate wildlife crime, you'd need to be very certain that the location wasn't recognisable. It would also be sensible to label the photograph as a reconstruction. Full disclosure and accurate captioning is not only ethical, but the safest course of action when it comes

to protecting your own reputation, and that extends well beyond the confines of digital re-touching.

While much attention is given to digital imaging and the opportunities for cheating with the aid of the computer, there's probably more suspicion of fakery among the general public than actually goes on. It does take a lot of skill to do it convincingly, not to mention considerable nerve to live the lie and brazen it out in front of your peers, so that's quite a restraining influence. There is also the more humdrum reality that most of us would prefer to get it right in camera and spend as little time as possible at the computer, because that means more time in the field doing what we love. Where there is probably much more cheating than the non-specialist audience generally realizes is in the area of captive and game ranch photography.

WILD OR CAPTIVE?

Taking pictures of an animal or bird in a captive collection might seem like a fairly innocent activity, and if you've done a good job and the photograph could pass for a genuine encounter with a wild creature, is there any harm in keeping quiet and letting people believe what they want? You might think this doesn't matter much in amateur circles, or among strangers, but at what point does it start to become significant? And how can such behaviour possibly have any adverse affect on the animals concerned? But imagine this single instance multiplied by several million similar episodes, and it starts to feel more uncomfortable. Could it be that the proliferation of game ranches and falconry collections has more to do with making money than any genuine conservation need or educational purpose? You might not think

▲ *This wild boar was photographed in a large enclosure, where it was part of a long-term re-introduction scheme in Scotland. I would have no hesitation in labelling the subject as 'captive', even though that doesn't begin to describe the circumstances and good intentions behind the animal's captivity. This detail would go in the description field attached to the image, but wouldn't necessarily be passed on to the eventual audience if the photograph were to be published elsewhere, where it's beyond my control.*

that's such a bad thing, but what if wildlife photographers are responsible for creating the very market force that drives this change? Does it create a pressure to remove more birds and animals from the wild to satiate the human recreational demand? Are the welfare standards and the living conditions of the animals as good as they should be, or are shortcuts being taken to maximize profits? You need to be asking a lot of questions before you subscribe to this kind of photography. To begin with: 'Have these birds or animals been bred in captivity?' and 'Is

there any intention to release them back into the wild?' On the positive side, photography of captive subjects may relieve pressure on some wild populations of endangered species that are already under stress, but the difficulty of such an undertaking is probably sufficient deterrence in most cases anyway.

It would be fair to say that the definition of captivity is very woolly and imprecise. Some creatures may be held in temporary captivity only, say as part of a scientific research programme, or solely for the treatment and rehabilitation of the sick and injured. Surely photographing these isn't as bad as hiring a trained animal model? A wolf may be kept in isolation in a small cage in a zoo, or it might be part of a substantial pack roaming a very large enclosure as part of a reintroduction programme. Both situations would probably be popularly defined as captive, but the latter does have the better ethical credentials, not to mention much greater difficulty attached to any photography. At the extreme end of the spectrum, some purist photographers hold the opinion that most African big game should be categorized as captive, because so many are kept within the boundary fences of game reserves and are not totally free to roam. Or maybe they just think wildlife photography in Kenya is too easy and not worthy of their talents? Keeping all of these diverse viewpoints reconciled is always going to be tough.

As with digitally re-touched or altered pictures, the commonly agreed best practice is to declare the captive status of your subject in your picture captions (or verbal explanations), and let the viewer make up their own mind. Or in the case of pictures offered for publishing, supply the information and let the editor decide when it's appropriate

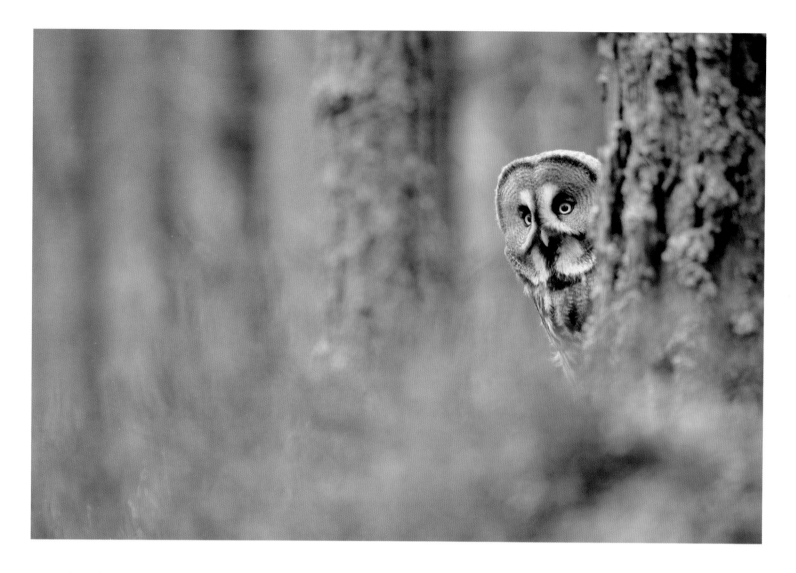

to pass it on. (Context is an issue again here; we don't care so much about a cheesy greetings card sold in a gift shop or garden centre, but in editorial features we do tend to care very much.) There used to be a convention of including the symbol of a capital letter C within round brackets – (C) – to signify the captive or controlled status of an animal subject. This dates back to the time when there wasn't much room to fit all the relevant caption information on to the mount of a 35mm transparency, so this shorthand once served a useful purpose. Some photographers still persist with this convention in the captioning of their digital photographs, but I suggest that it's now unclear and inadequate; it's not a widely known or accepted practice, and most people would probably presume it to be an attempt at a copyright symbol. So let's use plain English, consider including the word 'captive' in the file name, or at the very least explain the circumstances unambiguously in our cover letter, email or telephone call.

However, it's not just some photographers who find it convenient to withhold information about captive status; many newspaper and

magazine editors and all sorts of other publishers are complicit, because the conspiracy of silence can suit both parties. Ask me no questions, I'll tell you no lies. So if we photographers play fair here, then we also need editors to play their part, and that may mean printing fuller captions that acknowledge captive status than they have been used to hitherto. You don't see this happening very often, but a commendable few have begun the practice. It's particularly disappointing that most conservation NGOs don't currently have such a policy, when we should be looking to them to set a good example.

This brings us back to the question of does it really matter? Are we not just indulging an innocent fantasy with a slightly idealized version of the truth? Well consider this. Over several decades, almost every photograph of an otter in freshwater habitat published in Britain, has been of a captive specimen. In many circumstances it hasn't even been the correct species, with the similar Asian short-clawed otter substituted. The latter likes to stand up on its hind legs, which may be very cute and appealing in a picture, but our wild otters just don't

do that. Generations have grown up not knowing the difference, and I don't think there's any excuse for that. As well as misrepresenting biological fact, we raise false expectations in the viewer (suggesting animals are much more common or approachable than they really are) and at the same time put pressure on the honest photographer to either achieve the impossible or join the ranks of the cheats in order to stand a chance of competing. It's time we stopped telling lies and making excuses for those who perpetrate them.

BEHAVIOUR IN THE FIELD

If we are moved to photograph nature and wildlife in the first place, it is hard to fathom why anybody would deliberately abuse or disrespect the very subjects they wish to portray. And yet you often hear accounts of bad practice by photographers and even, in extreme cases, examples of vandalism and cruelty.

Let's agree that, as a minimum requirement, we should do no harm to the living things we photograph or to the places where they live, nor do anything that might adversely affect their chances of survival or impact on their reproductive success. To be able to judge this, we really need to understand a lot about our chosen subjects and what constitutes their normal pattern of behaviour, so it is incumbent on us to research, observe, and monitor – and then to adapt our own behaviour accordingly.

Most problems created by photographers arise through simple ignorance rather than malice, but that is no excuse. So learn to recognize stress behaviour and displacement activities, and respect an animal's comfort zone. Examine the likely consequences of your actions, such as whether you are placing your subjects at risk of predation by disturbing their natural cover or by enticing them out in to the open with food or water. Even when our own behaviour is exemplary, we still need to remain conscious of the cumulative effect of

disturbance. At some honeypot locations, nature reserves and national parks there may be many other photographers passing the same way and trying to photograph the same subject on the same day. So here it's even more important to be able to understand when an animal is exhibiting symptoms of stress, and to err on the side of caution. We're really back to Chapter One: the importance of good fieldcraft and thinking before we act.

Other problems tend to follow from excessive enthusiasm on the part of the photographer: disturbing creatures for too long and pushing them too far in pursuit of ever more impressive photographs. Here the culprits do usually know better, but their judgment is clouded by competitive zeal. It's more difficult to know how to deal with this, but if setting a good example fails then perhaps the threat of exposure and consequent loss of reputation might be the best hope. Bear in mind that there are also legal limitations on what we are permitted to do in the course of photographing wildlife, and these differ between countries, so it's up to you to make sure you comply with the law.

With some activities connected to wildlife photography, it's always going to be difficult to arrive at a consensus as to what constitutes responsible and ethical behaviour. One such issue is that of baiting with live animals. Some photographers don't think twice about baiting an owl with a live mouse, but for many it's a step too far. However, feeding live daphnia to fish or mealworms to robins seldom raises an eyebrow. Where do you stand on that scale?

In the final analysis, ethics are personal decisions. I saw fit to make my own statement at the start of this book, and I would ask others please to join me in refraining from doing anything that might undermine public trust in nature photography or bring it into disrepute. Most importantly, I do fervently believe that it is possible to act responsibly and ethically without compromising creativity. Help me to prove it.

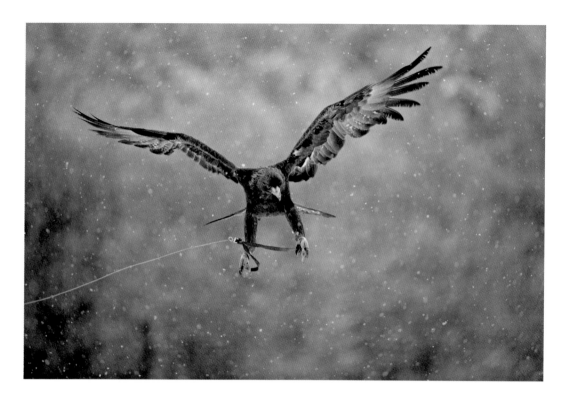

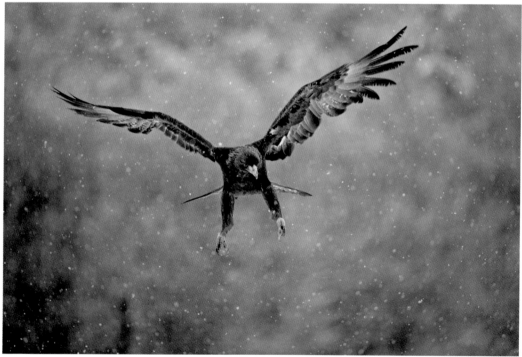

▲ You can see the temptation. Even my rudimentary Adobe Photoshop technique is pretty convincing here, but that doesn't excuse the double whammy of captive subject (a golden eagle) and blatant digital re-touching. I can, and do, come clean and declare everything, but would that deter the publishers of commercial posters or gift stationery? Indeed, is it remotely important to the kid who wants to display the picture on his or her bedroom wall? Context will often determine the course of action. One of my chief responsibilities as photographer is to make all the relevant facts available at the start of the production chain.

CASE STUDIES

This section presents a series of real life examples of photographs from my own portfolio, telling the story behind the pictures and then attempting to critique them with the nearest I can get to an objective analysis. I have tried to select a diverse range of subjects and treatments featuring animals, plants and habitats, near and far, and using different equipment and methodologies – though I have deliberately avoided anything too esoteric in the way of hardware. Some pictures were well planned, others more spontaneous. My reasoning is that by describing the thought processes behind the images, it may reveal something about the creative act that is more difficult to identify in the preceding chapters. Real life is always more complicated than theoretical illustrations.

It's perhaps revealing that, having chosen these favourites, I can identify a common feature in that they were mostly undertaken for my personal gratification and not on any paid assignment or with any commercial outlet in mind. They all work as stand-alone images, rather than as part of a sequence or larger portfolio, each with its own self-contained message.

N.B. The focal lengths given in the technical data are 35mm film or 'full frame' DSLR equivalents, having taken account of the camera's crop factor.

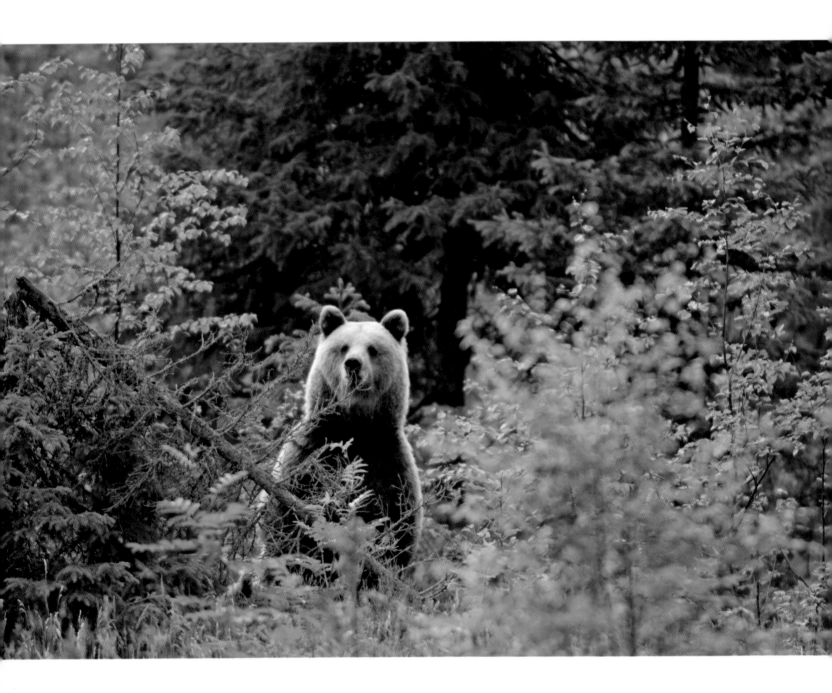

BEAR IN THE WOODS

There are only a few places where you can reliably see wild European brown bears, and all of these are sites managed for ecotourism, where the bears are attracted to supplementary food – or 'bait', in other words. The site I am most familiar with is in northern Finland, very close to the Russian border, not far south of the Arctic Circle and situated deep in the taiga forest. Visitors spend the night in a comfortable wooden cabin hide, where in mid-summer they can enjoy practically 24 hours daylight. There are also specialist photography hides availabe to rent, accommodating just one or two people, where the intrepid can get even closer to the bears. I have used both, and it is undoubtedly a very exciting experience offering fabulous photography opportunities that were unimaginable only a few years ago. Hardly surprising, then, that the wildlife photolibraries, competitions and picture-sharing websites are now heaving with images of wild brown bears in these suddenly familiar and identifiable locations.

When I have led tour groups to this site, I have noticed that the photographers among them generally spend the first night taking frame-filling shots and head portraits, as they are so impressed by how close the bears come, and feel this opportunity is one to be exploited to the full. And why not? But on the second night, I encourage them to think about the other options, about how the bears can be illustrated in their natural habitat – partly on the grounds that the extreme close-ups could easily be mistaken for images obtained in a zoo, but also that it would be a travesty not to show something of the magnificent boreal forest. This is more difficult to achieve, since the bait is often visible, and the forest floor immediately in front of the hide has been eroded to bare ground over several successive seasons. The area is also liberally sprinkled with the white droppings of gulls and ravens which are attracted to the salmon offal. It's not that pretty. Excluding the attendant flocks of scavenging birds can also be a challenge. Now you might well argue that this scene is the truthful one, the real photograph to be taken and the more interesting story to be told, rather than some romanticized vision of Utopia. But allow, for the moment, that our mission is the depiction of northern wilderness.

So now a degree of self-discipline is called for. Rather than be seduced by all the bear activity close in front of the hide, we have to look to the edges of the feeding arena, further back into the forest, and spot the more distant animals on approach. It's counter to all our natural instincts, and it hurts to decline those many easier shots that are ripe for the taking, but we need to concentrate on a different part of the forest and try to identify the likely approach routes and pre-visualize our preferred compositions. Not everybody is prepared to give it a chance on a short first visit.

This is my favourite shot from this hide. It shows an adult female bear, standing on her hind legs to get a better look at the feeding area, making herself look larger and more threatening, and deciding whether it's safe to proceed. The main reason for her caution is that she's accompanied by two young cubs, but these are obscured from view by the dense vegetation. There's no doubt the bear is moving through an area of vigorous wild forest: a mixture of mature spruce, young birch trees and standing dead wood. The broken trunk is probably the result of a heavy winter snowfall. It could be seen as an unwelcome obstacle since it partly conceals important parts of the subject, but I prefer to accept it as a natural part of the scene, lending depth and conferring a sense of wildness. Seen this way, it feels more like a privileged peek at a naturally shy wild animal, rather than an in-yer-face, everything-on-show supermodel. The bear looks like it belongs here.

That's the photograph I wanted, or one of them at any rate. Of course there are other stories to tell in your photographs, not least about the effects of green tourism and the wisdom of changing the feeding habits of wild animals. Who wants to take this on?

KEY POINTS

- Alert bear making eye contact
- Soft light halo on pelage helps bear to stand out from background
- Diagonal tree trunk leads the eye and lends perspective
- Partial concealment of main subject suggests an authentic, un-staged scene

TECHNICAL DATA
300mm focal length
1/40s @ f2.8, ISO 400
Bean bag lens support from permanent hide

HOLY PUFFIN

The Atlantic puffin is one of our most endearing birds, and also one of the most commonly photographed. I have been fortunate enough to visit many seabird colonies during my photographic career, and have taken pictures of puffins on numerous occasions at many different breeding colonies. I've used wide angle, telephoto and macro lenses. I've taken photographs of puffins surrounded by carpets of thrift and bluebells, engaged in bill gaping display, excavating nest burrows, silhouetted against the setting sun, carrying loads of silvery sandeels, and wheeling in flight over a cobalt sea. You would think that every conceivable image of a puffin had been realized by now.

On occasions, this knowledge somehow weighs heavily on me and the pressure to be original leads to a crisis of confidence. What can I do that's different, and how can I show this subject in a new way? I need some inspiration. So it was that I approached the Farne Islands, among a large crowd of early summer visitors bristling with tripods and long lenses – all expectant, but me without an idea in my head. I tried to tell myself to just enjoy the experience even if I came away with no new work of any merit. Or think of it as a research trip. Who would know the difference? All rational responses, but somehow I couldn't simply relax and go with the flow.

Two hours on Staple Island. Much jostling and elbowing at the roped-off viewpoints, unremarkable flat light, and consequent series of uninspired photographs destined for early deletion. My mood grew blacker.

Arriving on the Inner Farne that same afternoon, I had my telephoto zoom mounted on a tripod and slung over my shoulder, ostensibly ready for anything. Passing the medieval chapel of St Cuthbert, I was quite suddenly aware of a commotion behind the leaded light window. It was apparent that a puffin had become trapped inside the chapel and, attracted to the light, mistakenly saw the window as a possible escape route. I guessed it wasn't an unusual occurrence here given the huge numbers of puffins on the island, their natural curiosity and

their habit of exploring dark spaces. From the outside, I could make out the ill-defined and ghostly shape of the bird through the ancient weathered glass, and quite unexpectedly I sensed the germ of an opportunity – only of course I had the wrong lens fitted to the camera. A quick fumble in the backpack, change to a mid-range zoom, compose, and I hurriedly exposed three or four frames, moments before one of the nature reserve staff intervened and expertly gathered up the puffin to liberate it from its temporary incarceration. And the brief drama was all over.

Now I was feeling better about myself, though I wasn't altogether sure why at first. As it turned out, this was the only image I made that day which gives me any satisfaction. Certainly it's a quirky photograph and a lot different from the norm. It amuses me, I suppose, because we don't expect to see puffins looking through windows, and it's not immediately obvious that the bird is inside the building looking out, rather than the other way around. There's also the allusion to a stained glass window, and the sense of history does resonate, with this building and the puffins having cohabited for several centuries. The evocation of St Cuthbert is not without significance either, as this seventh century bishop and inhabitant of the Farne Islands was something of a proto-conservationist, establishing the first laws to protect the breeding birds of the islands, and most probably anywhere in Britain. That connection definitely appeals to me. Pure serendipity of course, but at least I didn't let the moment get away.

KEY POINTS

- The juxtaposition of wild bird and old building arouses curiosity, and we are forced to search for an explanation
- A largely monochrome image, relieved by the colourful bill
- Although the subject is indistinct, it's a very familiar bird so instantly recognisable
- Strong historical and cultural connotations

TECHNICAL DATA
300mm focal length
1/60s @ f10, ISO 200
Tripod

TARANSAY TRIANGLES

In recent years I have spent quite a lot of time sailing around the west coast of Scotland and the islands of the Hebrides. Each trip is unique, with no precise itinerary, because we have to take note of and respond to weather and sea conditions. That's a big part of the attraction, of course, not quite knowing where you're going to be on any given day.

On one of these cruises, we anchored by the remote island of Taransay, west of Harris, and decided to go ashore for a couple of hours to stretch our legs after a long sea journey. It was to be an amphibious landing on the beach by inflatable dinghy, and since the sea was quite choppy I didn't want to risk taking much in the way of camera equipment with me. I decided to stick with my underwater 35mm film camera and a moderately wide-angled lens, which would shrug off any salt-water spray or accidental immersion.

So I spent a while on the shore looking for otters. If I had found one I'm not quite sure what I would have done with the gear I had available, but the 'problem' never arose. It didn't particularly bother me that I wasn't taking any photographs, and a couple of hours soon slipped away.

Shortly before our rendezvous time at the landing beach, while gingerly negotiating the jagged shoreline, my eye was drawn to some interesting rock pools in the splash zone up near the high water mark. I spent a moment assessing the compositional choices, took one photograph while hand-holding the camera, and that was the sum of my creative efforts for the day.

Some years on, this remains one of my favourite images of the landscapes and habitats of the islands. It isn't a recognisable or celebrated location, and it deliberately eschews the conventional views that tend to feature white shell sand beaches, jade green seas and fluffy cumulus clouds. Yet it does say quite a lot about the island. For a start, the rocks are a very hard form of granite, resistant to erosion by the elements. The triangular patterns wouldn't have been apparent were it not for the (rain or sea?) water that had collected in the recesses of the rock, and the green algae growing at the fringes. These demonstrate quite eloquently that even in the harshest and most inhospitable of environments, life is possible.

It would have been a relatively simple matter to manipulate the scene. One obvious contrivance would have been the introduction of a shore crab or starfish to the larger rock pool. Though even if it had occurred to me at the time, I'd like to think I would have resisted the temptation. I prefer it just as it is: a quiet and contemplative study of a tiny area of remote coastline, seldom visited and easily overlooked, in the tradition of the *objet trouvé*.

The fact that a specialist underwater camera was used is largely irrelevant – it just happens to be what I had available. A standard digital compact would have been entirely adequate in this situation.

KEY POINTS

- Rhythm of triangles is compelling
- Lacking any familiar reference points, the scale is not immediately apparent
- Bright green algae contrast effectively with dark rocks
- Tells a story of life surviving in harsh conditions

TECHNICAL DATA
35mm focal length
1/125s @ f8, ISO 100
Underwater 35mm film camera, hand-held

TIGER PATROL

My first visit to Bandhavgarh National Park in India wasn't a great success. After fifteen excursions in the park I'd been fortunate enough to enjoy several tiger sightings, but had obtained no photographs of any merit. Harsh light conditions, aesthetically 'inconvenient' resting places, awkward camera angles and cluttered surroundings characterized my efforts. And all the tigers were basically just sleeping by the time I got to them.

Returning a year later, I can't say I went about things at all differently, but I was prepared to give it more time. From the outset, there were excellent photo opportunities with tigers at their kill, drinking at water holes and crossing forest tracks, but I still struggled to obtain any kind of notable or original images. Although these were wild animals, you couldn't really tell from the photographs I'd so far acquired.

Then one morning we entered the park at first light and made our way to one of the more remote areas of rocky ground and broken forest. This was late March and the sal trees were in fresh leaf, the air thick with the scent of their blossom that the Hanuman langurs love to eat. Responding to the alarm call of a chital deer, our jeep driver stationed us at a high vantage point where soon afterwards we caught a fleeting glimpse through the trees of a male tiger crossing a dry river bed and then climbing the opposite bank. Frustratingly, instead of breaking cover he lay on the rocky ground to rest a while. In the event this turned out to be useful thinking time, allowing me to anticipate his likely next move and plan my composition. I resolved that I wouldn't just take the biggest tiger image I could get, but rather incorporate some elements of the landscape – most particularly, a splendidly back-lit sal tree. It must have been the sun squinting above the hill beyond which presently disturbed the tiger, and he decided it was time to move off again. For a glorious instant he stood out in the clear, exquisitely rim-lit by the rising sun as he surveyed his domain.

What attracts me to this photograph? Well, it's

unquestionably a wild animal at large in the landscape, and clearly in its native habitat rather than some alien game ranch or zoological collection. It shows off the beauty and lushness of Bandhavgarh, confounding a common Western preconception of central India as an unremitting dry and dusty place. In purely physical terms, the photograph is dominated by the large, well-lit sal tree. However, the tiger has a much stronger psychological presence in spite of its small relative size – this has much to do with our cultural conditioning, our ingrained impression of the beast as a fierce predator, a creature we have grown up to fear, respect and admire. So we recognize the subject instantly and it assumes a status in the picture much larger than its literal size. On the other hand its small proportions give it more of a sense of freedom, while alluding to its vulnerability and the threats to its survival. The rim lighting not only helps the animal to stand out from the background, but softens and possibly romanticizes its image, in contrast to its fearsome reputation.

All in all, there seems to be a harmonious balance to the picture. One nagging doubt remains: what is the tiger looking at? Has he spotted some potential prey, or a rival male, or is he simply wondering where to find some shade to spend the hotter hours of the day? Conventionally, the animal should be looking in to the open space at the left of the picture to put us at our ease, but in this case I think that might remove some of the sense of mystery.

KEY POINTS

- Subject small in frame, lends an air of freedom and vulnerability
- Back light effective through sal trees and rim-lighting of tiger draws attention to main subject
- Unconventional subject position and line of sight introduces tension and raises questions

TECHNICAL DATA
300mm focal length
1/125s @ f8, ISO 200
Monopod, used in
open jeep

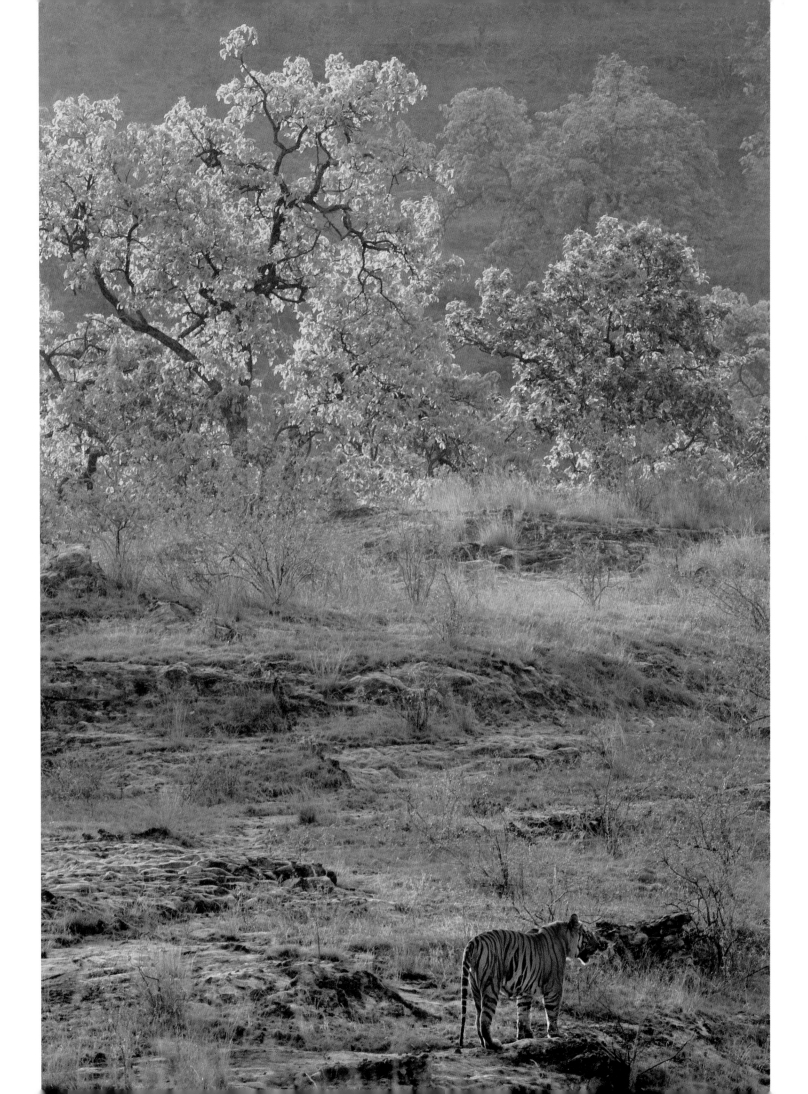

FAST FOOD OUTLET

The crow family represents many of the more intelligent and adaptable species of birds, and the rook is one of those that has adapted to survive in the modern urban environment. While they tend to be shy in rural areas, where they are still classed as agricultural pests (and therefore likely to be shot at), those that have grown accustomed to the urban way of life show no such fears of people.

At a number of motorway service stations in Britain, rooks have learned that the litter bins in the car parks are a handy and reliable source of fast food. Even if a half-eaten sandwich has been discarded to the very depths of the receptacle, the smarter birds have acquired a technique to extract it. By lifting the plastic bag with their bill and holding down the excess under their foot, and repeating this process, the food eventually comes within reach. It's a remarkable example of cultural transmission in bird behaviour that has been established over just a few short generations.

Photographing this activity doesn't require amazing levels of fieldcraft and neither is it that technically challenging, but you do need a certain amount of chutzpah. Hanging around a busy car park with a telephoto lens poking out of your driver's side window does lead to some raised eyebrows, I can tell you. Who is this guy? Private detective, paparazzo, pervert? It took me a few visits, but I did manage to come away with my facial features intact and without a criminal record.

There were other irritating logistical problems. Since people were coming and going all the time, it was difficult to control the background. I wanted vehicles to be present in the picture, but not too close to the rooks and not too brightly coloured either – so I had to change my position quite frequently or wait for the routine exchange of cars. Periodically, an employee would come round and empty the litter bins, so then I would have to wait for more discarded food to accumulate. Selfish, unthinking people would be constantly walking past and scaring the birds. Then, on one occasion, a driver made a hurried exit from his car and promptly vomited on the pavement next to me. This was far removed from the widely held perception of the wildlife photographer's glamorous lifestyle, conducted in the world's finest beauty spots.

The outcome is a topical documentary record of an interesting behavioural phenomenon. I suppose that it could be read as a comment on decadence and wastefulness in Western Society, where food is cheap and plentiful and nobody goes hungry, but I can't honestly claim that was in my mind when I took the shot. Most importantly it celebrates the evolutionary adaptation of rooks, how they have modified their feeding behaviour, and shows the typical surroundings in which they thrive.

Interestingly, I didn't see any other photographers queuing up to get their shots. There doesn't seem to be much danger of this becoming a new honeypot location on the well-trodden circuit of photography tourists.

KEY POINTS

- Not all wildlife subjects need to be illustrated in pristine wilderness
- Vehicle outlines add important context, but narrow depth of field ensures they don't overpower the subject
- References to human society open up the possibility of sociological and political interpretations
- The dangling French fry is an unexpected bonus!

TECHNICAL DATA
550mm focal length
1/500s @ f5.6, ISO 400
Bean bag lens support, using car as a hide

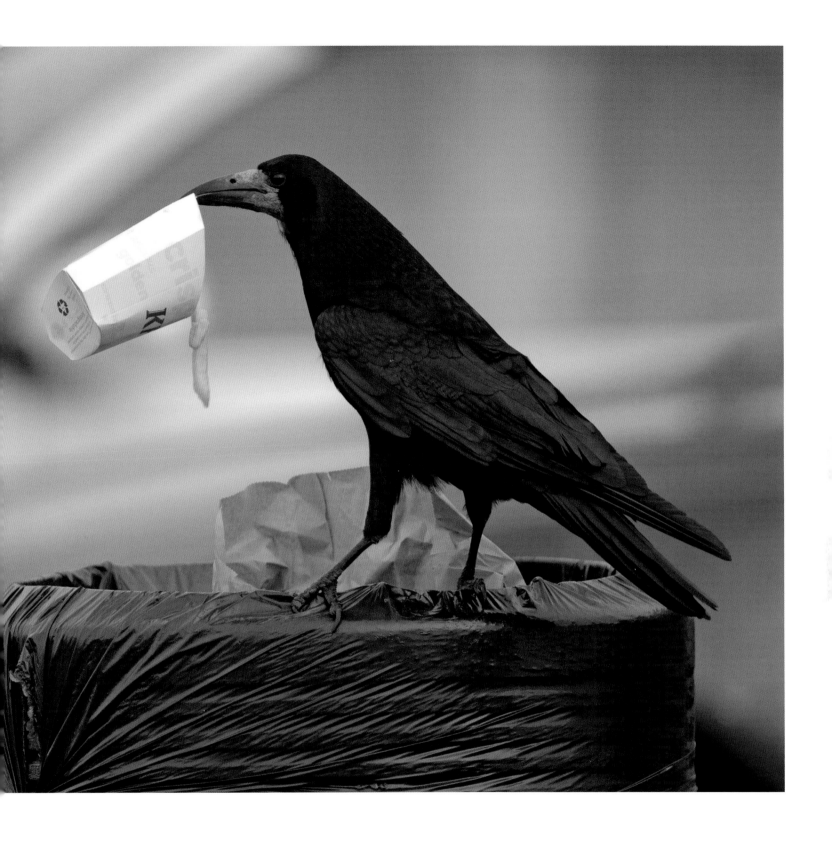

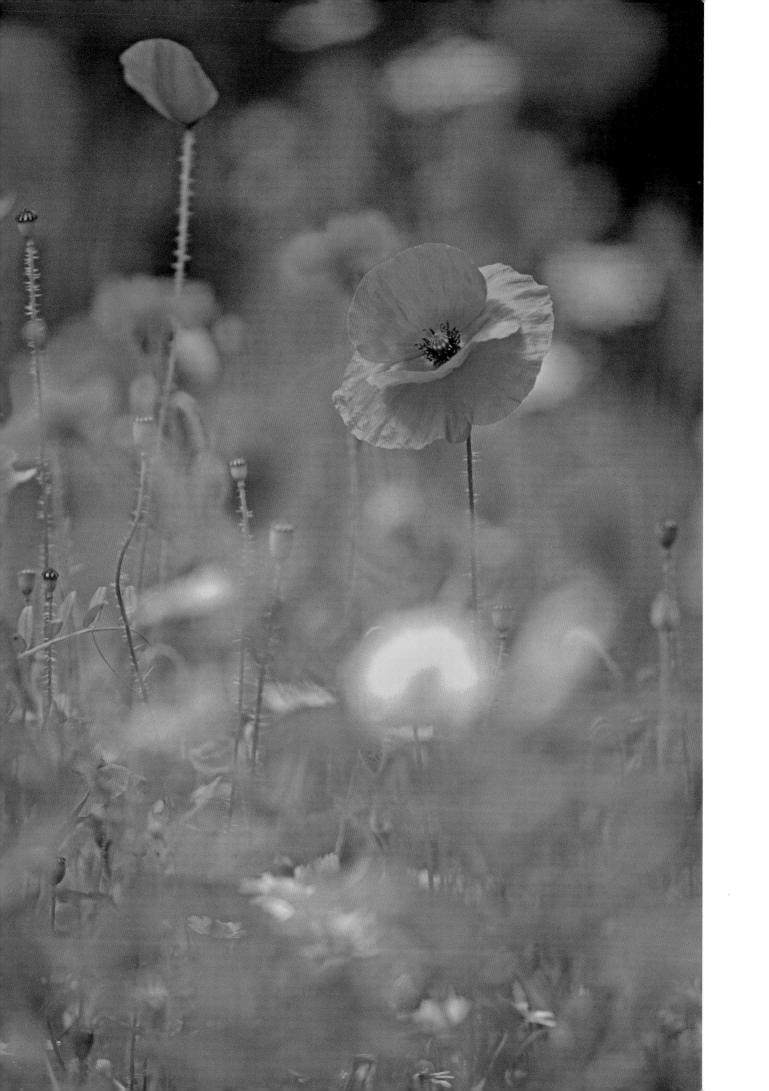

SUMMER PRIMARIES

I waited for a day of light cloud to photograph this small patch of re-seeded wildflower meadow close to my home, to enhance the colour saturation and to avoid any ugly, dark shadows. The splodges of primary colours in a field of secondary green shouted out for attention, and to achieve a vaguely 'Impressionist' mood I opted for a long focal length lens using it at maximum aperture to focus selectively on a single flower head and render the others as out of focus blobs. The cloud was persistent and the wind light, so I wasn't hurried and had plenty of opportunity to try out a number of creative ideas; various framing options in both landscape and portrait formats, with different flowers depicted in sharp focus.

In subsequent editing it soon became apparent that this composition just wouldn't work with anything other than a red poppy as the focus of attention. Other versions that focused alternately on a blue cornflower or a yellow corn marigold failed miserably, because the eye was drawn relentlessly to the red object even when it was out of focus. This created a conflict for the viewer with different subjects competing for attention, so the eye had nowhere to rest in the picture. The dominance of the red poppy flower is further consolidated by virtue of it being essentially circular, and its positioning at the 'intersection of thirds' I talk about on page 39. If that weren't enough, red and green are complementary colours (opposites on the colour circle) so appear even more intense when seen together, helping to create a potent and arresting image.

The colour red has connotations of passion, aggression, and danger in western culture, but I don't sense any of those emotions when I look at this picture – perhaps because the red is moderated and partially suppressed by the inclusion of the other flowers of yellow and blue. Poppies are also symbolic of death and remembrance, ever since the battles of Flanders in the First World War, so there are several conflicting cultural and psychological influences at work here. Meanwhile, the upright frame format accentuates the tallness of the flowers, particularly the poppy that is reaching above its neighbours as it competes for light. All in all there are a number of aspects to the photograph that might appeal to different audiences; you can equally well imagine it illustrating a biological text, an article on wildlife gardening, or advertising a fabric conditioner. In fact, it has most often been published in a legacy appeal by a wildlife conservation charity.

Had I chosen a shorter lens or a more generous framing, you would have been able to see the modern buildings that surrounded this tiny plot, and the people walking along the adjacent pathway. That would have been an alternative, equally valid representation of the scene but with an altogether different atmosphere and meaning. Of course, each of us should attempt to interpret the same subject in our own individual way. I would only suggest that you shouldn't assume because it's a flower you must automatically reach for the macro lens and stop it down to a small aperture.

KEY POINTS

■ Soft light enhances colour saturation and minimizes shadows

■ Long focal length compresses and stacks up flower heads

■ Widest aperture for minimum depth of field, selective focus isolates poppy

■ Poppy positioned in a compositional power point

■ Red colour advances, so the poppy is further emphasized as the main subject

■ Red and green are complementary colours and combine effectively

TECHNICAL DATA
500mm focal length
1/125s @ f4, ISO 50
Tripod & cable
release, white
reflector

BETWEEN THE TIDES

Flat landscapes don't readily lend themselves to successful composition, and intertidal mudflats are not only flat but largely uniform in colour and texture to further confound the photographer. Here and there the monotony may be relieved by patches of saltmarsh vegetation, or by the meandering tidal creeks caused by the repeated cycle of ebb and flow. These fractal patterns are most easily appreciated from the air, rather than viewed at ground level that would be our normal viewpoint. It is no coincidence then that most photographs you see of these areas seem to depend on boats as their central point of interest.

Furthermore, intertidal mud just isn't that exciting to many people. It's messy, you can't grow stuff in it and it can't be enjoyed in the same way as a sandy beach, so it's easy to dismiss as 'wasteland'. You wouldn't know just by looking at it that every cubic metre is wriggling with millions of living organisms. Except that sea anglers, shellfishermen and wading birds probing with their long bills do know precisely that. So to bring the habitat alive in a photograph and extol its virtues, it makes sense to incorporate something that lives off the mud and the vital food it contains.

One winter's day while enjoying a long walk on the Norfolk coastal path, I came across this particularly attractive saltmarsh creek formation. There were a few well-scattered redshank and dunlin feeding on the surrounding mud, but it was late in the afternoon and the light was fading quickly, so there wasn't much chance to make photographs on this occasion. However, I'd identified a good location and I now knew the best vantage point, the approximate time of day for the best lighting, and the state of tide I required. Provided the birds carried on feeding there, I would be able to return and complete my mission another day.

Seven or eight weeks passed before I had the chance to revisit. Fortunately, when the day came and I arrived on location, my calculations were correct and the wading birds were still in the vicinity. The one thing I hadn't bargained for was that in the intervening period a pair of bait-diggers or wildfowlers had taken a shortcut across the mud and left an ugly trail of boot prints. While I could exclude much of the worst by careful framing, I couldn't altogether disguise the disturbance and it would take many tides to do the job naturally, by which time the day length would be too long and the birds would have migrated north. I decided to persevere and try to make the best of the situation, and over the next two or three hours there were a couple of occasions when the dunlin flock flew through my chosen framing in very agreeable light conditions.

On review, I could see what I considered the strongest composition, but the boot prints would cut across the corner of the frame. They could be excluded by cropping almost to a letterbox format, or by rotating the frame. This would satisfy the most puritanical editors and the stringent rules of certain competitions, but leave me with a final image that fell short of my ideal. Or, it would be a relatively simple patching job in digital post-production. I think the wisest thing to do in a situation like this is to consider the context in which the photograph is to be seen, and if it's an editorial use be honest about the circumstances when submitting. I don't see it would be a great misrepresentation to display an exhibition print of the digitally re-touched version. But now you all know, I can't help wondering whether the image will be somehow devalued – in all its versions. I keep looking to repeat the shot, but tidal erosion may realign this dynamic estuary landscape before I get the chance.

KEY POINTS

- Long focal length lens and low winter sunlight strengthen graphic qualities
- Image converted to greyscale to accentuate patterns and shapes
- Meandering creek creates a leading line or visual pathway in to the picture
- Flock of birds transforms an otherwise lifeless landscape
- Various cropping options or re-touching possibilities depending on output and audience

TECHNICAL DATA
260mm focal length
1/800s @ f22, ISO 400
Tripod

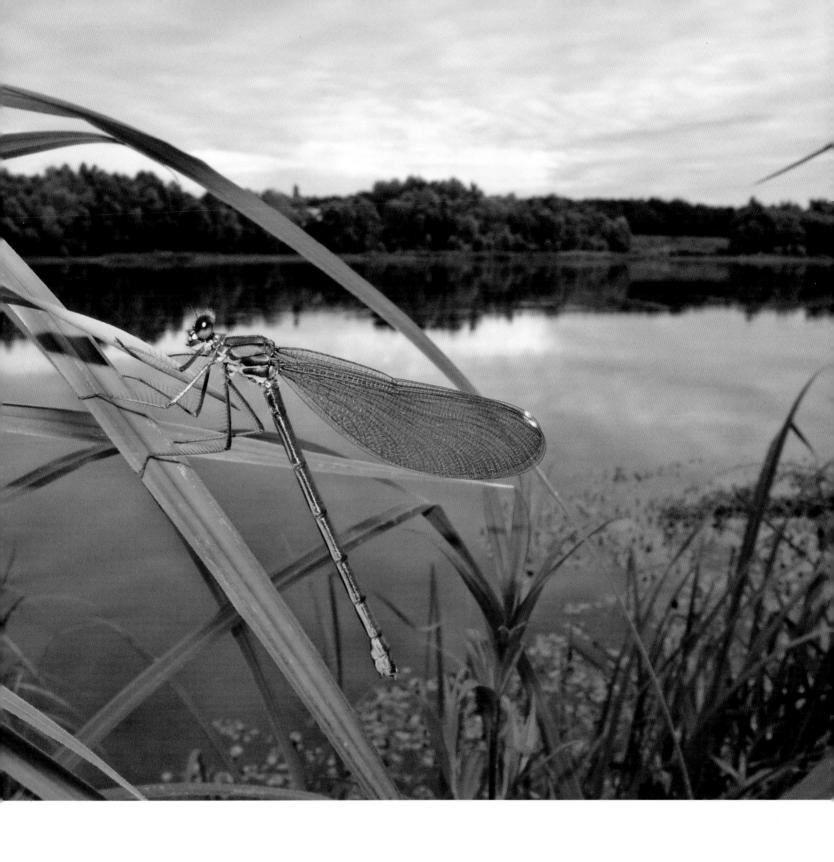

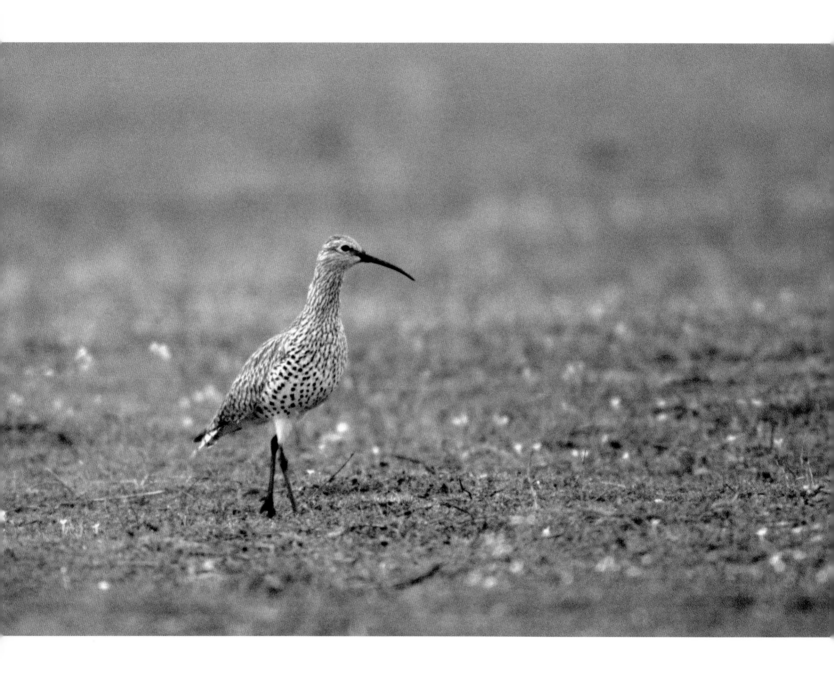

SLENDER CHANCE

The slender-billed curlew is an exceedingly rare bird, classified as 'critically endangered' by the International Union for Conservation of Nature. Its presumed nesting area is in south-west Siberia, but no nest has been found since 1924, and the last confirmed sighting of a migrant was from Oman in 1999. Not surprisingly then, there are very few photographs in existence of this species. Until the mid 1990s, its last known regular wintering area was in Morocco, at the coastal wetland of Merja Zerga, and it was here that I caught up with one in February 1995 – although I was there to do other things and never intended to commit much time to what had to be seen as a near hopeless quest. I gave it just one day.

It turned out that many circumstances were in my favour. Firstly, I was fortunate in having the logistic support of Birdlife International, as well as the doughty services of a local guide, Hassan Dalil, who quickly helped me to locate the bird. My visit coincided with Ramadan, so many of the farmers were absent from their fields that morning. Not least, I was able to call on my experience and fieldcraft to stalk the curlew as it foraged for food. This entailed crawling on all fours through a field of lupins to the edge of the marshes with my tripod and camera, and then waiting patiently for it to settle and resume its natural feeding behaviour. There was no obvious focal point to justify erecting a hide, so I just crouched as low down as possible among the vegetation. Meanwhile, Hassan helpfully kept a small crowd of curious children at bay. Amazingly, for one hour and twenty minutes I was able to watch and photograph the curlew at remarkably close range (considering the flat, open terrain). Occasionally it approached as near as 40 metres as it continued feeding. During this time I exposed five rolls of film, or about 180 frames, using a 500mm lens with a 1.4x teleconverter – the most powerful combination I could muster.

Naturally I was pleased to get any kind of result of a clearly identifiable slender-billed curlew. Undoubtedly it is a valuable scientific record, and it's a photo that is regularly published. It therefore serves a useful purpose, and may assist future researchers and observers in making a positive identification of this elusive creature. However, it leaves me curiously unsatisfied as a photographer because it gave little opportunity for artistic interpretation. In that respect, I much prefer the common curlew on page 96 with its more dramatic lighting. There's nothing much wrong with the slender-billed image, but it's not very inspiring either. And when I now inspect this grainy image made on push-processed transparency film, I can't help but wish I had today's digital technology available back in 1995. But sometimes you just have to accept that some photographs fulfil their remit, whether or not they enhance your own reputation, and be grateful you were able to be of service to the conservation and scientific community. I really don't relish the dubious distinction of having been one of the last people on earth to have seen and photographed an extinct creature, so let's hope this is not an epitaph. This is one instance where I'd be pleased to hear that somebody else had obtained a fantastic portfolio of new photographs of this bird that may make mine redundant.

KEY POINTS

- Valuable scientific record of critically endangered species
- Little opportunity for artistic interpretation
- Stalked with assistance from local guide
- Grainy image, due to push processing and enlargement

TECHNICAL DATA
700mm focal length
1/250s @ f5.6, ISO 200
Tripod

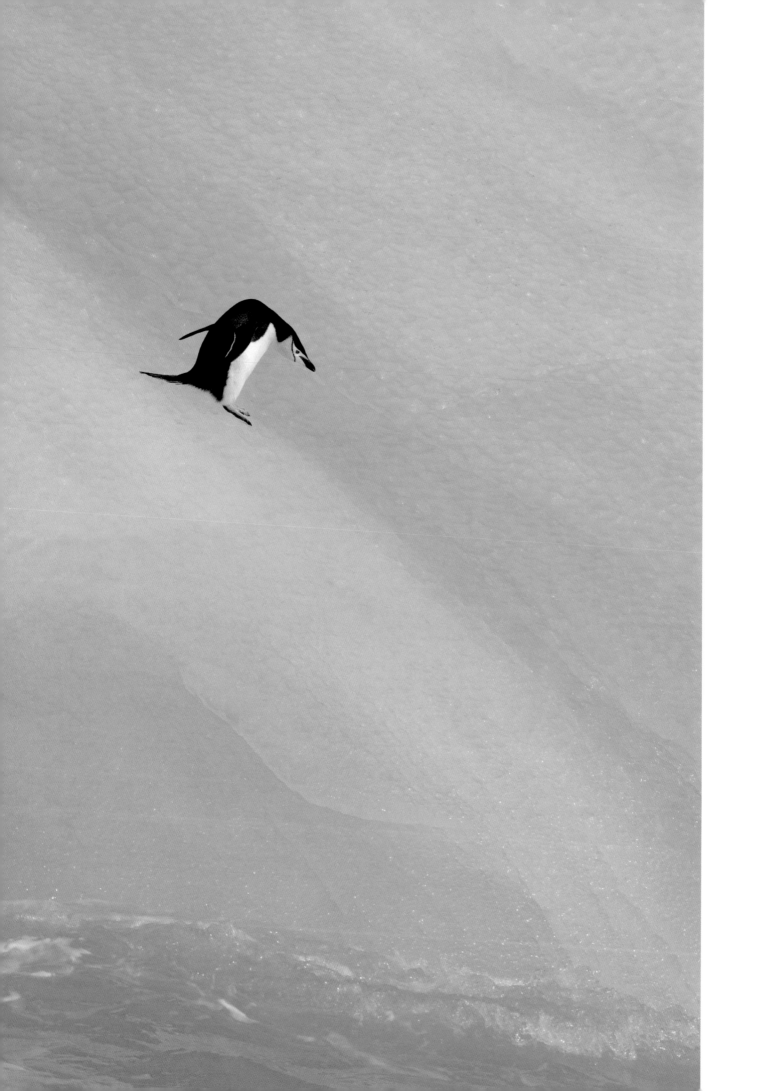

PENGUIN OFF-PISTE

Penguins are perennially popular subjects with wildlife photographers, for all those familiar anthropomorphic reasons. Their upright gait, Charlie Chaplin walk and cute faces make them irresistible camera fodder. They feature widely in advertisements, on greetings cards and calendars, and we have become used to seeing lots of amazing photographs of all species in every imaginable situation and in the most demanding conditions; think huddles of emperor penguins in a blizzard, or chinstrap penguins as leopard seal lunch. It's a bit optimistic then, to imagine that you can do much new or different on one three-week cruise to the Antarctic as a first-time visitor. That was my challenge as one of fifty excited passengers on a Russian expedition ship.

While on passage from South Georgia to the Antarctic peninsula, we awoke one morning to find ourselves at an anchorage in the South Orkney isles with the ship hemmed in by a flotilla of icebergs and shrouded in sea fog. You had to wonder how we ever got there. But as the day unfolded, the cloud slowly evaporated and between trips ashore we watched flocks of pintado petrels feeding from the sea surface around us and small groups of chinstrap penguins sprinkled among the icebergs.

From time to time the captain had to move the ship as icebergs threatened to close in on us. During one such manoeuvre, many of us gathered on the aft deck from where there was a good view of a particularly attractive blue iceberg. As it approached closer and closer, we could see various groups of chinstraps moving around on the ice. All of us were taking photos, and it wasn't difficult to obtain frame-filling shots. I had my telephoto zoom lens mounted on a monopod for support, and was watching for any unusual opportunity. One penguin was trying to negotiate an especially precarious-looking slope, and seemed destined to launch himself into the icy seawater below, or perhaps to descend ignominiously in an uncontrolled slither. I concentrated on him, framing the picture to allow for the expected direction of movement, and with a fast shutter speed set to freeze the action. In the event, the penguin was more adept than I'd given him credit for, and he managed to avoid the perilous drop to where the leopard seals lurked.

So this wasn't quite the photograph I'd planned for or expected. Nevertheless, it manages to capture the tension in the moment and a sense of imminent danger, which justifies the inclusion of the water below. You're expecting the penguin to slip at any moment, and that uncertain outcome is preserved forever in the single still image. It also has an element of humour to it, in the way the penguin's posture resembles that of a downhill skier (there's that anthropomorphism again). For these reasons, the picture acts at several levels and bears repeat viewing.

The aperture and shutter speed settings were all wrong for the shot I ultimately acquired. They were selected for sound reasons, but of course a much slower shutter speed would have sufficed for a bird practically standing still. With the high luminance levels and a near perpendicular plane, the depth of field wasn't critical so none of that mattered much in the finish.

One odd quality to the picture is the lack of any kind of shadow, which gives the penguin a strange cut-out appearance. I can only attribute this to the ice acting as a very effective natural reflector for fill light. Shame on you, if you suspected otherwise.

I'm afraid I can't tell you that I bravely endured camping out at -40°C, or that I was in danger of losing several fingers and toes through frostbite. I was just a very lucky tourist on the trip of a lifetime, and it was indecently comfortable.

KEY POINTS

- Sense of expectation and curiosity about what happened next
- Humour in anthropomorphic qualities
- Ice acting as natural reflector
- Penguin at strong position in frame

TECHNICAL DATA
600mm focal length
1/3200s @ f7.1, ISO 200
Monopod support

SHOOTING THE TUBE

My early experiences of the Atlantic grey seal were all from a colony near the mouth of the Humber estuary, in the east of England, and just about within peddling distance of where I grew up. This has since become something of a Mecca for wildlife photographers, largely because it's a mainland breeding colony which is reasonably accessible. In fact these seals are quite widespread around the coasts of the British Isles, especially further north and west. However, while the grey seal might be relatively abundant here, it is actually not that common in the rest of Europe.

Pictures of grey seals from the Humber are now ubiquitous. The backgrounds tend to be characterized by the brown, silty water of the estuary, and while there's always the possibility of the imaginative photographer creating something fresh, most of the images produced have become very repetitive and predictable. Furthermore, the colony has become a victim of its own success, and the pressures from human visitors have led to problems of disturbance. The conservation trust that manages the site now requests that photographers don't visit the outer colony at the tide's edge where the best pictures are to be made. It's regrettable, but I don't want to compound the problem and I'm happy to comply with their request. And anyway, I hate working in crowds.

Recently my grey seal encounters have mostly been around the Western Isles of Scotland, during the summer months. More often than not, you find them congregating around offshore salmon farms – where they are frequently regarded as a pest and a threat to commercial interests – or sleeping, slug-like, on some rocky skerry. Neither situation really offers much in the way of visual excitement. They are altogether more enigmatic when you hear their mournful calls wafted on the salty breeze, usually in the twilight of early morning or evening. Then you can more easily relate to the mythology of the song of the selkie. It's really quite haunting – still not a photo opportunity though.

During the summer of 2010 I managed to make my maiden landing on one of the uninhabited islands. There were a few grey seals hauled out on the beach, but they looked quite wary and not terribly interesting so I left these alone. Yet just offshore, I could make out the cigar shapes of other seals surfing in the waves, torpedo-ing parallel to the shore, similar behaviour to what I've seen in the southern hemisphere exhibited by penguins and sea lions. More seals approached from seawards, waiting for their chance to ride the next big wave, like a bunch of teenage boogie boarders at Newquay craning their necks to check out who's watching them from the beach. They obviously felt quite secure and at home in the water, and not at all threatened by a languid human stranded ashore, so fieldcraft was hardly an issue here.

I quickly discovered that the seals remained submerged for most of the time as they surfed, and particularly when the waves were cresting and at their most dynamic, so the seal shapes were somewhat indistinct and shadowy. Just occasionally they poked their heads out to breathe, and over about an hour of picture taking I managed just one clear shot with a face visible.

The first thing that strikes you about this photograph is the incredibly clear water, which is a feature of Scotland's Western Isles and their shell sand beaches. This is dramatically different from the muddy waters of the Humber. It evokes qualities of purity, freshness, cleanliness, and these are the kind of conceptual keywords I'd probably associate with the image when cataloguing. At the same time, the light and shade in the water divides the frame horizontally in to several bands, defining the shape of the wave and lending some structure to the picture. The only signifier of movement is the gentle bow wave streaming from the head of the seal, so it's just as well we have that clue otherwise it would appear very static.

In retrospect, I wonder about other ways I might have approached this subject; perhaps some pan-blur interpretation with a slow shutter speed? Or even more adventurously, an underwater viewpoint of the seals as they shoot the tube. Just how this might be achieved is still very sketchy in my mind, but the point is that all such projects seem to end up being regarded as works in progress. We should always be looking for ways to expand and improve our coverage of a given subject, especially once we have gained some unique insights. I hope to go back and have another chance.

Finally, it's tempting to speculate on the function of such behaviour in grey seals, which might come under the broad definition of 'play'. But what is its purpose and adaptive significance? Is it a social thing? Perhaps it represents practice for hunting fish, or as an anti-predator strategy? I can find no reference to any scientific studies – maybe there's a PhD thesis there for somebody.

KEY POINTS

- Classic repeat behaviour situation, allowing many photo attempts
- Clear water creates impression of purity and freshness
- Interesting animal behaviour, not widely recorded
- Further creative opportunities, not fully realized on one visit

TECHNICAL DATA
420mm focal length
1/800s @ f8, ISO 200
Tripod

EVENING RUSH HOUR

The winter roost flocks of common starlings have captured the public imagination in recent times, having appeared in popular natural history television programmes and even, somewhat unaccountably, in TV commercials for beer. This particular roost site in south-west Scotland has been active for many years, but achieved fame one December after featuring on BBC national news bulletins. Presumably it was a slow news day.

Not surprisingly, it didn't take long for the nation's photographers to respond, and some stunning images began to appear on the websites and in the magazines. I mean, seriously good work. I wasn't a part of that vanguard, but later the same winter I had to drive through the area on my way to leading a workshop further north, so I decided to break the journey and see for myself.

Right on cue, as dusk fell the starlings began to assemble in their pre-roost flight formations. Their performance was every bit as beguiling and dramatic as I'd ever witnessed, with the splinter groups merging in to an amoebic mass, morphing and twisting as they tried to bedazzle and confuse, and avoid the depredations of a marauding sparrowhawk – an uplifting experience for me, but basic survival tactics for them.

I was watching all this from a convenient vantage point at an adjacent motorway rest area, and from here I could see much of the surrounding countryside and some familiar-looking landmarks. While it was tempting to try for the more 'natural' rural landscape as a backdrop, this had been done before, and rather well, so I was anxious not to plagiarize – or possibly to risk unfavourable comparisons. I needed an alternative approach, but at this stage I didn't really have a plan.

As I was trying to take some preliminary photographs, many people were coming and going from the motorway services, most of them apparently oblivious to the show being enacted above their heads – but a few stopped and stared in amazement. All the while there was a steady stream of traffic whizzing along the motorway below, and occasionally the starling flock would traverse the busy carriageways just a few metres above the speeding cars and trucks. You had to wonder whether birds and drivers were aware of each other. I was drawn to the contrast between the two sets of travellers, and decided that this was the photograph I wanted to make.

It never happened that evening; I ran out of time before the birds settled in to their nocturnal roost. Nor the next two evenings, as the weather deteriorated and the starlings' routine changed. And then I had to be somewhere else. A year passed before I had another chance, but at least then I knew more or less where I wanted to be, at what time, and all the mechanics of the shot. Fortunately the birds behaved as predicted and I took a few dozen frames, whenever the flock streamed across the motorway.

In the subsequent edit, only one frame successfully captured the starling flock in strong shape and at a helpfully low altitude, while also coinciding with a small convoy of vehicles and blaze of headlights. The impending nightfall demanded a high ISO setting and slow shutter speed, but I knew this would also serve to emphasize the movement of both vehicles and birds. You don't need to see fine detail or the outline of individual birds to understand that these are starlings – they couldn't be anything else. The organic nature of the crowd is the interesting bit. Most importantly though, we are able to compare the urgency of the flock with the busy traffic on the motorway below – each travelling in their separate directions and heading for home at the end of a cold winter's day.

KEY POINTS

- Warm glow of headlights contrasts with the cold dusk sky
- Slow shutter speed emphasizes opposing movements of birds and vehicles
- Invites comparison between wildlife and people and their respective priorities

TECHNICAL DATA
155mm focal length
1/8s @ f5.6, ISO 1600
Tripod and cable release

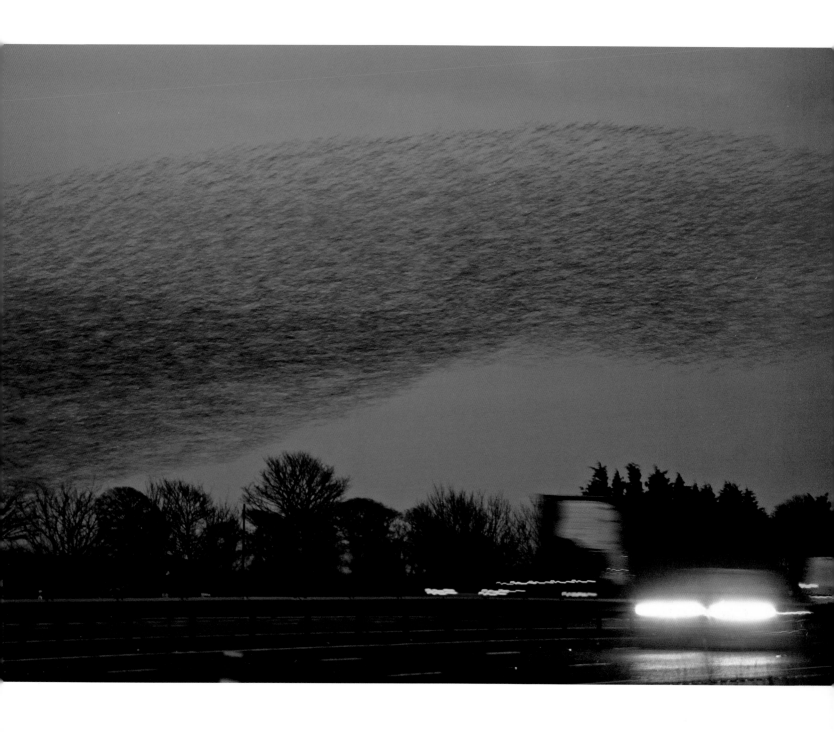

HE SHOOTS, HE SCORES

Breaching dolphins are simultaneously one of the most attractive and challenging subjects for the wildlife photographer. In Britain, the most consistently reliable location for seeing bottlenose dolphins at close range is at Chanonry Ness on the north shore of the Moray Firth in Scotland. I've been watching and photographing them here over many years. Indeed, I'm just one of a large band of human admirers, and I now recognize many of the people who gather on the beach here each summer. This is the best time of year, when the salmon and sea trout are running up river, and when the sea whips up with the cross currents on the flood tide the dolphins follow the fish close inshore where they seem to be easy pickings.

If you give it a few hours, you will almost always see the dolphins here. They don't always perform their aerial antics – that seems most likely to occur when two groups of dolphins come together, and then the elaborate breaching serves some purpose of social communication. Whatever the cause, it's a certain crowd pleaser, and most of the crowd will be trying to record the activity in some way.

The stills photographers quickly come to realize the limitations of their camera shutters and their own reaction time. In effect, by the time you have spotted the beak of the dolphin emerging from the sea and moved to press the shutter release button, it will almost always be too late to get a clear photo of that individual. Usually the best you can hope for is a shot of its tail end disappearing back in to the water from whence it came. So you need to develop another strategy, and that inevitably entails a lot of waste. One technique I employ is to sight along the top of the lens barrel rather than look through the viewfinder, shotgun-style, and frame up on the empty space where I expect (guess) the next dolphin might appear. It sounds ridiculously optimistic, but as long as I'm roughly correct, I find that I can sometimes make that small but necessary framing adjustment in the nick of time. And by pre-focusing on the sea surface at about the same distance, the auto-focus doesn't have too much work to do. If you're lucky and you get a really high breach, you might even manage to fire off more than one frame in a high-speed burst. Or a second dolphin might follow the trajectory of the first, particularly so if they are mother and calf together. There is still a high failure rate, but I find that at least a small proportion of attempts are successful by this method.

In this example I've managed to capture a juvenile dolphin clear of the water in mid-breach, and by good fortune it happens to be pleasingly angled in the frame. It's graced by warm evening light and a clean background, while the cascading water droplets introduce some feeling of energy. You can see fine detail such as the scars on the dolphin's skin that wouldn't have been apparent at the time, however closely you were watching. I'm sure that the cetacean researchers could identify the individual on this evidence.

I can't really think how I might have improved the shot (which was taken on film incidentally) and though I've tried many times before and since, I've not managed to better it. This is the full frame view, and I even kept the horizon level, miraculously. Yet in many ways, this sort of photography more closely resembles the shooting of clay pigeons rather than any considered kind of creative artistry. It's fun, and it's technically demanding, but there's little scope for fine nuance or subtlety. You either make the shot or you don't.

It's not difficult for me to place this picture chronologically. While it may not exactly be a JFK or Neil Armstrong moment, this photo will forever be associated in my mind with a world event that occurred on the same day – 30 June 1998. It was the evening of the England v Argentina football match during the World Cup in France. Michael Owen scored a memorable goal, David Beckham was sent off, and England eventually lost in a penalty shoot-out. And I had to watch it all (quietly) in a Scottish pub. But you have to consider these things in proportion, and I had a few blessings to count that evening.

KEY POINTS

- Technically difficult, best result from thousands of attempts
- Sighted along lens rather than followed through viewfinder
- Enhanced by low evening light
- Some pictures can have strong personal relevance and trigger memories for the photographer – that nobody else cares about!

TECHNICAL DATA
500mm focal length
1/1000s @ f4.5, ISO 200
Tripod

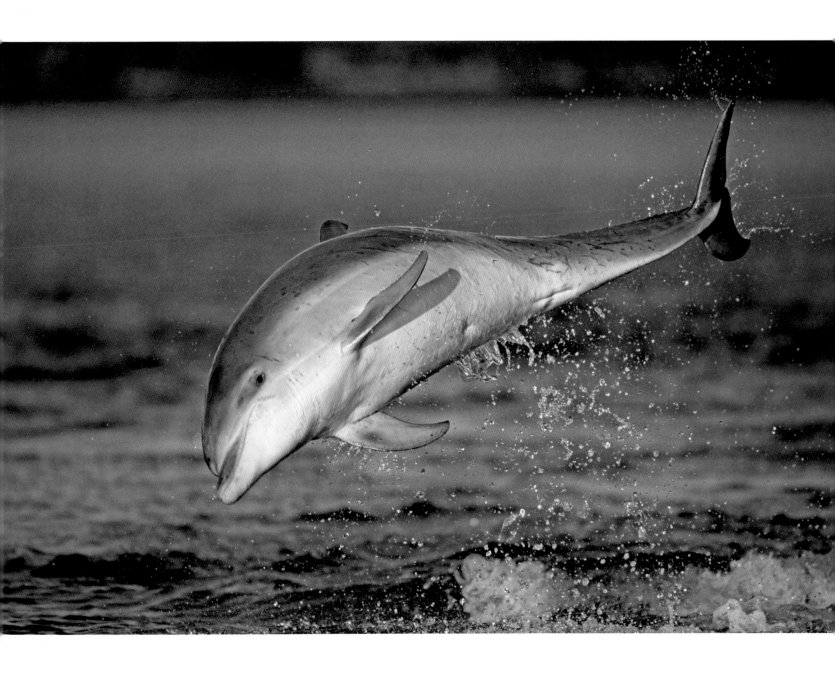

NOT TO SCALE

This is another of those photographs that came quite out of the blue, and I couldn't have planned. In the process of following an altogether different plan, I had set off from home in the very early hours of a spring morning to arrive at my destination at about first light. The site was a well-known flood meadow and nature reserve where it was my intention to photograph the carpets of snakeshead fritillaries.

I had barely arrived on location and walked a few paces from the car when I was suddenly faced with a new but transient photo opportunity. At the entrance to the reserve and less than a metre above the ground was a perspex board featuring a local map, damp with the morning dew and crawling with dozens of garden snails. You could hardly miss it, but I was tempted to press on with my original project while the light was favourable. Realizing that this scene would be fairly short-lived and wouldn't be here on my return however, I broke out the camera and tripod.

Once seen this was hardly a difficult photograph to make, with no great technical challenges to overcome and absolutely no field skills required. There were a few options open to me though. I could have gone for the wide-angle view showing the whole of the map and including as many snails as possible, but there was no apparent structure or theme to this, with an overpowering amount of small detail. I could have gone in close with one snail large in the foreground and incorporating a lot of background, but surrounding fences and paraphernalia conspired against that idea and it would have just been confusing. Instead I chose to highlight a small detail of the map with just a couple of snails, which allowed me to fool around with ideas of scale. I was particularly attracted to the 'You are here' legend and the dotted trails of the footpaths that the snails were stubbornly ignoring, in clear contravention of the bye-laws. Apparently, there was a gigantic snail not very far away from me at all, but I couldn't see it when I peered over the hedge. I could go on!

Thinking about this image now and where it succeeds, the essential ingredient seems to be that the snails are out of their 'normal' or expected habitat, and this gives rise to a paradox that I was able to exploit. Though in the end I am left with little more than a folly that offers no great insights in to the ecology of snails or makes any artistic statement, and struggles to find a place in the firmament of conventional wildlife photography. To be honest, I don't really know what to do with it, other than write about it here. There's no obvious publishing outlet, my agents are not remotely interested in holding it on file, and I can't see anybody wanting a limited edition print. And yet it amuses me, and I'm glad I took the trouble. I still went on to spend a happy and productive morning photographing the pretty and more commercial fritillaries.

KEY POINTS

TECHNICAL DATA
200mm focal length
1/180s @ f5.6, ISO 100
tripod

- Simple to execute, depending mainly on basic observational skills
- Curious contrast between the natural and the man-made
- Potential for humour and a gift for caption writers

SHUFFLING THE PACK

One of the most impressive bird spectacles I have witnessed anywhere in the world is that of the roosting behaviour of red knot. It occurs at a number of locations throughout the species' range, but my commonest experience of it is at the Wash estuary in the east of England where I've been watching and photographing them, on and off, over a period of about twenty-five years.

This arctic nesting shorebird gathers in large numbers around our coasts in autumn and winter. Most of the time they are busy feeding on the expansive inter-tidal mudflats, so they're well dispersed and you'd have to look quite hard to find them. And while they're rather colourful in their summer plumage, by autumn they have moulted into shades of pale grey and white. So far, so dull, you might think. Yet when the tide comes in and their feeding ground is submerged, all is transformed as the knot aggregate in a tight flock (also known as a 'pack') sometimes up to 80,000 strong. This flocking behaviour affords them some security from predators and they take the opportunity of the flood tide to rest and conserve energy until they are able to feed again. High spring tides force more and more birds together and further inshore, often to a regular roost site, and these are the best times for appreciating the mass spectacle. This relative predictability is the key to photographic success, but there are still many variables to contend with.

Wind strength and direction influence the birds' behaviour and sometimes they choose to roost at an alternative location a few kilometres along the coast. Other factors may also instigate a last minute change of plan – such as disturbance by people or predators. Curiously, for several winters during the 1990s, much lower numbers of knot arrived on the Wash and it was presumed they were finding more food the other side of the North Sea in the Netherlands. No guarantees then.

From where I live, if I want to arrive on location comfortably in time for a high spring tide, I need to set off no later than 4.00am – so you can imagine I like to consult tide tables and weather forecasts before committing to travel, and perhaps make a telephone call or two to ask what's been happening there recently. Even with these precautions, many times I have been disappointed. If the knot should arrive on cue, sometimes they dribble in to the roost site, a handful of birds at a time, in most unspectacular fashion. They gradually mass together on a shingle bank opposite my viewpoint from a public bird-watching hide, and there they will hope to stay for two or three hours, undisturbed, sleeping with their heads tucked under their wings.

However, sometimes a marsh harrier or a peregrine will appear on the scene and the flock of knot erupt into flight and promptly exit stage right.

With luck, they return to the same shingle bank after a minute or two, whereupon there is a jostling for position as each bird tries to find some personal space. This redistribution process gives rise to dramatic waves and pulses that ripple through the silvery sea of birds. Simultaneously, thousands of feeble chattering contact calls combine in a crescendo rush of white noise. Order slowly returns, but the birds are nervous now, and the mere suspicion of another predator attack prompts a 'heads up' response and for a brief instant all bills point in the same direction, like spectators at a tennis match.

For a long time I struggled to know how to do justice to this bewitching event through the medium of a still photograph, and how to interpret all its poetry. Sometimes I wished I were a film cameraman, or sound recording artist, but that would have been dodging the challenge. The idea to try to exploit slow shutter speeds evolved gradually, but there were few opportunities to experiment for all the reasons described above, until one October day when fortune smiled.

This image is just one successful outcome from a series of hundreds of frames. And no, I couldn't possibly have envisaged exactly how the scene would resolve as I pressed the shutter. But from many previous experiences of watching the behaviour of the flock, and with the instant feedback loop of digital capture photography, I could identify the potential and be fairly confident of some interesting results. When you see some birds moving and some birds standing still, or groups moving in opposing directions, you just know that good things will happen. Much of the skill is still in the editing, sifting the wheat from the chaff, and I had a few successes on that day each with slightly different emphases and interpretations.

In this example I have cropped the image at bottom and right of frame by approximately 10% to exclude some distracting elements, but otherwise it is presented as shot. I particularly like the notion of individuality and defiance, one against the world, exemplified by the single bird in sharp focus surrounded by ghosts. All in all it does a pretty good job of communicating the quintessential behaviour of the knot.

KEY POINTS

- Slow shutter speed expresses fluid movement in the flock
- Monochrome scene helps to concentrate attention on forms and shapes
- Overcast sky and low contrast suits the high key rendition
- Careful editing identifies the unique frame with one bird standing still
- Strong message of individuality, one against the world

TECHNICAL DATA
750mm focal length
1/6s @ f22, ISO 400
Tripod and bean
bag, from public
birdwatching hide

ACKNOWLEDGEMENTS

I am indebted to my literary agent, Pat White, for taking a risk on me and for finding a publisher for this work.

Special thanks to Mark Cocker and Bruce Pearson for their encouragement in the early stages, and to Michael Brunström, Andrew Dunn, Arianna Osti and the staff at Frances Lincoln for making it all happen.

Dave Matthews, Rosamund Kidman-Cox, Chris Jackson, Shabana Shaffick-Richardson, Chris Bowden, John Horsfall, Phil Cottier and my daughter Hannah Gomersall were kind enough to read and comment on sections of the draft manuscript, and I am extremely grateful for their efforts and suggested improvements. However, I take full responsibility for any errors, and for all the opinions expressed.

Lots of people helped with the photography in various unseen ways, and I thank especially:

Peter Cairns & Amanda Flanagan, for their kind hospitality, and use of hides and facilities at Northshots.

Chris Jackson and Mark Henrys, and their crews, for some amazing experiences and companionship at sea.

Mike & Gill McDonnell, and Brydon & Vaila Thomason for their friendship and hospitality in Shetland, Yossi & Shuli Eshbol in Israel, and Carles Santana & Roger Sanmartí of Photo Logistics in Catalonia.

Naturetrek Ltd, who facilitated my travel to Antarctica, Finland, India, Namibia & Svalbard.

Colleagues at the Royal Society for the Protection of Birds, Birdlife International and the Bombay Natural History Society.

I am very grateful to the 2020Vision project for allowing me to reproduce photographs taken on assignment.

My dear wife Pat took my portrait for the book's jacket, but has given so much more. I can't thank her enough – so she tells me.

Finally, I should like to pay a whopping tribute to a mentor; my former biology teacher at Grimsby Wintringham Grammar School, Mr B S 'Rat' Roberts. I may not have been a star pupil, but I think I must have learned something and certainly caught his infectious enthusiasm. His influence spread far and wide.

BIBLIOGRAPHY

Barthes, Roland *Camera Lucida* (Vintage 2000, 1980) ISBN 978-0-0992-2541-6

Barthes, Roland *Image, Music, Text* (Fontana Press, 1977) ISBN 0-00-686135-0

Benvie, Niall *Outdoor Photography Masterclass* (Photographers' Institute Press, 2010) ISBN 1861086792

Berger, John *Ways of Seeing* (Penguin Books, 1972) ISBN 978-0-141-03579-6

Brandenburg, Jim *Chased by the Light: Revisited after the Storm* (Northword, 1999) ISBN 978-1-5597-1671-0

Cairns, Peter; Möllers, Florian; Widstrand, Staffan; Wijnberg, Bridget *Wild Wonders of Europe* (Abrams, 2010) ISBN 978-0-8109-9614-4

Cartier-Bresson, Henri *The Mind's Eye: Writings on Photography and Photographers* (Aperture, 1999) ISBN 978-0-89381-875-3

Carwardine, Mark 'The Good, the Bad, and the Ugly' *BBC Wildlife Magazine 28:5* (May 2010)

Evening, Martin *The Adobe Photoshop Lightroom 2 Book* (Adobe Press, 2009) ISBN 978-0-321-55561-8

Freeman, Michael *The Photographer's Eye: Composition and Design for Better Digital Photos* (Ilex, 2007) ISBN 1-905814-04-6

Futerra Sustainability Communications 'Branding Biodiversity' *The New Nature Message* (2010) www.futerra.co.uk

Gomersall, Chris *Photographing Wild Birds* (David and Charles, 2001) ISBN 0-7153-1113-1

Grundberg, Andy *Crisis of the Real: Writings on Photography* (Aperture, 1999) ISBN 978-1-59711-140-9

Hill, Martha & Wolfe, Art *The Art of Photographing Nature* (Three Rivers Press, 1993) ISBN 0-517-88034-2

Jensen, Brooks *Letting Go of the Camera* (LensWork Publishing, 2004) ISBN 1-888803-26-6

Langford, M.J. *Advanced Photography* (Focal Press, 1969) ISBN 0-240-51028-3

Mandelbrot, Benoit B. *The Fractal Geometry of Nature* (W.H. Freeman and Company, 1977) ISBN 978-0-7167-1186-5

Munier, Vincent *White Nature* (Natural Wonders Press, 2006) ISBN 978-1-9053-7704-6

Patterson, Freeman *Photography and the Art of Seeing* (Key Porter Books, 1985) ISBN 1-55263-614-3

Patterson, Freeman *Photography of Natural Things* (Sierra Club Books, 1990) ISBN 0-87156-699-0

Patterson, Freeman & Gallant, André *Photo Impressionism and the Subjective Image: An Imagination Workshop for Photographers* (Key Porter Books, 2001) ISBN 1-55263-327-6

Robinson, Ken *Out of our Minds: Learning to be Creative* (Capstone, 2001) ISBN 978-1-8411-2125-3

Ruskin, John *The Elements of Drawing* (A & C Black, 2007 – first published 1857) ISBN 978-0-7136-8293-9

Sontag, Susan *On Photography* (Penguin, 1971) ISBN 0-14-005397-2

Töve, Jan *Beyond Order (Bortom Redam)* (Nya Vyer, 2001) ISBN 9197301167

Tulloch, Bobby *Otters* (Colin Baxter Photography Ltd, 1994) ISBN 0-948661-44-5

Wolfe, Art *Rhythms from the Wild* (Amphoto Art, 1997) ISBN 0-8174-5704-6

Zakia, Richard D. *Perception and Imaging. Photography: A Way of Seeing* (Focal Press, 2007) ISBN 978-0-240-80930-4

▶ *Two common cranes feeding late into the evening. Sweden (overleaf).*

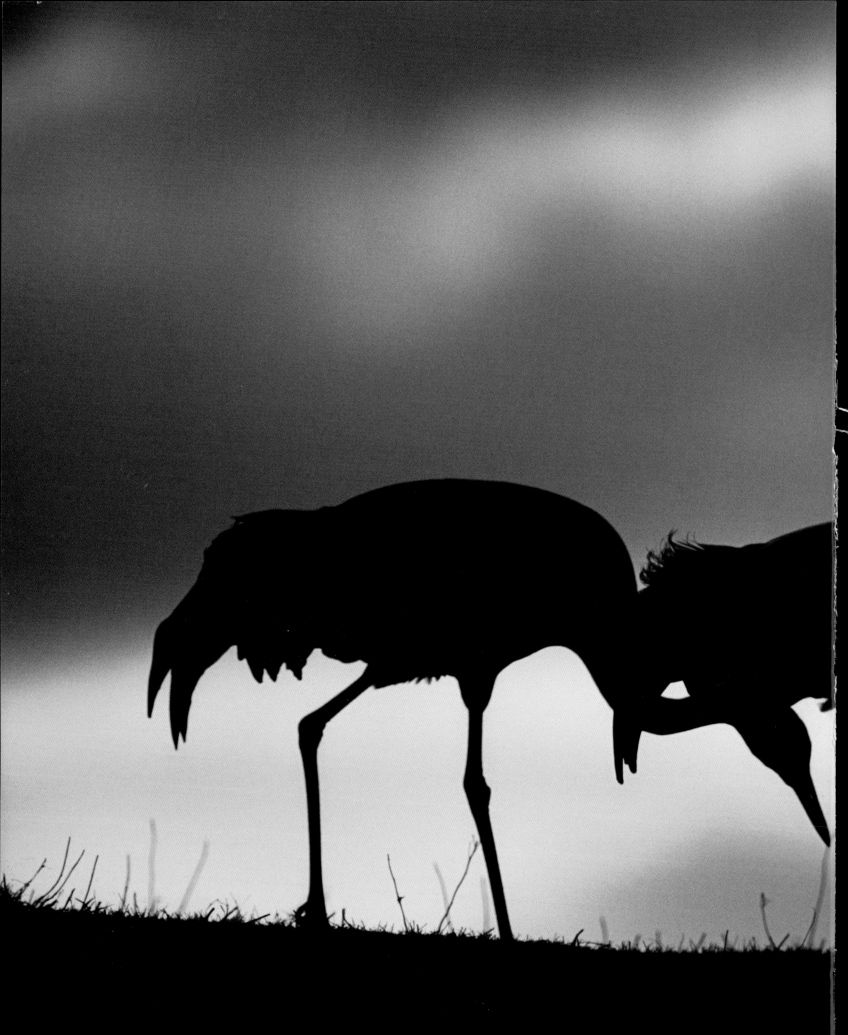

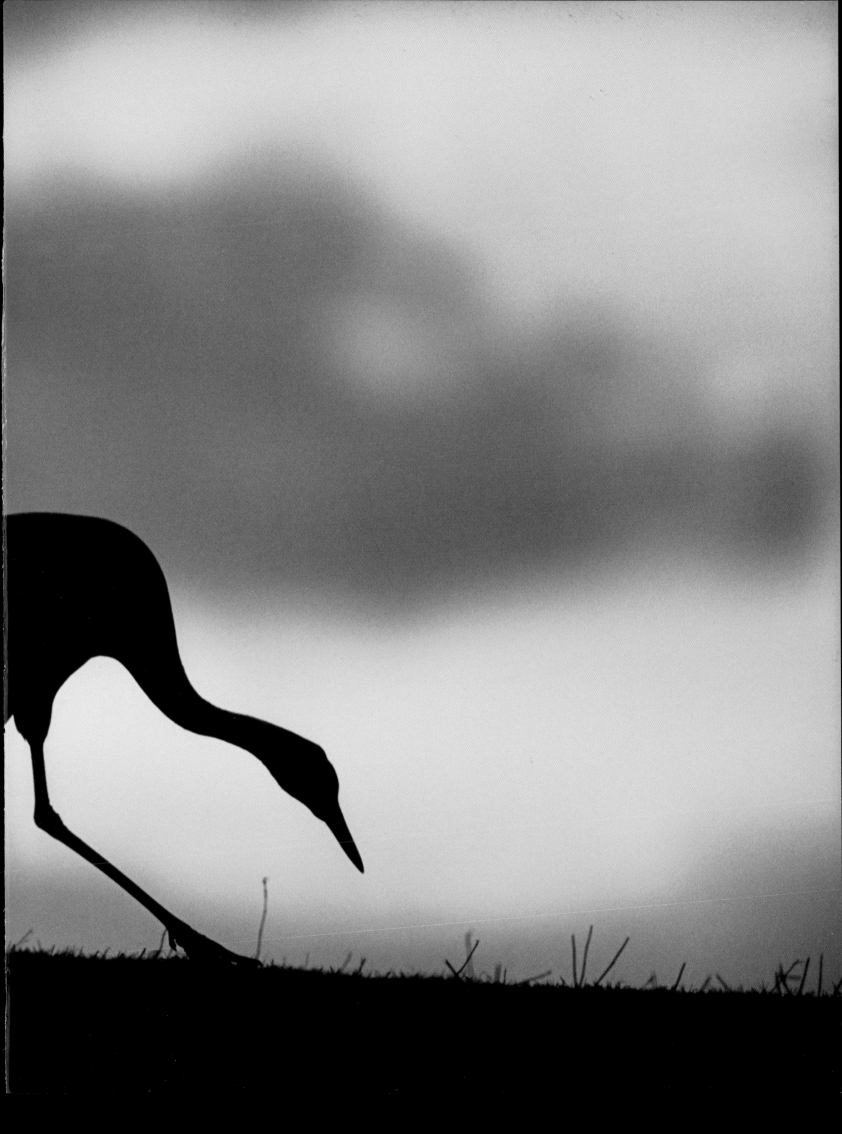

INDEX